HAUNT
HERTFORI

A Ghostly Gazetteer

Ruth Stratton and Nicholas Connell

The
Book
Castle

First published November 2002
Reprinted March 2003 by
The Book Castle
12 Church Street
Dunstable
Bedfordshire LU5 4RU

ISBN 1 903747 18 X

Cover Design by Serena Williams
Typeset & Designed by Priory Graphics
Printed by Print Solutions Partnership
Wallington
Surrey
SM6 9RQ

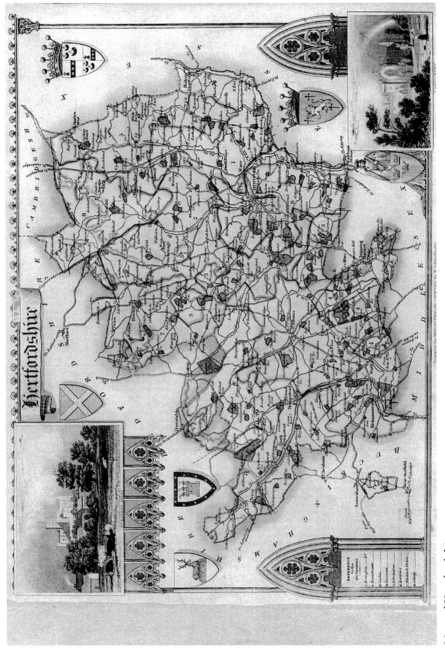

Map of Hertfordshire.

Acknowledgments

The authors wish to thank the staff of the British Library Newspaper Library, Dacorum Heritage Trust, Hertford Museum, Hertfordshire Archives and Local Studies, Hertfordshire Central Resources Library, Hitchin Museum, Phantom or Fraud (Galaxi Television) and Stevenage Museum.

Also grateful thanks to Loral Bennett, Tom Doig, Stewart Evans, Ken Griffin, Tony Joshua, Jeremy McIlwaine, Keith Marshall (of Marshall's Furnishings Hertford), Gary Moyle, Suzanne Nicholls, Lance Railton, Serena Williams, the Ghost Club of Great Britain and all those who supplied oral testimonies.

Additional thanks to Hertfordshire Archives and Local Studies for supplying and giving permission to reproduce most of the illustrations in this book.

About the Authors

Nicholas Connell has lived in Hertfordshire all his life. He is the author of numerous historical articles, many of which were about Hertfordshire's past and people. He is also the co-author of 'The Man who Hunted Jack the Ripper', a biography of the celebrated Victorian detective, Edmund Reid.

Ruth Stratton has also lived in Hertfordshire all her life. She has had an interest in ghosts from a young age, and has collected numerous articles and books on the subject. In 2001, Ruth was a researcher for a paranormal investigation team working for Sky Television on the series 'Ghost Detectives' shown at Halloween that year. Ruth has written various local history articles and tourist booklets and an exhibition charting a thousand years of Hertfordshire's history. In 1998 she researched and wrote 'To Hatfield and the North', a play celebrating Hatfield's 50th anniversary as a new town, which was performed in the town's theatre.

Both authors have worked at Hertfordshire Archives and Local Studies for many years, which has given them the opportunity to unearth numerous long forgotten Hertfordshire ghost stories.

Picture Credits

Abbreviations – HALS Hertfordshire Archives and Local Studies

	Map of Hertfordshire	HALS, CM 65
1	Aldenham, Wall Hall	Authors' Collection
2	Anstey, Anstey Castle	HALS, Hine Collection vol. 162
3	Ashwell, Ashwell Church	HALS, CV Ash/16
4	Ayot St Lawrence, Shaw's Corner	Authors' Collection
5	Ayot St Lawrence, The Brocket Arms	Authors' Collection
6	Ayot Green, Remains of Rouse's Car	Stewart P Evans Collection
7	Bishops Stortford, The George Inn	HALS, CV 260
8	Bishops Stortford, The Black Lion Inn	HALS, Acc 3556
9	Boxmoor, Robert Snooks' grave	HALS, D/EGr 38
10	Buntingford, High Street	HALS, Acc 3556
11	Bushey, Lululaund	HALS, LRR Collection
12	Cheshunt, Great House	HALS, CV Ches/3
13	Codicote, Churchyard	Authors' Collection
14	Codicote, Churchyard	Authors' Collection
15	Datchworth, The White Horse Inn	Authors' Collection
16	Datchworth, Rectory Lane	Authors' Collection
17	Datchworth, Datchworth Green	HALS, Acc 3556
18	Datchworth, Datchworth Church	HALS, Acc 3556
19	Datchworth, Clibbon's Post	HALS, East Herts Archeological Society Transactions vol. 7
20	Essendon, Essendon Church	Authors' Collection
21	Gilston, The Plume of Feathers	HALS, CV 380
22	Hatfield, Hatfield House Staircase	HALS, CV Hat/76
23	Hatfield, Hatfield House	HALS, CV Hat/68
24	Hemel Hempstead, The Olde Kings Arms	HALS, CV Hem/65
25	Hertford, Balls Park	HALS, CV Hert/235
26	Hertford, Sir Henry Chauncy	Authors' Collection

Introduction

Hallowtide in old Hertfordshire, when shadows lengthen and nights draw in, was the traditional time for families to gather around the fireside and thrill with age-old tales of ghosts. From All Hallow's Eve, when the veil between this world and the next is cobweb thin, through to the raw frost of New Year's Eve, storytellers would draw their cloaks closely around their shoulders, whilst the favourite tales tumbled out to the wide eyed listeners in the flickering candlelight. It was in this way, the rich tradition of local ghost-lore was preserved.

With not so much candlelight and fireside fable as computer and electronic archives, in a modern day slant on an old tradition, 'Haunted Hertfordshire' is a collection of over 300 of these hearthside tales, together with newspaper, magazine and oral accounts, captured in the most comprehensive county ghost guide ever published, ensuring their survival for many years to come.

Hertfordshire is a mysterious county of enchanting woodland, ruined churches and lost castles, whose rustic countryside whispers richly remembered folklore and custom despite its proximity to London. Ghost-lore inextricably weaves with folk tale and it is in rural little places like Datchworth, the county's most haunted village, where the atmosphere of the past lingers strongest. As soon as you leave the creeping infringement of the surrounding new towns behind, Datchworth's brooding air of timelessness reaches out and snatches you in to a world of grey ladies walking through solid walls and headless horses, whipped on by headless drivers, pulling creaking wooden carts on endless rides around the village. But it is not just in these shadowy corners that phantom footsteps stalk; having spent months unearthing innumerable tales of the supernatural in this curious county, we have found that haunted places can range from a gothic country mansion to a new town council house. Ghosts have no social divisions, appearing to the famous and ordinary alike and

capering with time and space, like the Roman soldiers who habitually turn up in a cul-de-sac semi in St. Albans.

Whilst researching this book, we discovered articles about ghosts and the supernatural regularly abound in magazines and national papers. It is a subject that has held universal fascination for generations and even in today's cyber world of enlightenment, the intrigue doesn't look like it's waning. Surely it is the very thrill of the unexplained that keeps us bristling with curiosity? In a world where we are swept along by science and progress, we still don't know exactly what a ghost is, and that is the allure.

Having been immersed in stories of ghosts spanning the centuries, the question 'what is a ghost?' is always nudging at the back of our minds. Various theories have been put forward to explain hauntings, ranging from past tragedies leaving scars on the atmosphere, to components of certain buildings acting as giant 'tape recorders', playing back certain events. '**Haunted Hertfordshire**' contains many previously unpublished, historical stories but also explores new research, ranging from glowing balls of light, appearing in photographs, speculatively associated with the appearance of apparitions to theories of an extra dimension, or parallel universe, where the right conditions may perhaps produce a time-slip, resulting in a glimpse of the past or future. But there are too many variations of 'ghost' to be explained by just one theory. Some drift silently about, seemingly unaware of their surroundings, whereas others prod, poke and even speak to the mortals around them.

Whatever a ghost is, Hertfordshire is teeming with them. Not just all the romantic favourites including cowled monks, dashing Cavaliers and headless highwaymen, but a surprising amount of spectral animals, cars, trains, bicycles and even a World War II tank! Some of them have a particular repertoire, mainly consisting of turning electric lights on and off, locking doors, lurking around in pub cellars and tampering with the equipment, twisting taps on, and spooking dogs.

There are also a remarkable number named 'Henry'. Perhaps this is just peculiar to the spectral playground that is Hertfordshire. Many of the older stories will have changed over time and the original truth lost in the mists of legend, but thanks to those who have shared their experiences with us in the 21st century, today's ghost stories are now safely recorded, preserved for centuries to come.

Maybe one day science will have found an explanation for ghosts and ghost hunting will be a recognised career option, but until then, enjoy the intoxicating enigma that we feel is better left unsolved. So when night falls over Hertfordshire and the mists roll in from the fields, wisping around the houses, shrouding them in a ghoulish glow, tuck yourself up beside the fire and lose yourself in the mysterious realm of the unknown. But wait, what was that noise? Was it a tree branch tapping the window in the wind or the cold, skeletal hand of a spectral visitor, knocking to get in?

ABBOTS LANGLEY

Manifestation: Death at the Rectory

History:

Mystery surrounds the death of Mary Anne Treble. Some say she died in 1914 of double pneumonia as a result of an accident where she fell downstairs, others whisper that she met a more sinister end at the rectory. What really happened to Mary Anne has become lost in gossip and folklore and sadly we shall never know for sure. What we do know is that Mary Anne is buried in St. Lawrence churchyard, but her spirit does not rest in peace.

Her ghost has been seen drifting between the church and the vicarage and also appearing inside the church during Mass on All Souls' Day. A former Vicar's daughter would wake up and see Mary Anne looking wistfully out of the bedroom window and residents in the cottages across the road also reported seeing Anne's ghostly face looking out at them.

A fireplace, in the room where Mary Anne is said to have died, was altered many times, but would not remain repaired and constantly fell out of the wall. Unaccountable noises have also been heard to emanate from the haunted room and in the late 1970s, the Rector and his wife began to find electrical appliances had switched themselves on. This appears to be a common theme with many hauntings, especially concerning electric lights.

Whatever happened to poor Mary Anne, the Vicar's housekeeper, she was fondly remembered in the village for giving sweets to small children

St. Lawrence Church was built in 1150 but damaged by fire in 1969. Abbots Langley's most famous inhabitant was Nicholas Breakspear, who was born here and was the only Englishman to become Pope (1154-1159).

ALDBURY

Manifestation: Phantom Coach and Horses

History:

'May I drop dead if what I tell you isn't the truth', said an old Aldbury resident in the 1970s. Her father had ventured out one night to collect some dinner party guests and on the road to Pendley he suddenly heard the clop-clop of horses' hooves, but no horses could be seen. A coach was apparently speeding in his direction and his horse shied violently in fright but the vehicle, which he felt pass right by him, remained invisible.

It is the belief that on gloomy nights, a phantom coach, driven by former Lord of Aldbury, Simon Harcourt, still rides the road to Tring. But strangely just the sound of the horses' hooves and the jingle of the bells on the harness can be heard; nothing has been seen….yet.

ALDENHAM

Manifestation: Haunting Housekeeper of the Mansion

History:

Lynn Englebright is not a woman easily scared. Housekeeping manager at Wall Hall Mansion, currently belonging to the University of Hertfordshire, Lynn has seen ghosts before and it was in February 2001 during her nightly cleaning job she encountered what she claims, 'the clearest thing I have ever seen.'

Lynn and another cleaner, Theresa, were working in offices in the philosophy block of the old mansion. Lynn was vacuuming alone when she heard what she thought was Theresa come into the room. Without turning round, Lynn said, 'I cleaned this room thoroughly only yesterday.' There was no answer and Lynn peered over her shoulder and saw a dark pair of shoes skirted by a long grey dress folded in soft layers. Her eyes travelled upwards and took in the form of a lady standing with her hands on her hips. She wore a dress nipped in at the

waist, a tight bodice top with a white collar and long sleeves. Her grey hair was taken back and her older woman's face was frowning hard at Lynn. 'There's no use you frowning at me like that' said Lynn, unafraid, 'I did this room yesterday, I'm not doing it any different.' The woman in grey folded her arms and continued to frown disapprovingly. At that moment, Theresa came in and asked Lynn who she was talking to. Lynn blithely replied that she had been speaking to the woman in grey and Theresa fled from the room.

Lynn isn't the only one to have seen the old woman, believed to be the ghost of a former housekeeper when the mansion was a private home. Security staff have also seen her, plus children's laughter has been heard when there are no children present and Lynn has often heard the swishing sound of a long skirt. M7, a lecture room, is always freezing cold no matter what the weather and, where the former housekeeper has been seen before, many staff have reported lights being mysteriously switched on and off when they are in the room.

Wall Hall Mansion is a spectacular looking building. Its gothic frontage is often used as a location for film and television. Originally built as a farmhouse in the late 1700s by George Woodford Thelluson, the castellated exterior was added in 1802 and the house was known as 'Aldenham Abbey' but historical reference to Wall Hall can be traced back as far as the 13th century. In 1812, Admiral Sir Morice Pole acquired the house and had a ruined church constructed in the garden as a spectacular folly. After 1910 the building was owned by American millionaires the Pierpoint Morgans and in 1945 Wall Hall was in the hands of Hertfordshire County Council and provided an emergency teacher training college.

ANSTEY

Manifestation: Phantom Fiddler

History:

On the Barkway and Cambridge Road is an old chalk pit, known as Cave Gate, long fallen into disuse, which for generations was avoided

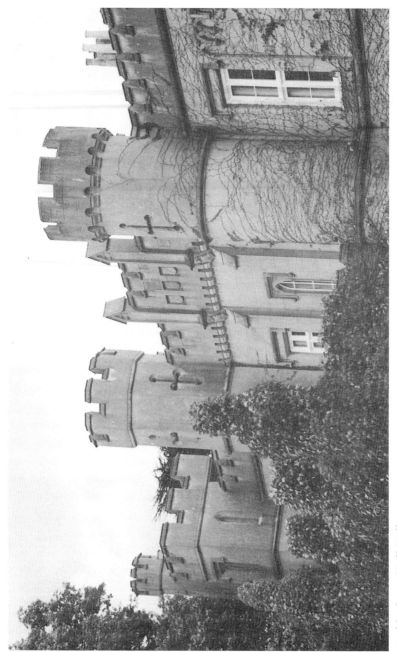

1. Aldenham, Wall Hall.

4

2. Anstey, Anstey Castle.

as a haunt of the powers of evil. An ancient secret passage is said to connect it with the ruined Anstey Castle, about a mile and a half away, whose mounds lie a mile to the east and whose dank dungeons had a notorious history of torture and abuse.

Around 1750, George, a fiddler, was said to have been drinking at the local inn, now the Chequers. After a few flagons of ale, he swore that he would explore the tunnel that very night, accompanied only by his dog and his fiddle. A handful of friends walked with him to the tunnel and fearfully watched him disappear through the overgrown entrance. The listeners followed the distorted strains of George's fiddle, coming from under their feet, to Castle Hill whereupon there came a terrifying scream and the fiddling ceased. George's dog hurtled out of the tunnel, tail-less and with singed fur but his master was never seen again. The tunnel has since been bricked up, but it is said that on windy nights, the sound of George's fiddle can still be heard drifting up from beneath the earth. Locals say crops do not grow on the ground above the tunnel and when it snows, it melts first on the mound.

In 1944, the moat was drained to remove a crashed B17 Bomber and iron gates, shut fast, were seen at the entrance to the tunnel.

ARDELEY

Manifestation: Poltergeist Legend

History:

An old story exists in folklore about Moor Green Farm which was haunted by a poltergeist at one time. Dates, times and details have been swallowed up in history and this scant memory is all that appears to remain.

ASHWELL

Manifestation: Headless Figure in Churchyard

History:

A letter dated 18th September 1911 was sent to the Editor of the *Herts & Cambs Reporter* telling of a headless spectre that the author's mother had encountered one night in Ashwell Churchyard. The lady, Georgianna Covington, was on her way to choir practice one Friday evening, when, entering the churchyard from the corner gate, she spied someone walking in the opposite direction from the rectory to the same door. The moon was shining very bright, and as she turned to enter the church, she saw with horror that the figure, dressed in black, was headless. It glided noiselessly up to the door and vanished suddenly. The terrified woman stumbled through the chancel door and fell unconscious on the floor, much to the consternation of the assembled choir, who abandoned practice for that evening.

A researcher into the Ashwell ghost worked out that this sighting would have occurred about 1850, the 500th anniversary of the worst Plague epidemic in the county in which Ashwell suffered most and after became known as the county's Plague village. In the North wall of the tower Latin graffiti survives from the 14th century, describing the suffering of the local population.

Manifestation: Phantom Coach

History:

On the night of Sunday November 26th 1871, a coachman returning to the Rose and Crown stables in Baldock, was thrown into the stream when his coach overturned in the road. His body was discovered next morning down stream. The horses were found lying in the water; one dead, the other much injured. Is it his phantom coach, drawn by two horses, which spooks late night travellers on the road between Ashwell and Bygrave?

3. Ashwell, Ashwell Church.

Manifestation: Tea-Time Mystery

History:

It was a hot summer's day in the 1890s. A travelling man, thirsty and dusty from the road, stopped to rest at a cottage advertising teas. He knocked at the door and was greeted by a small, thin boy who looked haggard and grey with dark shadows under the eyes. He was invited to sit down at a table outside and the boy went off to fetch his tea. When it arrived, the tea was cold and terribly sweet and the traveller went in search of the boy to ask for another, but could not find him anywhere. He went back and knocked on the cottage door once more. This time a middle-aged lady answered and suspiciously told him: 'I don't do teas no more.' Mystified, the traveller showed her the tea-cup, but her curt reply was that it wasn't one of hers and there was no boy living there. With that she hurriedly shut the door.

Bewildered, the traveller looked for the sign in the window offering teas, but found it had vanished. Walking back through the village, he stopped and asked a local person about the tea-house. He was told the woman had offered teas up until 20 years before, but then lost her son to illness and had become a recluse.

ASTON

Manifestation: Knight in Armour

History:

An unknown 16th century knight in armour has been seen to ride into a wood at Aston Bury, and then disappear. In 1957, two village farmers found a gentleman's sword dating back to around 1540. Very little else is known about this mysterious knight and perhaps this sword is the only clue to his existence.

AYOT ST. LAWRENCE

Manifestation: Ghost of George Bernard Shaw

History:

Shortly after his death in 1950, Shaw appeared to his housekeeper, Mrs Alice Laden. Mrs Laden was clearing out her cupboards in the kitchen at the playwright's home known as Shaw's Corner. 'Suddenly, there was a knock at the door. Without thinking I said 'Please come in, Mr Shaw.' The door opened and, as I turned, Mr Shaw stood on the threshold He looked just as he was in real life. He said: 'I heard a noise and thought you may have had an accident.' It was not until I began to explain that I saw there was no-one there.'

Some days later, Mrs Laden was again visited by her former employer's ghost. 'I was standing at the foot of the staircase and heard his footsteps on the landing. He called out: 'Are you there Mrs Laden?' and then his footsteps died away.'

The village is also reportedly haunted by the ghost of Lawrence of Arabia, who visited Shaw many times and on whom Shaw based his character Private Meek in 'Too Good to be True'. The roar of his motorbike is rumoured to have been heard in the leafy lanes of Ayot St. Lawrence.

Manifestation: Ghostly Monk

History:

The ancient **Brocket Arms** inn built around 1378 was once a hostelry for pilgrims. For many years now, strange mutterings, thumps and footsteps have been heard upstairs on the first floor. The apparition was first recorded about 9pm in 1969, ten years before all the major alteration work took place. Witness Teresa Sweeney was carrying some sandwiches through the dining room. On her left she says she saw: 'a man dressed all in brown in a monk's outfit with a cowl and everything. His head was bent over so I couldn't see his face, but, as I turned to face him, he vanished.' Then he was seen again, this time on a winter

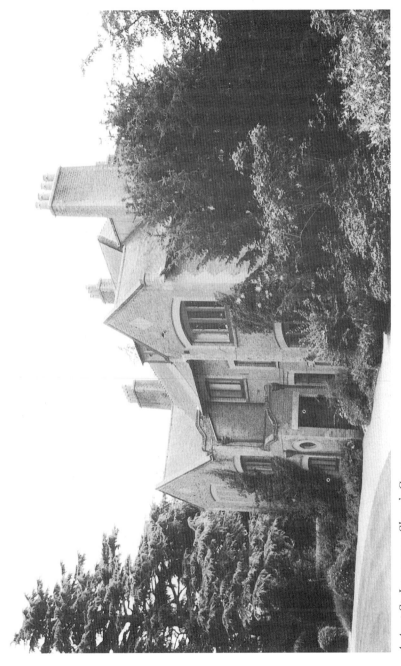

4. Ayot St. Lawrence, Shaw's Corner.

11

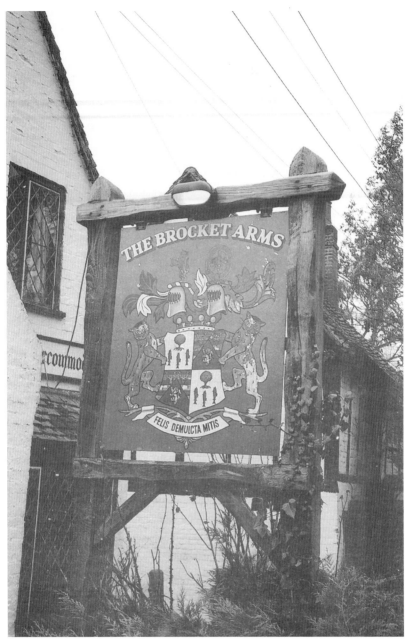

5. Ayot St. Lawrence, The Brocket Arms.

morning but described as: 'an old emaciated face in a sort of smoky haze in the doorway of the dining room.' As on the first occasion, the figure vanished into thin air.

The ghost is believed to be that of a monk who hanged himself in one of the upstairs rooms. On the wall in the bar is a poem outlining the unfortunate's fate. Its author is a C.H.A and it was written in 1940. The poem takes you through history from the Spanish Civil War to the Second World War, but this is the salient verse connected with the ghost:

>*A monk had ridden as he fled from the mob*
> *of howling villains who feared no god.*
> *They slung him up to a beam in the bar*
> *declaring he should not have ridden so far.*

The current landlord, Toby Wingfield-Digby, has resided at the old inn since the early 1980s. He is troubled by alarms regularly blaring out at 3am when nobody has been around to set them off. The alarms have been checked and re-checked by experts but they were completely baffled as to why this should be occurring. Toby has, on a couple of occasions, suddenly experienced feelings of panic and claustrophobia in certain parts of the building for no reason and a guest staying in one of the bedrooms awoke one morning to find inexplicable burn marks on the tops of her feet that certainly hadn't been there when she retired to bed. Toby has often felt there had been a fire at the building at one time in its long history but it was only when one day a man walked into the pub with a pair of hazel twigs and intriguingly claimed he could sense the restless ghosts by use of dowsing, the story began to piece together. One guest apparently saw the monk, who appeared to be on fire, staring at him during the night. He was naturally very shaken by the encounter.

Manifestation: Grisly Car of Ayot Green

History:

At nearby Ayot Green, an old fashioned car bearing the number plate MU 1468, mysteriously appears from nowhere and parks beneath the trees on the green before vanishing equally as suddenly.

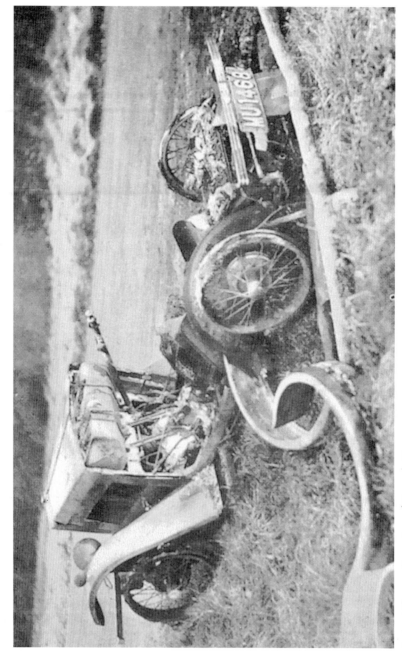

6. Ayot Green, Remains of Rouse's Car.

14

This is the car belonging to murderer Albert Rouse who, on bonfire night 1930, kidnapped a tramp and travelled to Northampton. Rouse's journey ended in Hardingstone, Northants, where he murdered his victim and set the car ablaze. His plan was to walk through Northampton and get a train to Scotland, but as he was leaving the scene of the crime, he ran into two men and taken by surprise, hesitated and changed his mind, ending up in Wales.

Albert Rouse was a 36 year old commercial traveller in and around Hertfordshire and was often seen parked up in his car at Ayot Green 'entertaining' various women. He was described as a handsome man with a 'facile' tongue. Astoundingly, he was caught by carelessly forgetting to attach his identity disk to the tramp's body, but instead leaving it in his attache case in the car. Rouse was married in St. Albans in 1914. At his trial, it was stated, 'It has been calculated that nearly eighty women were more or less seduced by him.' When his hectic, juggling lifestyle became too much for him, Rouse faked his own death and allegedly this was the first time in British criminal history that a car had been used as a vehicle for murder.

BALDOCK

Manifestation: Tale of John Smith

History:

Buried in the churchyard at Baldock is John Smith, one time Rector. This man with such an unexceptional name became well known for his translation of the cryptic shorthand used in the diary of Samuel Pepys. Smith, Rector from 1832-1870, deciphered all six volumes, which had lain in Pepy's library for nearly a century, whilst a student at St. John's College, Cambridge. The flitting shadow of Smith's wraith is reportedly often seen in the church.

BARKWAY

Manifestation: Henry the Friendly Pub Ghost

History:

This ghost has been such a long-term regular at the Chaise and Pair public house, that he has been lovingly named 'Henry' by some of the mortal regulars. Henry is a friendly and helpful ghost who apparently changes barrels in the cellar. He has been making his presence felt at the pub for many years and has been seen during the night.

Manifestation: Brighton Bill

History:

The spectre of William Phelps, better known as 'Brighton Bill', haunts the Wheatsheaf pub and the north east corner of the graveyard. Bill was virtually beaten to death in a boxing match at Norris Folly in 1838 and was brought back to the inn to die. He can still be heard moaning and sighing in pain.

BARLEY

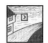

Manifestation: Footsteps at the Fox

History:

The old Fox and Hounds inn, in this tiny hamlet of Barley, has a distinctive inn sign that spans across the road from the pub, depicting a fox being pursued by hounds. For years the pub has been haunted by the sound of footsteps. It was originally the farmhouse and was converted to an inn in 1797. However, the previous Fox and Hounds burned down in 1950.

BARNET

Manifestation: **Ghostly Knight**

History:

The Clock Towers in East Barnet was demolished in 1925. This famous old building was where Lady Arabella Stewart set forth in male attire in 1611 for Calais to meet her husband, William Seymour, after his escape from the Tower of London. Beneath where the building stood is believed to be a maze of underground tunnels where the ghost of Sir Geoffrey de Mandeville, former sheriff and justice of Middlesex and Herts and one of the most powerful men in England in the 12th Century, reputedly appears every sixth Christmastide. He has also been spotted at Trent Park and the Cockfosters area. Trent Park, now a University Campus, has an old earthwork in the grounds known as 'Camlet Moat' which is traditionally thought to be the remains of the manor house of Enfield, and it is here that his ghost has been seen. One local legend says that he was drowned in a well near the old house. Another explains that he was arrested by King Stephen's men in a violent struggle at St. Albans in 1143 and Sir Geoffrey was taken to London and compelled to yield his fortresses in London and Essex, so he would escape the death sentence. This put the rebellious knight in a 'towering rage' and, vowing revenge, he was soon in revolt again when he was hit by an arrow during an attack on a fenland fort, dying in Mildenhall in 1144. Plenty have seen him, clanking around East Barnet, clad conspicuously in armour, red cloak and spurs.

Sometimes, Sir Geoffrey is accompanied on his nightly excursions by a beautiful lady in grey, who has been seen by various people in the area, occasionally alone.

During 1926 and a spell of roadworks in the area, Sir Geoffrey was seen clearly in moonlight by several local people and again in December 1932 when a vigil was arranged and the watchers saw the ghost as plain as day. The success of the first vigil prompted a second on Christmas Eve and the watchers were treated to a headless dog

which appeared first. Then, according to an independent observer –
a reporter from the *Sunday Dispatch*, 'As we stood staring there was a
sudden break in the clouds and a figure in armour could be seen
clearly.' The reporter went on to make enquiries and found at least
a dozen people willing to testify to seeing the ghost more than three
times. His next scheduled visit is Christmas 2004.

Manifestation: Ghosts of Camlet Moat

History:

Camlet Moat was once a wild and lonely spot. It is vividly described by
Sir Walter Scott in 'The Fortunes of Nigel' and is where a deep well
stood, rumoured to contain the hidden De Mandeville treasure. Very
little remains of the original moat and the area is thickly grown with
bushes. Dick Turpin is rumoured to haunt the area together with all
the surrounding roads. Sometimes his ghost is seen complete with tri-
corn hat, riding coat and high boots, hiding behind trees. On wild,
stormy nights, Turpin tears across the surrounding fields and roads, his
cloak flying in the wind.

Turpin's grandfather is believed to have kept the Rose and Crown
inn near Clay Hill and it was here Turpin performed some of his most
daring exploits, going to ground in the Rose and Crown when things got
too hot.

The shadowy figure of an old witch in black prowls around the site
of the old moat. She moves slowly and painfully, leaning heavily on a
stick and is believed to be the ghost of a woman who lived near Enfield
Chase, became notorious as a witch and was executed in 1622,
according to Ford and Dekker, who wrote a drama: 'The Witch of
Edmonton' based on this real character.

A horse and rider out near the moat were pursued by a phantom
man who only stopped at a certain gate on the road.

Manifestation: Fearful Ghost – a Magistrate's Testimony

History:

'I have seen strong men walk away from this house with wide staring eyes and limbs trembling as though their knees would refuse to support their bodies. Once I saw a spirit myself.'

Such was the testimony of Mr Walter Stutters for many years a magistrate in East Barnet. This report, dated 1927, was with regard to the ghost said to have been seen by two women and a night watchman in a house near the Grange, East Barnet.

'Women', he added, 'have been seen to hurry away, wrapping their cloaks and shawls about them, seemingly anxious to get away from the scene they had witnessed. I have on several occasions been inside the house and have heard a suppressed report and more frequently a jingling noise. On one occasion I saw quite plainly before me, a spirit. Looking at it closely, I saw right through it and was able to distinguish objects in the other side of the room. Gradually it passed away, leaving no trace of its passing.'

Mr Stutters also described low rumbling sounds, as if heavy weights were being moved, short, sharp tappings and sounds like muffled voices. The hauntings seem to centre around the cellar where a shadowy form glides about the floor.

Manifestation: Sad Figures of Barnet Hill

History:

In the 1990s a woman was driving her car up Barnet Hill. On approaching the junction of Meadway, she saw a young woman and child standing in the middle of the road opposite. She slowed to let them cross but was horrified when other cars continued speeding up the hill on course for a collision with the pedestrians. On reaching the crossing, there was no sign of the woman and child, yet there was nowhere they could have disappeared to in such a short time.

It has been suggested that the ghosts are those of a young woman and child who were killed on the crossing one Christmas in the late 1950s, early '60s.

Manifestation: Phantoms in the Park

History:

A husband and wife were walking through Oak Hill Park, East Barnet in the mid 1980s after midnight one night when they encountered a headless apparition hovering about a foot above the ground. The black figure reportedly floated silently around the pavilion with its legs moving in slow motion and at one point actually turned and 'looked' straight at the couple, who understandably, turned and fled for their lives.

Forty years before, some teenage girls were meeting friends in the Park early one evening. They spied a man sitting on a bench wearing what they described as a big 'Oscar Wilde' type hat. He was lit by a street lamp so they were able to get a clear view of him. He was in Victorian or Edwardian dress, a dark suit or coat. The girls approached him but when they got to about ten feet away he simply vanished in front of their eyes. One of the girls described it as similar to having a 'light switched off in front of you', another became hysterical and passed out.

Thirty years later in the 1970s, a friend of the girl had some photographs developed of the Park and in one of them a figure materialised that had not been there at the time. It was a man, dressed in exactly the same way that the girls had witnessed so clearly years before.

Manifestation: Ghost of Nimbus 55020

History:

It was twilight at New Barnet in 1980. The local train was making its way towards Hadley Wood South tunnel when the sound of a throbbing Deltic diesel engine emerged into the dusk light. A couple of train spotters on the footbridge watched in amazement as the steam engine chugged into view, wreathed in an aura of glowing luminescence. Once the train was out of sight, leaving behind only the trails of smoke, the spotters turned to each other and found the details they retrieved from the passing train were Nimbus 55020. They went cold. The Nimbus

had been cut up some months beforehand. On checking at Hadley Wood station, they were told no southbound train had passed through. They could only conclude that they had not only seen, but also heard a ghost train that evening.

BENGEO

Manifestation: Sensory Perceptions

History:

On the corner of Cross Road in Bengeo stands a very unusual looking turreted house. The previous owner tells of a distinct smell of perfume drifting around the house when no-one was wearing any, or indeed possessed any of such a fragrance. The pervasive and warming smell of wood-smoke also curled itself into corners when no fire was lit. The figure of a woman has been seen in the house.

BERKHAMSTED

Manifestation: Attention Seeking Shade

History:

A ghostly monk manifested several times in the 1940s and '50s in a Georgian House in Piccotts End. Then some years later, unique medieval wall paintings were discovered in a 500 year old cottage which adjoined the house. The theory is that the Bonhommes monks of nearby Ashridge, originally a 13th century monastery, were possibly responsible for the paintings. In the 1960s, a poltergeist manifested itself in the house and caused a nuisance by door slamming and rappings. Footsteps were heard in an empty upstairs room and the mischievous ghost graduated to throwing pictures from walls. Objects would appear and disappear and crockery would smash whilst still on the shelf.

Manifestation: Spectre of the Cellar

History:

Dogs refuse to go near the cellar in the old 500 year old Crown Inn, High Street, Berkhamsted. Light bulbs jump out of their sockets and bottles of wine shatter of their own accord. The story goes that the cellar was once a room where an old lady sat in an alcove on her rocking chair and resentful at the intrusion, she tampers with the barrels. One person claims to have seen the ghost and that was a previous landlord, Bill Aggett.

Manifestation: Warriors

History:

There is the fanciful belief in Berkhamsted that on a summer's evening when the sun shines gloriously in the western sky, if you look in the direction of Wigginton, you may be lucky enough to catch a glimpse of the departed warriors who laid ruin to the castle, with their spears and helmets glinting in the evening sunshine, going through their military procedures as if still engaged in actual warfare.

BISHOPS STORTFORD

Manifestation: Grey Lady and Other Apparitions

History:

The Grey Lady is almost a tourist attraction in herself. For over 500 years her ghostly presence has haunted Bishops Stortford from one side of the town to the other. But the main focus of her haunt is **Maslens** store in Bridge Street. There staff have reported objects such as headless flowers and nuts and bolts being thrown around by an unseen force. They have also experienced strange knocking noises, lights switching on and off and feet running down an empty staircase

at night. Once, when the store was being refurbished, workmen saw a hammer standing on end and scratch marks appearing in fresh plaster work. A terrified plasterer ran from the building when his bucket was kicked over and tools thrown about while he was working alone one Sunday. Maslens was formerly known as Handscombs hardware store and was housed in the only standing remains of the Bishop of London's Palace, dating back to the 16th century. This was only discovered in the 1960s when, during alteration work, part of the modern ceiling was removed, revealing the original ceiling of the Palace.

The Grey Lady has reportedly been seen often in the **George** public house in North Street, most recently a few months ago. The pub, now a hotel, dates back to 1417 and played host to King Charles I in the 17th century. Room 27 is supposedly where the ghost is particularly felt and she didn't disappoint a team of psychic investigators when an all-night vigil was held in the room. Guests in the room have felt invisible eyes watching them and one couple saw a strange swirling grey mist around the bed. Another guest saw the figure of a woman in a grey gown bending over the bed with her arms raised as if in pain. She vanished as soon as the guest cried out. There is an old oak door in the room with a handle purported to be 200 years old. This secret room has not been opened for years and nobody really knows what is behind it, but even recently guests complained that the lights kept going on and off by themselves.

A 'white mass' has been seen hovering in the cellar, but the ghost's favourite trick is to turn off the beer gasses and this she does on busy nights, according to the current landlord. 'You go down to the cellar to turn the gas back on and 10 minutes later they are off again but nobody has access down there and the taps have been physically turned off.'

The presence of the grey lady has also graced the 15th century **Boar's Head** inn up on the hill opposite the church. The tenants in the mid 1970s were forced to have the premises exorcised three times because of troublesome spirits.

Here, the story of the ghostly Grey Lady takes an unusual twist. In the 1970s, Jane Foster from Takeley experienced her first (and last) ouija board session at a friend's home in Stanstead. The date was

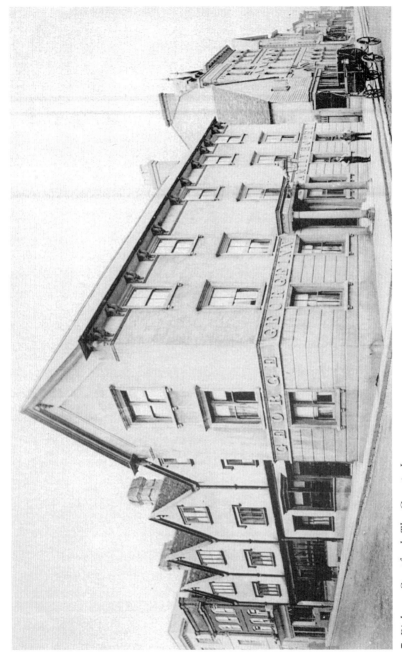

7. Bishops Stortford, The George Inn.

Saturday December 23rd. The Grey Lady came through and revealed herself as 'Sarah' and said she met her end by being raped and murdered by a Squire's son on a Saturday December 23rd in the past. Sarah begged the group to help her to pass over and be at peace.

In 1983, a local man was taking a short cut through **St. Michael's churchyard** about 10.30 one night when he noticed a large black figure trudging off the path and amongst the graves. The man said he couldn't make out the figure's features, but it was definitely far larger than any human. He swears he was not on his way back from the pub and was in fact quite sober.

A spectral army Captain in full uniform parades the grounds around nearby former **Windhill House**. Now St. Joseph's, the original building was 17th century and 'L' shaped. During the Napoleonic Wars, Captain Winters allowed a local band of Yeomanry to camp in the grounds of the house but was tragically shot by accident in the dark by one of his own corps.

In local folklore, the top of nearby **Holloway Hill** was greatly dreaded by those who had to pass that way after dark and the gruesome stories seemed to be confirmed when during road alteration, skeletons were dug up there.

Near Bishops Stortford is **Hadam Hall**, a part destroyed Elizabethan structure with octagonal turrets built for the Capel family in 1575. The Hall is believed to stand on a much older premises which was mentioned in the Domesday Book. Since 1952, the building has been used as a school.

A spectral horse and cart with eerie lights moves silently along the drive away from the Hall and a lady in grey peers intently out of the window, possibly watching the phantom gardener and dog out in the grounds. This grey lady is thought to be either a young servant girl who took her life or Elizabeth Capel herself.

Manifestation: Middle-Aged Man

History:

In the mid-1930s, a policeman patrolling the streets of Bishops Stortford, reported seeing the apparition of a man standing in North Street near the junction of Hadham Road and Northgate End. He described the figure as being of middle-aged appearance and staring intently, oblivious of the officer's presence. As the officer approached, he suddenly disappeared, leaving the policeman in no doubt that what he had seen was indeed a ghost.

Manifestation: Victorian Girl

History:

The Black Lion, a 17th century Bridge Street inn was re-opened as 'Scruffy Mac's Irish theme bar' in the late 1990s and shortly after, objects such as mobile 'phones and keys started to go missing. In the late 1960s and '70s, a little girl in Victorian dress was often seen around the inn. She appeared in a resident's bedroom and one night footsteps were heard outside another bedroom and the handle of the door quite clearly turned. But on investigation, there was no-one outside on the landing. At one time, a friend of the landlord's stayed overnight and while he was in bed, the door opened and somebody came in the room and actually got into bed with him. The bed moved with the impact of whatever it was but there was nothing there.

One room at the inn used to be used for storing coffins in the time of the Bishop of London's residence.

Manifestation: 17th Century Man and a Serving Wench

History:

In the 1980s the 16th century Cock inn on the corner of Stansted Road and Dunmow Road was run by Mike Tunks and his wife Mollie. Mollie had witnessed the ghosts on several occasions. 'They just appear and disappear very quickly' she stated. When the pub underwent renovation work in the mid 1970s, tables reportedly flew across the room and lamps smashed before the work had even started.

8. Bishops Stortford, The Black Lion Inn.

Manifestation: Ghostly Knocking

History:

In 1923, the *Hertfordshire Mercury* reported that a discovery had been made at the Star inn on Bridge Street. During alteration work to open a new bar, a valuable and ancient oak-panelled partition had been found in one of the walls. Shortly after, the landlord, Mr Ives, repeatedly heard a knocking in the new bar whilst attending customers in the main bar. Whenever he went to see who needed serving, there was never anybody there. No knocking has been reported by the current landlord but in the mid 1990s, the cleaner came face to face with the Grey Lady.

BOVINGDON

Manifestation: Gleaming Presence of Box Lane

History:

Historian W.B Gerish wrote of Box Lane: 'It is a haunted lane with a unique charm in daylight as well as in dusky hours, running sharply uphill and blinking lazily across uneven stretches of grassland with a dark tunnel of trees and blocked up doorways alongside it.' A strange gleaming presence has long been reported here in Box Lane, sweeping past the wall of the largest old house. Gerish vouched for the apparition, having witnessed it for himself and felt a 'strange tingling sensation' on passing through it. His dog too, leapt aside and barked.

Murvagh House (now re-named) in Box Lane was troubled by a poltergeist in the 1980s. Doors would open by themselves in the middle of the night and unexplained crashes and bangs were a regular feature. In the wood panelled dining room, the residents were hosting a winter dinner party when suddenly a massive candlestick flew across the room in front of everybody seated around the table.

St. Lawrence Churchyard is fabled to have been desecrated by bloodshed and the dead are not able to rest in peace.

BOXMOOR

Manifestation: Danse Macabre

History:

On Boxmoor Common, near Hemel Hempstead, a small granite headstone peeps out near a ring of chestnut trees, on a patch of grassland triangled by busy roads. This is the grave of Robert Snooks, the last highwayman to be hanged in England on 11 March 1802. The headstone was added in 1904. It is believed that if you dance around the grave three times at midnight and shout 'Snooks' the robber would obligingly appear and join you in a danse macabre.

The odd thing about Snooks' grave is that it may be 200 years old but there are often fresh flowers and children's drawings placed by the headstone.

BRAUGHING

Manifestation: Five Monks and an Invisible Assailant

History:

At one time, there was a monastic building at this charming little village, belonging to the Manor of Cockenhatch. It may also have been connected with Cockenhatch Priory, now only a moated site, which was in existence for several centuries until the Dissolution. According to legend, five monks died one day in May, poisoned by trout they had poached from a nearby stream. After the death of the monks, the whole village seemed cursed by misfortune. Cattle died, crops failed and harvests were blighted. Five years after their demise, the monks were seen walking at Horse Cross and suddenly the fortunes of the village improved. It is believed the spectral procession occurs every five years.

Essayist John Aubrey in his *'Miscellanies'* of 1696, reported that a Mr Brogrove of Hamels, near Puckeridge, whilst riding in a lane near Braughing, was given a blow to the cheek or head. He looked back and saw that nobody was near him. This blow was followed by another two.

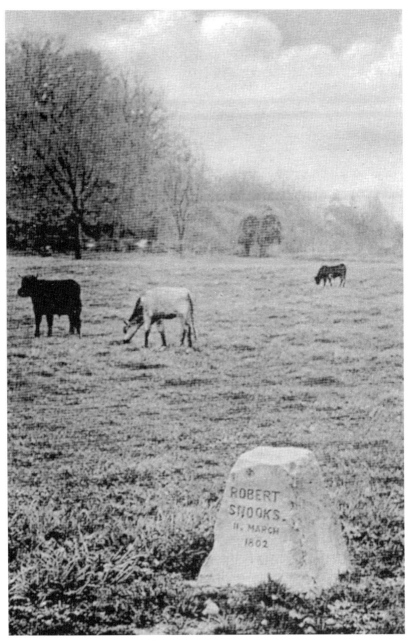

9. *Boxmoor, Robert Snooks' grave.*

Frightened, the gentleman turned back and never did discover the cause of his invisible assailant.

Manifestation: The Tall Lady of Cockhampstead Priory

History:

It was Christmas time 1954. Walter Martin, a Braughing man, had a taxi business and regularly took a client from Cockhampstead Priory to the station and back each day. Having dropped his client home this particular frosty evening, Mr Martin was driving back from the Priory when his headlights picked out a woman walking along the drive in front of him. The first thing he noticed about her was her height. She was about six feet tall, dressed in a beautifully fitted grey two-piece, with her hair drawn into a bun. Only then did he notice that her dress was very outdated for the period. It was bitterly cold and Mr Martin was just about to offer her a lift when suddenly she was no longer there. He jammed on the brakes of the Landrover, fearing he might have run her down but she was nowhere to be found. The strangest part was that she couldn't have slipped away alongside the drive because it was fenced on both sides all the way along to the end. Mr Martin went back to the Priory and asked if a woman fitting the description had been staying there, but nobody knew anything about this mysterious pedestrian.

Some time later, a neighbour told Mr Martin that she had often seen a lady in grey walking about nearby and who seemed to disappear into thin air. Although he has driven that way many times since, Mr Martin has never seen the tall lady again but remains convinced that what he saw that evening was a ghost.

BRICKENDON

Manifestation: The Notorious Brickendon Spirit

History:

On 4th January 1920 a little girl from a farm in Brickendon heard rapping noises in her bedroom. Two days later, her brother Norton

concluded that a message was being rapped out in Morse code and proceeded to ask questions of the entity behind the raps, but it was not her brother the entity wanted to communicate with, it was little Dorothy White herself.

Dorothy told the *Hertfordshire Mercury* newspaper:
'About a month ago strange rappings were heard on my bedroom wall. We all talked about it because it was so very strange. Then one time he [the spirit] spoke to me down at the fowl house. I thought it was father doing some repairs. I listened again and I heard the words 'don't be frightened, it's only your old chap.'

A lonely girl with very few friends, her family believed a spirit had come to keep their daughter company. Dorothy was acquainted with Morse code, having learned it from her brother. She would converse with the spirit by a series of rappings, for hours on end and it seemed to know everything about the family although would not reveal its name, save for the initials B.M.

The strange happenings of Blackfield Farm became widely known and a crowd of hundreds would gather at the Farm, hoping for a glimpse of life beyond the veil. The police were called in on more than one occasion to restrain the hoards of inquisitors that gathered at the gate.

A reporter from the *Hertfordshire Mercury* came at the end of January to 'interview' B.M. He was joined by Councillor Searles and two representatives of London newspapers. The group met with some abusive and abrupt answers to their questions:

Q. Where have you met me before?
A. In Hell.
Q. Where was Mr H born?
A. In bed
Q. When is fine weather coming?
A. When it stops raining.
Q. Can you tell us anything that will help us to live better lives?
A. Shut up!

The party then went downstairs and were treated to an entertaining exhibition of tap dancing from the upper floor. On leaving, a member shouted goodbye up the stairs and the spirit tapped out 'Ta-ta.' Before

the evening's activities had taken place, Dorothy's room had been searched thoroughly and any object that was regarded with suspicion, was removed. It certainly appeared that this little girl was a spirit medium.

At the beginning of February, Reverend Bayfield, Rector of Hertingfordbury and member of the Society for Psychical Research, visited Dorothy. Outside the farm, a large crowd jostled with each other, anxious for the latest in an exciting adventure for this small little village. About ten o'clock at night, an expectant gasp rippled through the crowd as at length Reverend Bayfield stepped out of the front door to address the sea of hushed faces before him. He took a deep breath before speaking.

'It is my conclusion that the raps were not caused by any super-normal means. There was no spirit in the case but on the other hand I am convinced that there was no deliberate fraud on the part of anyone concerned. The patient is often from moment to moment unaware of what he or she is doing and in the present instance I made certain that the girl did produce the raps but it seems probable she was largely unconscious of the fact and it was due to the state of her health.'

The crowd began baying and laughing. Reverend Bayfield carried on bravely: 'It is quite possible for a person in a certain state of health to do certain things without knowing, is that clear?' There were shouts of 'Yes' and some jeering. The Reverend pleaded with them to go and leave the family in peace. But the crowd became angry; robbed of their ghost that had been so widely publicised over the previous weeks, they began to demand answers of the Reverend, but he would not answer their questions.

In a later interview with the *Hertfordshire Mercury*, the Reverend still refused to explain how the rappings had been produced, thus leaving the conclusion of whether the Brickendon ghost was real or fraud to be formed by the general public themselves.

A newspaper article in the 1980s blew away the cobwebs of the mysterious goings-on at Blackfield Farm when it revealed that the Morse code that the 'spirit' was using to communicate was activated by a series of hidden wires running to the house from the front garden.

Brother and sister had concocted the ingenious ruse and hoodwinked a great deal of people, including famous writer and spiritualist Arthur Conan Doyle.

Manifestation: Psychic's Experiences at the Farmer's Boy

History:

A Hertford girl had taken a job at the Farmer's Boy pub in Brickendon. Considering herself psychic, it wasn't long before the pub's resident spirits were introducing themselves to her. Every morning when coming in to open up, staff would find all the beer pumps turned off and the cellar re-arranged in an old fashioned style with kegs lined up on the floor and every day it would need to be re-set. Objects would be moved in the kitchen and the ghosts seemed to dislike things on the wall. One of the spirits was a mischievous child that used to sit on the dessert freezer so it couldn't be opened. Staff had to ask politely for the spirit to get off so they could lift the lid.

In one particular bedroom, knocking has been heard on the wall and 'something' even attempted to open the door. When that failed, a figure walked through the wall. One night, the girl awoke to hear her dog crying at the bottom of the stairs. She went to let it out but the downstairs door was locked and despite her hammering loudly for it to be opened, no-one came, so she and the dog went back up to bed. The room had become freezing cold and the dog was still crying. Shivering, they hid under the bedclothes until about half an hour later, a friend came upstairs insisting the door had not been locked at all.

One night, the girl was sitting in her car outside the pub when she saw the bar lights come on. Knowing everyone was in bed, she watched carefully as someone strode up to the optics and helped themselves to a drink. The figure then came over to the window and to her horror, she saw it wasn't any of the regular bar staff. She describes the figure as that of a man in his 40s with dark, scruffy ear length hair who was staring at her with intense eyes. The man started talking to her even though in her mind she was telling him to leave her alone but he didn't leave her head until she had driven quite a way from the pub.

BRICKET WOOD

Manifestation: Mysterious Figures in Smug Oak Lane

History:

A lady motorist in the mid 1980s was driving along Smug Oak Lane when she saw a woman walking in the road before her. As she pulled out to pass the figure, the woman vanished without trace. A St. Albans man had a similar experience with a 'figure in an overcoat' and another lady on the same route could not explain why one minute she was driving along with no problems and then her car suddenly left the road and suffered extensive damage.

BROXBOURNE

Manifestation: Woman in White in the Woods

History:

In 1762 an article was written about 'The White Witch of the Wood' or 'The Devil of Broxbon.'[sic] The writer was visiting his uncle at Broxbourne and states he was: 'surprised to find everyone in the extremest [sic] terror, on account of an apparition which they told me appeared even at noon-day in Broxbon [sic] wood.' This spirit, they said, had the form of a woman, was in white robes and sometimes seemed to glitter all over like a star. They added that while at a distance she only glided along very slowly between the trees of that thick forest, but when any person had courage to go nearer to her, she moved much faster and by degrees, vanished. As she had never been seen in any other place, they gave her the name of the White Devil of Broxbon Wood.

Some believe that this wasn't actually a ghost but a local girl who had run away from home to avoid an unwanted marriage.

BUNTINGFORD

Manifestation: High Street Hauntings

History:

Here it appears the High Street has more than its fair share of ghosts. In one house, the family saw a young girl in a white nightdress walk into the dining room and, thinking their daughter was sleepwalking, followed her into the dining room. But the girl vanished and they found their daughter sound asleep in bed. Footsteps would be heard on the landing and the latch doors were opened and shut, always when their own children were asleep. Toys would be moved about; in particular a wooden horse that was moved at night to block the door into the kitchen. It would have been impossible for a member of the household to have moved it and then get upstairs again afterwards. Both the small children talked about 'the lady in white' not letting them sleep.

Footsteps have also been heard at number 87 High Street where the **White Hart** inn stood from 1600.

Buntingford's most infamous haunting however, is that of the **Old Bell** inn at 43 High Street. The pub itself is long gone but Bell House Gallery gift shop which occupies the same site is still known locally as 'the haunted house'. The building dates from 1450 so it is not surprising several ghosts are said to reside here, including a grey lady and a man dressed in black who walks down the stairs. Mrs Parker, a former occupant in the late 1940s, said of the ghosts: 'Only last Saturday when I was alone in the living room with my daughter we heard feet coming down the passage and I saw the door handle turn, but of course when I opened the door there was nothing there as usual.'

But it is the story of Hannah Bedwell that is best known.

In the 1940s part of the inn was let out to three families. These tenants all experienced strange happenings at various times. Footsteps would be heard upstairs when the rooms were empty and the sound of a baby crying in distress came often from one of the bedrooms where a woman was heard sobbing in grief. One night, one of the tenants, Tom Parker awoke with the feeling of a great weight bearing down on

10. Buntingford, High Street.

him. 'I struggled to get free, but couldn't. At last I had the idea of trying to roll from under the weight and after what seemed hours, I managed to do it.' Tom was found next morning, fast asleep but lying half out of the window. Another tenant woke in the night choking, with the feeling of hands tightly gripped around his throat. A Canadian guest described as a 'real tough guy' went to sleep here one night but in the morning his room was empty and he was discovered in another room refusing to go back into his original room or give any explanation for his strange behaviour.

Journalists from the *Hertfordshire Mercury* organised a séance in the building and the spirit of 'Hugh' announced himself and told them via the upturned glass that the house had many spirits wandering through it. But then Hannah Bedwell came through to them and gradually the tragic story unfolded. Hannah had once worked at the inn and fell pregnant illegitimately. Frightened she would lose her job and be turned out, she killed the child by lying on it. Hannah was only 15 at the time and the father, John Price, a porter at the inn, had been killed. But she was arrested and allegedly hanged for infanticide. Hannah had said that her fellow spirits in the house, which as an inn had been frequented by 'bawds and cut-purses', were all unquiet.

Manifestation: Some Watery Wraiths

History:

Near **Monk's Walk** was a pool surrounded by trees where legend holds that a monk is supposed to have drowned a child. On dark winter evenings the monk has been seen searching the area. But the pond has long since gone.

Another pond and another child incident, this time at **Aspenden Hall**. Many years ago, a nursemaid was out walking the baby in the grounds when the pram slipped out of her hands and rolled down the slope, tipping the child neatly into the pond where it was drowned. The child can be heard crying in the stillness of the night and the tortured wraith of the nursemaid eternally searches.

This watery tale concerns the river near **Chapel End**. In the 1930s

three lads, Charles Edwards, Samuel Clark and Fred Lee were strolling along the river when they noticed a number of moving lights appearing underwater in the middle of the river. They stood watching in amazement, unable to offer any rational explanation for what they were witnessing. The lights, which they described as 'sparks', began to rise to the surface of the water, crossed the road, moved up an area known as 'totties ditch' and finally stopped at the back of the Crown inn where the sparks formed a moving circle.

The lads fled back down the lane in terror. Later that evening, a crowd went along to investigate and the police called in the gas and electricity companies to check their pipes and cables but no explanation has ever been found for this strange phenomenon.

Manifestation: Creepy Church

History:

At Christmas time 1931, two young lads were playing in the road behind St. Peter's Church. It was late afternoon and getting dark when all of a sudden something white crossed the road beside them and disappeared. In fright, the two of them took to their heels and ran home.

BUSHEY

Manifestation: Strange Happenings in the Student Accommodation

History:

The International University is a striking building and was once busy with overseas students, but its corridors are now silent except for the clatter of film and television crews who use this location on a regular basis. Some of the crew stay in what was the student accommodation and have been frightened by odd happenings. Windows and doors open by themselves, strange noises and objects being moved around are just some of the things they have experienced.

11. Bushey, Lululaund.

Manifestation: **Stage Presence**

History:

Artist Baron Hubert von Herkomer made a dream come true when in 1913 he built a film studio in the garden of his home, Lululaund, a mock Bavarian castle. The garden studio was converted from an old chapel and had a distinctive glass roof. Von Herkomer's second wife, Lulu, died only a year after their marriage, but performed in many of the films produced at the Bushey studios.

When von Herkomer died in 1914, the studio was taken over by the British Actors Film Company. Allegedly, Lulu von Herkomer's ghost drifted through the unlit gloom of a film set, frightening two actresses and the producer. A terrifying shriek was often heard near the dressing rooms.

Lululaund was demolished in 1939 and all that remains of the von Herkomer's Bavarian fantasy is a dilapidated entrance way. The studios were used by many well known professionals until 1985 when they were sold off and mainly demolished. Offices now occupy the site, but the glass roof has been preserved and graces the present building.

BYGRAVE

Manifestation: **Headless Pedlar**

History:

One filthy evening in 1739 the lonely figures of a cloth pedlar and his horse were seen trotting towards Ashwell along an ill-kept road from Baldock Fair. The pedlar was feeling pleased with himself as he had been prosperous at the Fair and was returning with a full purse. But as he crossed lonely Bygrave Common, darkness fell and the weather worsened. His face was slashed with the rain driven by a piercing north-east wind. In the distance he saw a farmhouse with a welcome light in the window and decided to seek shelter there until the storm passed. The door was opened by the farmer, Thomas Fossey, who was heavily in debt due to bad harvests and his own poor management. He

welcomed the pedlar and his bulging purse inside. It doesn't take a great imagination to work out what happened next, but early next morning, labourers on their way to work found the pedlar's horse wandering confused on the road towards Ashwell. What had become of its master no-one ever found out, but he was never seen alive again. Farmer Fossey, however, in some unexplained way had become prosperous.

Some years later, a labourer encountered a pale, headless spectre wandering along 'The Warren' in front of Bygrave Farm and carrying the severed head under his arm. This was confirmed by others as the years rolled by and in the 1870s the ghost was still treading its same path. Sometimes it was accompanied by a lady and a child.

At a later date, Bygrave Farmhouse came into the occupation of Mr John Smyth and during the course of major alterations, a gruesome find was made in an old well discovered beneath a depression in the lawn. In it lay a headless skeleton. The skull was found buried by itself near the churchyard at Wallington, coincidentally where Farmer Fossey had moved to after he had sold off Bygrave Farm. Of the lady and child, their remains were found beneath the drawing-room floor but what the sorry tale to their end was, nobody knows.

CALDECOTE

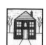

Manifestation: Strange goings-on at the Manor House

History:

In the late 1970s the housekeeper was working alone at the Manor House when suddenly she was pushed from behind and fell headlong down the stairs. Luckily she escaped serious injury but this wasn't the first time this had happened.

Dr David Bates, an expert from the Society of Psychical Research, was called in to investigate. 'The housekeeper felt that there was something in the house that did not want her', said Dr Bates. She also saw the figure of a lady in black and heard strange noises coming from the room under the cellar.

In the early 1980s, an archaeologist working in the house grounds claims to have had similar sightings.

CHESHUNT

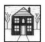

Manifestation: Apparition at Cheshunt Great House

History:

In the notes of Hertfordshire historian W.B. Gerish at the turn of the 20th century, can be found the story of a lady in grey who glides up the wide staircase of this house and disappears into an upper room where a dark stain upon the floor is believed to be that of human blood. Strange and unaccountable noises were also heard by the caretaker.

Manifestation: Phantoms of an Old House at Cheshunt

History:

In the middle of the 19th century Mr and Mrs Chapman came to lease a large old house at Cheshunt, identified by Elliott O'Donnell as Cecil House, now demolished but which stood in Theobalds Park. After several months, the family began to have strange experiences. One evening as it was turning to dusk, Mrs Chapman, on going into the oak bedroom, saw a figure near one of the windows. It appeared to be that of a young woman with long dark hair and wearing a short white petticoat. She seemed to be looking eagerly through the window as if expecting to see someone. The apparition then duly vanished, leaving Mrs Chapman baffled.

Some days later, the nursery-maid came to her in a state of great agitation and trembling with fear, saying a hideous old woman had been peering at her as she passed a window in the lobby. Then the noises started. In the middle of the night the pump in the yard sounded as if someone was striking it with a crowbar but there was never anyone around. Footsteps were heard in different parts of the house but no-one could be held accountable for them. The servants sitting in the kitchen heard footsteps approaching the door and the latch lifted

12. Cheshunt, Great House.

44

and the door opened. Something entered and they could sense its presence, but nothing could be seen.

It appears the story behind these strange phenomena may be that of a young woman, Miss Emily Black, who lived in the house about 80 years previously and who had a child. It is uncertain whether she killed the child or whether he grew up and joined a regiment and went to India. The hideous old woman seen by the nursery-maid was believed to be the family's nurse. But all of this is conjecture as the story only emerged as a dream had by one of Mrs Chapman's servants and the only factual evidence is that a Mrs Ravenhall and her niece Miss Black had lived in the house. However, somewhere in the story a dark-complexioned gentleman in a fustian coat fits in, as he was seen by Mrs Chapman and also by the coal agent who claimed a man fitting that description had ordered coal for the family.

After the Chapmans left, no-one seemed able to stay in the house very long and it stood empty for years until it was ultimately pulled down and only partly rebuilt.

CHIPPERFIELD

Manifestation: Household Ghosts

History:

A bungalow in Megg Lane had an unhappy history and was reputedly peopled by a host of unearthly occupants, including a Roman soldier about six feet tall and in full armour standing against a bedroom wall, a monk in cowled habit and in 1943 a priest manifested with his hands pressed together as if in prayer.

CODICOTE

Manifestation: 'Old Sissiverne'

History:

The old house of Sissevernes lay on the hill to the east of the main road from Welwyn to Codicote and was approached by a little roadway called Stratton's Lane winding up a steep hill. The unusual name was developed from a former Norman owner; *sis* being Norman for six and *verne* is alder-tree, thus the place was called 'Six Alders'. The old house was typical of a country farmhouse, a long, low building of red brick, and famously possessed a great fireplace under which it was reputed that ten people could comfortably sit. The ghost said to loiter around the house is that of one of the Sissevernes family known as 'old Sissiverne' who loved the place so much that he asked to be buried there.

The house was rebuilt in 1870 but the ancient kitchen and the original fireplace are said to remain.

Manifestation: Ghosts of Codicote Churchyard

History:

In the gruesome days of body snatching, Codicote churchyard, like many others, did not escape unscathed. Here, a child known as 'Little Norah' searches the ground near where the corpse of John Gootheridge, a local farmer, was found lying in the churchyard in 1824. He had been buried only a few days before and his ransacked grave lay nearby. It is believed the snatchers had been disturbed.

In the 1950s it was reported that several witnesses passing the churchyard had seen a shrouded female figure standing among the gravestones and that it even came out and followed them down the road. A red-faced old woman with corkscrew curls also wanders amongst the stones.

A piece of medieval folklore survives in Codicote church in the form of a wood carving of 'The Old Dog'. Starting out as a bench-end carving, this fantastic wooden creature is a motley amalgamation with the head

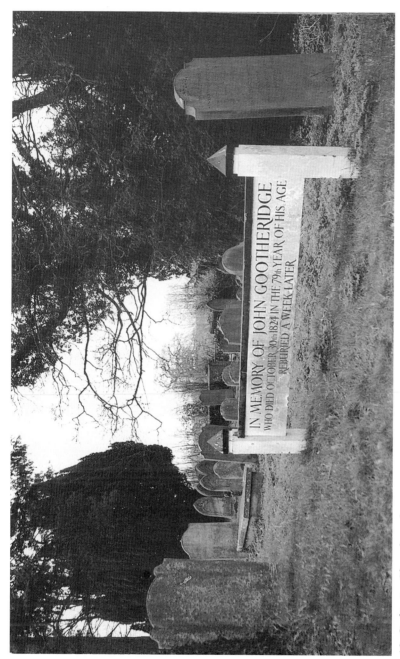

IN MEMORY OF JOHN GOOTHERIDGE
WHO DIED OCTOBER 30th 1824 IN THE 79th YEAR OF HIS AGE
REBURIED A WEEK LATER

13. Codicote, Churchyard.

14. *Codicote, Churchyard.*

of a monkey, ears of a bat, mane of a horse, body of a dragon, tail of a lion and the legs and hooves of a cow! Why he is called the 'Old Dog' is a mystery but it is believed that to pat him will ensure good luck.

Manifestation: Ghostly Woodcutter

History:

Winter travellers on the Whitwell Road near Codicote have often heard the sound of an axe coming from the nearby woods and, on stopping to listen, they hear the crashing of a falling tree but no trace of a newly felled tree can be found. The noises are said to go on all night but stop at dawn and it is usually Christmas Eve when the sounds can be heard.

The tale was told to Hertfordshire historian W.B. Gerish in this fashion:

'If you care to rise before the sun and to stroll quietly towards Bendish and Breachwood Green, you will hear the phantom woodman at his work, but however quickly you enter the thicket or copse whence the sound proceeds, you will find no woodman there, nor timber to betray his recent presence.'

Also in Codicote exists a dwelling known as **Rose Cottage** which was haunted by ghostly dogs and a **Shepherd's Cottage** is also haunted but the identity of the ghost is not recorded.

COTTERED

Manifestation: Old Charlie

History:

At Cottered in the 1920s, a farmer had befriended a lonely old 'gentleman of the road', locally nicknamed 'Old Charlie', and offered him a home in return for light duties around the farm. Charlie preferred to sleep in the barn rather than take up a room in the farmhouse. When Charlie died, his ghost was seen often in the barn, which is today sadly buried beneath a new housing estate. But a ghostly old man has been seen shuffling along the street nearby and vanishing into thin air.

DATCHWORTH

This quiet little village at the edge of the sprawling new town of Stevenage demands an introductory paragraph all of its own. Mentioned in the Domesday Book variously as 'Daecawrthe' and 'Thatcheworth', Datchworth is celebrated for being Hertfordshire's most haunted village, boasting over a dozen ghostly inhabitants. You cannot fail to notice the unquiet, brooding air of the village; as if it is waiting for something to happen. The curious little church with a witch's hat spire, observes all from the top of Rectory Lane, which weaves its lonely way through the fields. Datchworth was featured in 1998 on Carlton's 'London Tonight' programme and the TV crew concluded Rectory Lane to be one of the most unsettling places they had visited.

Manifestation: Headless White Horse of Burnham Green

History:

> "*At Burnham Green where the recent dead*
> *Ride a white horse without a head…*"

The quiet, twisting Whitehorse Lane got its name from a restless equine spirit that has been seen galloping up from Mardleybury. The horse is believed to have been the favourite of a Royalist farmer, Pennyfather, who lived at Welch's Farm. During the Civil War the Roundheads attacked his farm and decapitated the farmer, spiking his head in the stable yard as a warning to all, (the actual spike was said to still exist in 1981). His white horse resisted capture and was also decapitated and has been seen by several witnesses in the area. 'The horse was pure white and stood about 15 hands high', said a lady living at Tewin Orchard, who believes she saw the spectral stallion early one evening in the 1960s. She saw what she thought to be an ordinary horse grazing in the orchard behind her cottage. The horse subsequently vanished despite there being no exit through which it could have escaped.

Locals believe that no animal can be persuaded to walk along the lane at night. The White Horse pub at the top of the lane opened in 1806 and attributes its name to the legend, its inn sign once depicting a

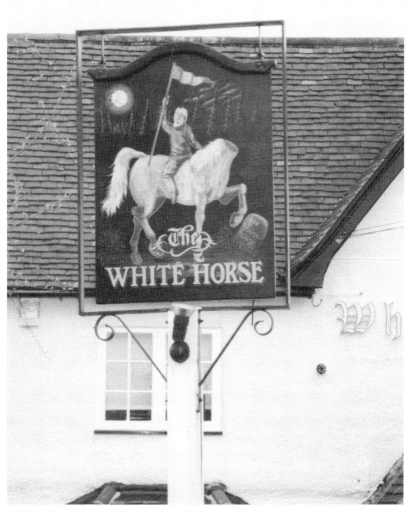

15. Datchworth, The White Horse Inn.

headless white horse rearing up in front of an eerie full moon.

Manifestation: Headless Old Lady of Hawkins Hall Lane

History:

Another headless apparition in the village, this time of a little old lady dressed in black. Frequently seen at evening time, she shuffles along Hawkins Hall Lane in, some say, a purposeful manner. From the back she appears bent with age but when seen from the front it is clear she is headless. The story goes that in the 1800s an elderly woman hanged herself with a piece of wire in a Knebworth cottage after the sudden death of her husband. But why she should choose to haunt this particular spot remains a mystery – for now.

Not far from Hawkins Hall Lane is Bury Lane and home to a writer. She and her family have often seen a shape whisk past the back window which they have got used to. Her husband once saw an old man looking in through the same window and rushed out but there was nobody there.

Manifestation: Red-haired Spectre of Hollybush Lane

History:

It is rumoured that a family in Hollybush Lane have their own ghost and one that appears on many occasions. It is a female, complete with head, and a long mane of red hair. Bizarrely she appears in bright clothing accompanied by the sound of tinkling bells. Sometimes her ghostly footsteps have been heard on the landing. But again, there seem to be no clues to her identity. The only connection that has been offered is that the haunted property stands close by Pond House with its pond and nearby moat, from which at least one body has been recovered. In the middle ages, workers' cottages would have stood on this spot and perhaps this flame haired wraith is a remainder of these times past.

Manifestation: The Many Spectres of Datchworth Green

History:

One night, a woman was seen standing alone by the swings on the Green. When viewed closer, it became obvious that she was dressed in a very odd way. She wore old fashioned clothes and her feet seemed to stand above ground level. When the observers moved closer, she vanished.

On another nocturnal walk towards the Green, a lady living in the village became aware of a noise like a horse and cart approaching, yet she could see nothing on the road. But still the noise got louder and the furious galloping of the horses and creaking of an old coach was unmistakable. Very frightened, the lady pushed herself right against a hedge out of the way of the invisible vehicle that pelted past her at breakneck speed. Not only was the noise very loud but she actually felt the passing of the horses and coach. The noise died away as rapidly as it had grown but still nothing could be seen.

There is a house on the Green called Pettits which is haunted by the sound of ghostly footsteps on the stairs and walking from room to room above. Family and friends of the occupants of Pettits have often gone in search of this suspected intruder, but no-one is ever found and the unseen visitor continues the restless pacing.

At dusk, the figure of an old woman gathering sticks has been seen.

In the late 1990s, the landlady of The Plough public house perched aside the Green was often troubled by a middle-aged man who used to appear behind her whenever she looked in a mirror. Curious to unravel the mystery, she attended the local spiritualist church where a clairvoyant told her that she had a spectral admirer. The ghost introduced himself as 'Jacques' from around the 18th Century.

16. Datchworth, Rectory Lane.

On a cold, winter's night in 1984, a vigil was kept by the side of Mardleybury Pond. The British Psychic and Occult Society were seeking a glimpse of the infamous Grey Lady who frequents the spot. According to local legend, the ghost is that of a young lady who lived at the Manor House opposite in the 18th century. One night she was coming home from a party when her coach driver took the bend in the road at speed and overturned the coach, spilling the fair haired woman out into the icy waters of the pond where she was drowned. Since that time it has been reported that a figure of a young woman in grey appears, flitting around near the tragic spot, to lone travellers and 20th century motorists. In fact her sudden appearance has caused many a driver to brake suddenly at the sharp bend, fearful that they have hit a pedestrian. One Welwyn man was sure he hit her while driving near the bottom of Whitehorse Lane on the approach to the Woolmer Green turning. He veered sharply off the road and hit a tree. He described the figure as having long hair and wearing a flowing gown or cloak.

But back to the vigil. Nothing untoward happened until 4.15 am when the night watchers spotted a definite white-ish mist in the shape of a figure, hovering about the water at the far end of the pond. They attempted to photograph the phenomenon but nothing showed up in the developed print.

A gentleman in the late 1980s reported seeing the blonde spectre on the well-lit road near Sherrardswood School. He said: 'She seemed to give a laugh and just vanish.'

In nearby Tewin Wood, a resident was cleaning her car in the driveway when she became aware that someone was watching her. She looked up and saw a tall blonde lady whom she described as: 'pale of face and very beautiful. She appeared dusty and travel stained and looked frightened. When I asked her if she was lost and could I help, she disappeared. She did not walk away but rather dissolved before my eyes.'

Mardleybury Manor House overlooks the pond and its chequered history stretches right back to Anglo-Saxon times. One particular room

in the house is said to be haunted by a ghost who likes to throw clothes around and move objects. The sudden and inexplicable smell of incense wafts through the house from time to time and there are sounds of heavy breathing, crunching and a variety of bangs and thuds. Heavy flooring that took two men to lift, was laid by itself and a mysterious headscarf appeared on the owners' bed but no-one had seen it before or had any idea where it had come from. A former owner of the Manor, Mrs Stack, said of the ghost, 'Whatever it is, it is friendly.' Also, a cleaner who worked at the house was convinced it was haunted, as she saw pictures drop off the walls and objects mysteriously moved around.

Manifestation: Gruesome Cart of Rectory Lane

History:

A dark winter's night, crisp and cold with not a glimmer of moonlight. Two friends walked up the unlit winding Rectory Lane towards the Church. The wind blew the trees in an unsettling manner but all else was silent. Suddenly a rushing sound was heard behind one of the girls as if a car was coming up the lane at speed. Instinctively she yelled and shoved her bemused friend into the hedge for safety, but nothing passed them and the noise died away.

In recent times also, footsteps have been reported in the lane but there has been no-one there.

However, Rectory Lane is famous for one particular haunting. A horse-less cart creaks its way up the lane, with limp legs and arms dangling over the sides. It has been seen by the Green, on its way up to the churchyard. Some say this is the plague cart as a bell has sometimes been heard to accompany the gruesome visual. But the more likely explanation comes from a true story.

The harvest of 1768 had been a bad one. Men were without work and famine was sweeping through the county. James Eaves and his family from ´Datchworth were hungrier than most. He had been without work for months and they faced their inevitable fate in the ruined poorhouse on the edge of Datchworth Green. The Parish overseers showed no compassion for the starving family who were left

17. Datchworth, Datchworth Green.

57

near naked and helpless with fever, scratching around in the straw of the poorhouse hovel. They were never seen alive again. Their last journey was made in a rough cart by moonlight. Their emaciated bodies heaped onto the cart, they were taken up Rectory Lane and buried in a mass grave in the churchyard. The case of the neglected Eaves family led to a high court enquiry which saw the overseers brought to justice for their actions. The poorhouse stood near a little pond on the Green, near to where the present whipping post is situated. The pond was filled in during the 1920s and a cottage called The White House now stands on the site of the poorhouse.

The ghostly cart has been seen by many people over recent years But as with all sightings, accounts vary considerably. Some say the cart is both seen and heard, some that it glides silently, while others see the dangling remains. Many have come to investigate and peer and listen at Rectory Lane and one thing is certain, no-one goes away unaffected by the eeriness of the location.

Manifestation: Chatterings in the Churchyard

History:

A lady walking her dog one evening decided to cut through the graveyard and immediately the energy around her changed. The air became filled with a noise like 'the chattering of a thousand monkeys.' Growling and with hackles raised, the dog ran from the churchyard whilst she was overcome with the feeling of bleak oppression that didn't lift until she too had got away from the place. Shadowy figures are believed to flit there at dusk.

Manifestation: Grim Reminder of the Pieman

History:

Hidden amongst the trees half way along the Datchworth to Bramfield road is a plain wooden post. This innocuous looking object has a far more sinister background than on first sight, for it marks the spot where a notorious highwayman was shot and captured in the 18th century.

18. Datchworth, Datchworth Church.

19. Datchworth, Clibbon's Post.

Walter Clibbon's occupation as pieman at the local markets allowed him to discover who was carrying large sums of money and he was able to intercept them and rob them afterwards in his alter ego as highway robber, but he finally came to a nasty end on the Bramfield road when he was shot by one of his intended victims. His injured body was then tied to a horse and dragged towards Bulls Green, where he was clubbed to death by an angry pack of locals. He was left overnight in The Horns inn where there was huge celebration at his capture and demise.

Locals today talk of the dim shape of a horse pulling a writhing body along the lanes and sometimes only the sound of hooves or the moaning of the ghostly pieman are heard.

In the late 1970s, journalist Evelyn Hall-King and her psychic friend, Eileen Ison, visited the area. Eileen reputedly knew nothing of the ghost stories associated with the village yet nearby the spot where Clibbon was murdered, she suddenly bent double, moaning that she was being viciously beaten on the head and shoulders. 'The horses,' she said, 'they're coming. Can't you hear them?'

ESSENDON

Manifestation: Beautiful Young Rider

History:

Mrs Crisp was on her way to St. Albans through the frosty lanes of Essendon one sunny January morning. Suddenly a horse and rider appeared from nowhere and began ambling across the road in front of Mrs Crisp, who slammed on her brakes. In amazement, she watched the young rider, a girl with long golden hair dressed in a bottle-green habit and wearing a little tri-corn hat. She particularly remembers the girl had her head bowed as if deep in thought and the metal parts of the bridle shone out in the brilliant winter sunshine.

Manifestation: Authors' Haunt

History:

Camfield Place, hidden in the Hertfordshire countryside at Essendon, has been home to one of Britain's most famous authors and has connections with another. Until her recent death it was occupied by Dame Barbara Cartland and before then was owned by Beatrix Potter's grandfather. It is believed it was at Camfield that 'The Tale of Peter Rabbit' was written. This first famous author had the odd experience of watching twelve candles snuffed out one by one, by an unseen hand.

The young Beatrix was said to have been afraid of the ghosts in the hall and up the stairs, but the apparition seen by many in her successor's time is far less frightening. The ghost is that of a black and white cocker spaniel belonging to Dame Barbara, who claimed she was the first person to see the canine ghost, sitting under a table in the hall. Her other dogs were afraid of him because apparently he would go for them ferociously at feeding time.

Manifestation: Knocking from Beyond the Grave?

History:

Two teenage visitors to St. Mary's Church in August 1983 found the door locked and were unable to go inside to look around. As they sat down on the bench overlooking the graveyard, there came a loud knocking on the door yet they were alone and there was nobody inside the church, so who was knocking and why remains a mystery.

20. Essendon, Essendon Church.

FLAMSTEAD

Manifestation: Selection of Spirited Females

History:

A man, using the gents at the **Rose and Crown** pub in Trowley Bottom, was frightened out of his wits when he felt a hand on his shoulder and turned around to find the cheeky ghost of a young girl smiling at him. The intrusive ghost often sits on the edge of the landlady's double bed, leaving a clear indentation where she has been. She also has a habit of sitting on the blanket chest in the same room. True to form, however, she appeared to the former landlord one morning as he was getting dressed. This frivolous spirit is thought to be that of a young woman believed to have been murdered in the barn behind the pub, but her body was never found.

The oldest part of the **Three Blackbirds** inn is the restaurant and this is believed to be haunted by a lady in a white blouse and white mob-cap.

The Britannia inn has long gone but its memory remains in Britannia Cottage. Strange sounds have been reported here at night described as being like, 'someone clonking around in boots.' One tenant saw an old lady in a shawl disappear through a wall. Part of the cottage was used as a NAAFI canteen for the servicemen during World War II.

Manifestation: Apparition of Delmerend Lane

History:

A dustcart driving down Delmerend Lane one dark winter's morning in 1922 picked out a woman in a grey shawl and bonnet in the road in front of them. She was leading a small child by the hand but vanished into a hedge, leaving no trace. The refuse collectors were convinced they'd seen a ghost and were reluctant to travel that way in the dark again.

An apparition matching the above description has also been seen in **River Hill**, as has a figure in white who locals think is a Miss Reeve.

Manifestation: Spectre of Pepsal End

History:

Pepsal End Manor no longer exists. Between 1926 and 1933 a Mrs Dorothy Stokes of Luton lived in the house as a little girl and claimed regularly to have seen the ghost of an old lady called Mrs Lines who had lived in the house before them. Dorothy described Mrs Lines as small and pleasant faced, wearing a bonnet and carrying an umbrella. She said that she and the ghost 'just looked at each other' and the ghost appeared to be searching for something.

FURNEUX PELHAM

Manifestation: A Hawker's Tale

History:

From the 16th century, commercial travellers were known as 'Hawkers'. They would wander from village to village with their baskets and carts selling their various wares and collecting much local news and gossip as they passed through. In the 1890s one particular Hawker was known as 'Tab' and his interest was in traditions and superstitions of the county. Tab was luckier than his forebears in that he could read and write and as he travelled Hertfordshire, he scribbled notes of his adventures.

On a visit to the church at Furneux Pelham, Tab felt as if he was being watched. He turned around when the feeling became strongest, but could see no-one and as far as he could make out, he was alone in the church. After he had been there about ten minutes, Tab heard the main door slam shut and footsteps walking down the aisle, yet no-one passed him. Spooked, Tab turned and was on his way out when he noticed the figure of a man sitting in the front pew. The man had not passed Tab but there was no other way he could have entered the church.

Outside a man was cutting the grass and Tab enquired of him as to whether he had seen anyone enter the church. The old man told Tab that it must have been the apparition of a Mr Arnott who died some years previously and who likes to sit quietly in the church sometimes.

GILSTON

Manifestation: Unknown Spirit at the Inn

History:

A gallows stood at Pye Corner, the point where the three roads meet, just outside the Plume of Feathers inn. Anyone drinking in the tavern would have an enviable view of executions taking place outside. But when the weather was bad, it was said that hangings took place inside the inn itself, in an upstairs room. Whilst working in the attic some years ago, an electrician fled after experiencing something frightening that he could not explain. Downstairs in the pub, glasses are moved and the fruit machine has been found half way across the room in the middle of the floor, all when no-one has been present. A particular seat by the fireplace seems to have a strange atmosphere and is shunned by the locals. The story goes that one bitterly cold night, a stagecoach pulled into the inn-yard with an unknown passenger frozen on the back. He was carried in and sat beside the fire, but it was too late, he was already dead.

GRAVELEY

Manifestation: Grave Misconduct

History:

In 1838, the *County Press* newspaper ran an article about an old lady resident in Graveley at the time who had been experiencing a supernatural knocking at her front door when nobody was around. The village was in a great state of excitement as no natural being had been discovered as the cause for this occurrence and many villagers came to the house to experience the knocking for themselves.

21. Gilston, The Plume of Feathers.

GREAT HORMEAD

Manifestation: Wandering Monk

History:

The shade of a long-dead monk haunts Brick House and in the late 1980s was seen wandering in the churchyard. He was described as though he were looking for something. Local tales tell of a murder committed in the vicinity and perhaps the monk is in some way connected with the tales.

HARPENDEN

Manifestation: Treasury of Tavern Tales

History:

It was the middle of the night in 1960; the relief manager at the **Cross Keys** in the High Street had locked up and gone to bed. Suddenly he awoke, staring into the darkness, wondering what had disturbed him. From down in the bar he could distinctly hear voices drifting up the stairs. Apprehensively he crept down, fearing several intruders might be laying in wait for him and quietly opened the door, peering through as tiny a crack as he dared. The bar was in complete darkness except for the light from the street lamp outside which gave just enough illumination to show three figures crouched over one of the bar tables. The door from behind which he was hiding, swung open and the three turned to look at him. The faces were ghostly with shaven heads and they wore dark, heavy robes like those of medieval monks. With a gasp of shock and disbelief, the man ran upstairs and locked himself in his bedroom.

This was not the first sighting of the monks. Westminster Abbey had owned a guest house on the site up until the 13th century and this is where the pub's name originated; the cross keys being the insignia of St. Peter and the main bar has two brass crossed keys set in the floor.

In the late 1960s, the licencees had several strange occurrences including a large ashtray found spinning for no apparent reason in an empty bar one afternoon and a clothes brush disappearing in front of witnesses, reappearing three days later in the fireplace.

Roy Mills, landlord of the **Silver Cup** in 1985, was a complete sceptic when it came to ghosts. He had not been drinking the night he bumped into a lady in grey in the corridor. She smiled at him before walking straight through a closed door. Roy described her as wearing her hair pulled back and believes her to be a member of the Archer family who owned this 17th century pub near the common for many generations.

In the cottage behind the pub, in the late 1960s, a small boy kept telling his mother about the 'man' in his bedroom. At first she dismissed it as boyish imagination, but his description became more and more detailed and she realised her son was describing a First World War soldier. Research allegedly revealed that a 19 year old soldier was killed in the War but had originally occupied the boy's bedroom.

Manifestation: A Ghostly Gathering in the 'Village'

History:

During the Second World War, superstition ran high. If you were to see the ghostly old woman sitting on a seat in front of a cottage in **Leyton Road**, it was considered a very bad omen. All those who saw her, never returned from the War.

The old **oilskin factory** near the Silver Cup inn had a shadowy spectre who would open and shut doors and further along the road is a **cottage** beside West Common which was formerly a public house. A man was seen here, floating through a bedroom wall into the house next door. Years later when renovations took place, an ancient doorway was revealed exactly where the ghost was seen to disappear.

Bleak **Agdell Path** is the spooking ground for Ann Weatherhead. Fabled to have lived in a dell in Hagdell Field, now part of the Rothamsted estate, she was frequently seen walking along the path and also the drive from Hatching Green to Rothamsted Manor. So prolific were the sightings of Ann that young girls feared the area and would

not walk alone there after dark. Even the schoolmaster of Rothamsted Cottage was convinced of its ghostly reputation.

In the 1930s, the Webster family occupied **Bowers House**, behind the High Street. Mrs Webster often saw the figure of an elderly lady with long hair and dressed in a grey shroud. And in **Harpenden Hall**, noises on the stairs have terrified many a visitor. Footsteps have followed people when no-one is behind them and grey figures flit across the landing. Children have reported seeing a 'funny lady' up the stairs wearing a long dress with no feet.

In the mid 1980s, three young male tenants of picturesque **Rose Cottage** at Church Green were driven out by the ghostly inhabitants. The men had often heard strange noises in the night and could take it no more. The Cottage is believed to be haunted by the ghost of a young woman who in the 17th century is supposed to have murdered her illegitimate baby before taking her own life. She floats around in her night-dress, moving furniture about as she searches for her child. The Cottage was blessed by the local priest but this only served to quieten the spirit for a short time before the noises began again in earnest.

HATFIELD

Manifestation: Apparition for the King

History:

It was January 24th 1680. Elizabeth Freeman, 31, a single woman, was sitting by her mother's fire-side in **Fore Street** in the early evening when she heard a voice behind her say, 'sweetheart.' Looking round, Elizabeth saw a woman all in white, her face covered by a white veil. A pale hand gripped the back of Elizabeth's chair and the apparition spoke: 'The 15th day of May it is appointed for the Royal Blood to be poisoned. Be not afraid for I am sent to tell thee.' The woman then vanished.

The following week the apparition appeared again to Elizabeth and asked if she remembered what had been said. When Elizabeth replied yes and asked, 'In the name of the Father, Son and Holy Ghost, what

art thou?', the woman took on a harsh voice and said, 'Tell King Charles from me and bid him not remove his Parliament and stand to his Council. Do as I bid you.' Once again the figure dissolved.

The mysterious woman in white appeared to Elizabeth once more only and the frightened girl was reported to have had an interview with the King who reputedly told her to go home and serve God and she would have no more trouble from apparitions.

So who was the ghost in this long surviving tale? She was thought to be Lucy Waters, also known as Mrs Barlow, an early mistress of Charles II during his exile and by him she had a son afterwards created the Duke of Monmouth. Lucy is referred to in a contemporary song loyal to the cause called No Protestant Plot, which declares:

"A spectre told strange things to honest Bess
Which much amaz'd the Hatfield Prophetess"

Manifestation: Spectral Coach and Four

History:

Spectacularly a coach and four black horses materialises at the gates of **Hatfield House** and travels at a furious speed up the long drive. At the entrance to the house it is said to pass through the doors and continue up the stairway before vanishing. This must have been of great inconvenience to the residents at the house, but fortunately it is said to occur only once a year on New Year's Eve.

The coach is thought to have belonged to the first Marchioness who was burnt to death when she knocked over a candle in her bedroom in 1835, destroying herself and most of the west wing of the House. The first Marchioness often took the coach to London and was quite a character. She loved hunting and gambling and continued these pursuits right up to her death at the age of 85. After the fire, her son put screens across the entire one hundred fireplaces in the House.

In 1982, guides at the House told of a presence which had recently frightened a workman and a visitor. It is the first Marchioness who they believe floats along the long gallery.

22. Hatfield, Hatfield House Staircase.

23. Hatfield, Hatfield House.

Hatfield House is probably best known for its associations with Elizabeth I for the Old Palace was her childhood home and it was beneath the famous oak tree in the grounds that she learned of her accession to the throne in 1558. The House itself is said to have been built by Robert Cecil in the shape of an E to commemorate the popularity of this Queen.

At the **Old Palace**, ghostly footsteps are heard along a particular passage, opening a door and descending stairs with slow, distinct steps. It is said that on moonlit nights the shadowy figure of a female emerges from the Old Palace gateway and glides across Fore Street to vanish through the old church door.

Manifestation: Lady in Black

History:

At an undefined location in Hatfield, an old tale states that a well known ghost is that of a little old lady in black who has been seen at various times during day and night. She beckons to people in the street and sometimes even talks to them.

Manifestation: Ghost that Saved a Train

History:

Through the mist of a murky night around 1886, a heavily laden train approached **Hatfield Railway Station**. It was travelling at a normal speed, close on 60 mph, when through the station lights the driver saw the figure of a man standing at the foot of the bridge that spanned the line. As the train flew past the station, the driver lost sight of the man until, sensing someone close by, he turned to see the stranger beside him at the footplate. He was dressed entirely in black and radiated a sense of cold, but the driver was especially struck by the look of utter sadness in the man's eyes. As the train ran through Welwyn, the apparition placed his hand on the engine's regulator and without knowing why, the driver felt compelled to do the same. The figure

vanished, leaving the driver slowing the train down for a reason he did not comprehend. But it was just as well because as the train came to a halt outside Hitchin, he discovered two trucks had been derailed and lay across the main line. Had the engine carried on as the signals instructed, there would have been a fatal collision.

Manifestation: MC Who Refuses to Leave

History:

Sir Robert Chester, who was master of ceremonies to four monarchs, lived in **Bush Hall House**, now a hotel, in the early part of the 19th century. According to stories, he is still attached to his old home as his ghostly figure has been seen floating up the stairs and billowing in and out of the bedrooms.

Manifestation: Spirit of Learning

History:

At the University of Hertfordshire's Hatfield Campus a misty figure has been seen in the Todd Building by security staff. The figure appeared in a darkened, secured building where lights reportedly turn on and off of their own accord.

HATFIELD HYDE

Manifestation: Cloaked Stranger

History:

St. Mary Magdalene's church is relatively modern, being only just over a century old. Members of the choir became aware of a cloaked figure who would enter the church by a locked door and hover about the font before vanishing. No identity has been put forward for this stranger's mysterious appearances.

HEMEL HEMPSTEAD

Manifestation: Strange Orbs at the Inns

History:

The heavily timbered **Olde King's Arms** is rumoured to have been a courting venue for Henry VIII and Anne Boleyn. Staff have independently reported seeing a 'big fat man' who would sit by a bed and laugh. Could this be the statuesque Henry himself? He certainly was a large man, standing six foot four in height and with such an ever expanding girth in later years that armour had to be especially made for him.

The inn was first mentioned in the early 1600s and the building merged with its neighbour, the Black Lion, sometime in the late 1700s. In 1845 its yard was used as a market by straw plait dealers. A lady in white has also been seen here.

At a recent investigation at the inn, a team of paranormal investigators took a picture of a strange orb of light in a disused part of the building. The light just appeared from nowhere and hadn't been in the picture immediately before or after.

The **Crown** inn is recorded as dating as far back as 1523. In 2000, the same team of paranormal investigators set up an overnight vigil here with special camera equipment to record any paranormal activity.

Sometime during the night, Graham Matthews, the team's director of photography and arch sceptic, and team leader Ross Hemsworth described the feeling of being 'suddenly chilled'. Graham said, 'I could sense we were no longer alone. I could see nothing unusual but immediately got my camera out. The look on Ross's face confirmed he felt it too.' Graham shot several pictures around the room with flash and captured several orbs, some seeming to have their own illumination, not lit by an exterior source.

The team believe that orbs are balls of energy captured on film or via infra-red cameras which they feel are the soul forms after death. Often when clairvoyants have pointed to an area where a spirit is sensed, if a picture is taken at that precise moment, an orb will appear

24. Hemel Hempstead, The Olde Kings Arms.

in the exact spot. Graham has carried out many experiments with photography trying to recreate the orbs but to date he concludes they must remain inexplicable.

Customers have reported a sudden feeling of unaccountable terror as they approach the stairs of the **White Hart** inn and one member of staff could not explain why she couldn't go near them. The face of a man looking terrifyingly distressed has been seen near the stairs, appearing in black and white like a photographic negative. No-one knows what has frightened the man so much or why he continues to haunt the stairway. His story must be entwined somewhere within the long history of the inn, dating as far back as 1530 in parts.

HERTFORD

Manifestation: Tale of the Jenningsbury Ghost

History:

It was just before Christmas 1785. Benjamin Cherry Esq., an Alderman of Hertford and eminent butcher and dealer in cattle, was talking to his bailiff at his farm at **Jenningsbury** and on sending him to turn some persons out of an adjoining field, Cherry immediately threw himself into the moat.

The bailiff returned after a short while to discover this impromptu act, but every method used to recover Cherry's life was ineffectual and he died leaving a fortune of £30,000. For many years after, the spirit of this unfortunate man roamed the premises, shaking the well bucket and chains and otherwise alarming the dwellers of the farmhouse. Sometimes he would appear in the road, frightening the unwary traveller, but according to legend he was never known to be abroad after midnight.

Manifestation: Ladies of the Manor

History:

Leahoe House stands in the leafy grounds of County Hall. Owned by Hertfordshire County Council since 1935 as a recreation and leisure centre, it was originally built in the mid 1800s for Dr George Elin, M.D.

One night after closing time in the late 1980s, Tony Joshua was locking up the bar where he worked voluntarily. Passing through the snooker room at the back of the bar, the hairs on the back of his neck suddenly stood up, his heart raced and for some reason he felt really scared. Walking out into the corridor, Tony happened to look up towards the top of the stairs and there stood the figure of a woman in a long black skirt and nun's grey habit. All his feelings of fear drained away from him and he felt totally at ease. He was transfixed looking at the woman and when he finally switched the lights off and turned to leave, she was still standing there.

Tony has often sensed her presence since that time, although never again has he seen her. He states this experience changed his sceptical views about ghosts.

Another time, a man was sitting at the bar having a drink when a light from the ceiling flew across the room with no physical explanation.

Looming out of the moonlit darkness of a wild October night is **Balls Park Mansion**. This spooky 17th Century house is the scene of an autumn haunting. Standing in enchanting grounds, it has been much altered over time and is currently not in a good state of repair. Now in the ownership of University of Hertfordshire, it originally belonged to Hertford Priory and after the Dissolution, passed into the hands of the Willis family. The lavish Jacobean style wood panelled vestibule, with its fireplace of much older Elizabethan origin, is where the haunting takes place.

Late in the evening, many of the University staff have reported seeing the resident grey lady ghost. In October 2001 a member of staff was leaving at 7pm, but finding the front door to the mansion locked by security, she turned to find another exit and saw a grey figure standing under the balcony in the vestibule.

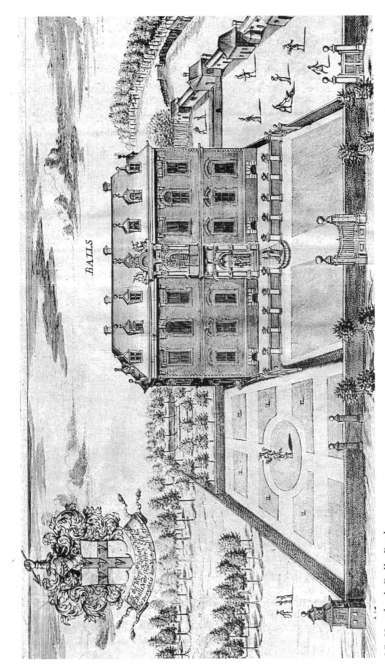

BALLS

25. Hertford, Balls Park.

80

One misty autumnal night in recent times, a member of the security staff was walking towards the door of the Mansion when he was suddenly flung backwards several feet, by an invisible force.

According to local fables, the ghost is that of a lady who threw herself off the balcony from the first floor into the vestibule one October. She has been seen many times during this month in the vestibule and also on the first floor, pacing the corridors.

Manifestation: A Tour of Haunted Hertford

History:

Our first stop on the tour is **Caffe Uno** whose previous existence was as a charity shop. Paranormal investigators have concluded that this is the most malevolent haunting in the town and chilling reports telling of a strange half-man, half-beast believed to haunt the building. The ladies that staffed the shop refused to use the toilets because they felt there was an evil atmosphere which made them feel uncomfortable. Instead, they would walk all the way across to the public toilets in the Gascoyne Way car park.

During its transformation from charity shop to restaurant, the builders had many strange experiences, which they were initially reluctant to reveal. One particular week some pieces of timber, which had been left leaning against a wall, suddenly moved across the room, as if by unseen hands. This was witnessed by three of the men working on the site. The day before, some wires running across the ceiling had been mysteriously ripped out of the clips holding them in place and were left hanging dangerously.

Whilst building the internal wall, bricks that had been left uncemented in the wall in preparation for the next day, were seen to have been moved 90 degrees by the builders. No explanation could be offered. They also witnessed an unearthly mist rising up from the basement and a particular Christmas time at 2 am, the staff were cashing up when marching shadows began moving around the walls.

One Sunday morning, after the restaurant had been completed, the cleaner was working alone in the building, up on the second floor. A

chain ran across the top of the stairs to the second floor to keep the public out. The cleaner replaced this chain as he began his work when suddenly an almighty crash came from the floor below. 'It was a tremendous noise, like a lorry dropping off a skip', he said. He rushed downstairs, and as he did so, noticed the chain had been removed but even stranger, he could find no explanation as to the cause of the noise.

One Thursday in May 1996, the pharmacist at **Sheffield's Chemist** reported a strange knocking sound on the floorboards upon which he stood. Wherever he tried to move to escape the knocking, it followed him. The following day, Friday 13th, a bottle of special diabetic medicine travelled along the passage by itself and smashed in front of witnesses, then a shelf crashed to the floor. Pat Blake, member of staff, said 'I felt nervous at first, but as time went on, we got used to it. In fact, we used to talk to it in the end and it would respond with one knock for yes, two for no.' But things were to get stranger at Sheffield's. 'One day, a bottle of strychnine just appeared through the wall. It just came out of thin air and dropped to the floor without smashing' said Pat. Strychnine may be classed as poison today, but was used as a medicine in the past. The bottle was taken straight to the police.

'Another time we found one of our two hundred year old prescription books somewhere it shouldn't have been. It was opened at a particular page and then the next day it just vanished. We hunted high and low for it, but it couldn't be found. So I asked out loud: "can we have our book back?" and about an hour later it literally appeared through the wall and fell to the floor with a bang. But the strangest thing was it was still open at the page it had been open at before. It was like it was trying to tell us something.'

Pat decided to contact the Society for Psychical Research, but the ghost had other ideas. Stamps disappeared and when she tried to call out, the phone went dead. 'One day I asked if it had a story to tell and it tapped out yes', said Pat, intriguingly. 'It told us by way of letters represented by taps that it had been killed by its brother in order to inherit the business.'

Its story told, the ghost seems to have quietened down of late.

Built during the 19th Century, the **Corn Exchange** used to house

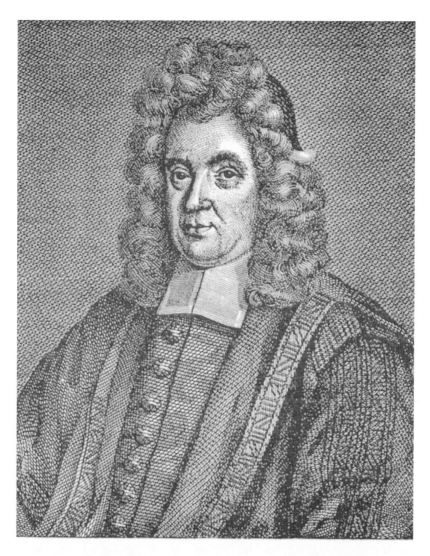

Sʀ. HENRY CHAUNCY

of Yardley Bury, in the County of Hertford. Knᵗ.

Serjeant at Law.

26. Hertford, Sir Henry Chauncy..

musicals and shows and now has the reputation of being haunted. The caretaker in recent years would go in during the day when the building was empty and hear scenery shifting, musicians clearing their throats and instruments being tuned, but there would be nobody there.

Between 1702 and 1775 the municipal jail stood on the site that is now The Corn Exchange. Overcrowding, filth and lack of air made it a constant menace to the town. There were several outbreaks of smallpox and other plagues and hangings would take place outside on an inn sign. It was only in 1777 that a new prison was constructed at Ware Road.

It was 5.30 pm and a member of staff was locking up in the bank vault at **Barclays** when she felt something brush against her shoulder. When she turned around, she saw a lady in Victorian outfit walk past her. This building has been much altered in its time. An extra storey and a Regency front have been added to an earlier wooden framed structure. At the turn of the century the ground floor was a shop and a recent examination suggested that the left-hand section was originally part of the Dimsdale Arms inn.

The manageress of **Threshers** wine store has reported a 'chilling feeling' in the cellar which makes the hairs on the back of her neck stand on end. Regularly, a tap would be turned fully on and the water pouring onto the floor when staff arrived for work in the morning, yet the building had stood empty over night.

One day, a tremendous crash was heard from the bottle store and on investigation by staff, six bottles were found on the floor, neatly arranged in the shape of a star. According to the manageress, this was the most scary thing to have happened. Interestingly, before Threshers, this building has always housed a wine merchants since 1933.

63-65 Fore Street, now **Albany Radio**, was originally a private dwelling in Georgian times, charmingly named Cupboard Hall. One of former resident Susan Brown's earliest memories was of waking suddenly in the middle of the night. 'I saw a lady leaning over me at the foot of my bed. She wore a dress of very rich texture.' The lady was dressed in Georgian costume, suggesting she may have been one of the first residents in the building.

Further along Fore Street stands the **Red House**, built over 400

years ago and part of the Christ's Hospital for the orphaned children of London. A number of sightings of a lady dressed in a grey matron's outfit and carrying a tray up the stairs have been reported here. Perhaps she is one of the former staff employed to care for the children, reluctant to leave her duties.

Pearce's Bakers shop in Railway street, a former slum area of the town, boasts the phantom smell of tobacco down in the cellar. Staff member Sheila Woodford says: 'We're not allowed to smoke down there yet there's the distinct smell of cigars sometimes. I get a cold shiver when I have to go down there, it gives me the creeps.' Pictures are reported to fall off the counter for no reason and objects fly off the shelves when no-one is nearby.

Many of the **Hertford Museum** staff have complained of noises and an uncomfortable feeling in the building, which was constructed early in the 17th Century. There is a particular area around the staircase that has a chill feeling of cold air as if someone has just passed through.

The **Hertford Club's** present house was built in the 16th Century. This was once the home of Hertfordshire historian Sir Henry Chauncy who wrote the County History of Hertfordshire in 1700 and was the recorder at the trial of Jane Wenham, the last reputed witch in England sentenced to hang, which was held at Hertford in 1712. Jane Wenham was pardoned, but it was her trial that did much to bring about the repeal of the Witchcraft Act in 1736. Thus staff at the Hertford Club refer to their ghost as 'old Henry' though it is not certain that this is the restless spirit of the man himself. Creaking floorboards and footsteps have been heard when there is no-one there. The barman reports how he came back to work to open up at 6 pm one evening and could hear laughter and male voices coming from the snooker room. He thought perhaps he had locked someone in earlier when he'd shut up for the afternoon. When he went into the snooker room, the cues were in their racks, quivering and the balls were scattered on the table as if a phantom game of snooker had just been abandoned.

The **Old Vicarage** is now an osteopath's business. A patient visiting the clinic announced that she had seen two Roman Centurions guarding the front gate when she came in. Also, a lady dressed in

Victorian clothing has been seen walking across the entrance hall or loitering in the waiting area. The odd thing about this ghost is that she is only visible from the knees upwards, as is the case with many spirits; indicating changes in floor level over the centuries. The Vicarage is indeed a historic property with the unusual feature of having the garden path made out of gravestones.

Four police officers had been assigned for duty on the 30th September 1996 when **Marshall's Furnishings** suffered a major fire in the warehouse store at the rear of the shop. The warehouse was so badly damaged that the police offered 24 hour cover as the building was virtually open and a prime target for looters.

It was the woman police constable who had the unenviable job of guarding the back of the building overnight. As she stood there alone in the windy darkness, glass was falling all around her as the heat of the fire had cracked the window panes, thus loosening the glass and blowing it out two storeys below. On looking up she saw a man peering from one of the upper window shells. It was no usual man. She described him as a Cromwellian figure with long black curly hair and a moustache. The hairs on her neck bristled and she screamed down the radio for help. When her male colleagues arrived, they went inside to search the hollowed building but could find nobody there. The WPC remains adamant to this day about what she saw.

A customer to the shop in 2000 had cause to visit the storeroom and asked if the building was haunted. She said she could sense a presence in the back of the shop. An experienced psychic investigated the storehouse in October and picked up the spirit of a 46 year old man but unfortunately a description was not forthcoming.

The lovely old **Salisbury Arms Hotel** in the centre of town has the ground plan of a medieval inn. One day, the cleaners were working up on the first floor when a middle-aged man, dressed in black, walked across the corridor and into a small room where the hot plate is kept. Thinking he was a lost guest, the cleaner went to investigate, but found the room was empty. There was no other exit; remarkably it appeared the visitor had completely vanished.

Also, a Cromwellian figure has been seen by various people at

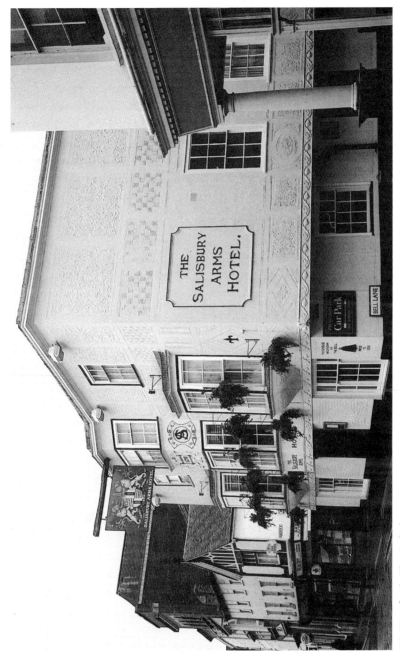

27. Hertford, The Salisbury Arms.

different times, walking the corridor. Room number 6 is said by staff to be the haunted bedroom.

The paranormal reputation of the *Hertfordshire Mercury* building is well known in Hertford. Says staff member Gary Matthews, 'You talk to all the people who have worked here over the years and they will tell you about the strange noises and the presence that has been felt.' Gary was a sceptic himself, until one Christmas three years ago when he happened to be working alone late one night. 'I suddenly became aware of the lights flashing on and off. I checked my computer screen and that was OK, so I knew it wasn't the power. Then I heard the door handle moving and when I looked over at the door, the handle was indeed moving up and down.'

Gary went and looked around the building to check no-one else was around, playing tricks on him, but the building was empty. When he returned to his seat, the lights went off completely then came on again and the door handle began moving once more. Gary hurriedly packed up and made a swift move home.

Mike Poultney was in the *Mercury* building one Sunday and was just locking up when he heard a door slam above him. Thinking there must be an intruder, he called the police. An officer with a large black alsatian came to search the premises and sent the dog into the cellar to ensure no-one was hiding there. After a few minutes, the dog began desperately scratching at the door and shot out of the cellar, its hair standing up on end. Continuing the search of the rest of the building, they came to an office which had a bunch of keys in the lock. The keys were swinging round and round as if someone had just closed the door. Brandishing his truncheon, the policeman rushed into the room, but it was empty. It was the final straw and with that, both policeman and dog made a hasty departure.

There is a story that the cellar is reputedly haunted by a kitchen maid who was murdered by the butler at some point in the building's history. Also a machine operator is reported to have died in what is now the offices, one Friday afternoon.

The **Woolworths** store in Maidenhead Street stands on the site of an old pub called The Maiden Head. It was built around the 17th

century and was included in a survey of inns in Hertford which was carried out in 1621. The pub was demolished in 1931 and a year later Woolworths was erected. Three members of staff have had strange experiences in the store room which is situated behind the audio section. A heavy 6 foot long clothes rail was moved away by itself and clothes have been thrown around of their own accord.

Wiggingtons toy shop claims to have more than one ghost. When Roy Roberts took the shop on, customers browsing upstairs would come down and tell him that the building was haunted.

'One lady went into the room above the toy shop, formerly the back bedroom, and said there was definitely a spirit there. Her husband later told me she was a psychic.'

Jane Holt, Roy's daughter, lived in the back bedroom until she was 18 and as she lay in bed at night, a lady in Victorian clothes would often wake her by stroking her brow. Jane wasn't frightened as this lady seemed to bring a great feeling of love. A man would stand at the end of the bed with white hair and beard and dressed in a morning suit.

Former employees in the building were scared of going up to the room above the toy shop to make their tea because many of them had sensed a ghostly presence.

The late Graham Wyley, psychic investigator, went in to see what he could do. 'Immediately I entered the haunted room, I went cold. This indicates there is a presence here.' Graham also experienced an oppressive feeling in his chest which had been reported by some visitors to the shop on other occasions. Graham believed the room was originally a bedroom when the building was constructed in the 1500s. 'There is a feeling of grief in the room. A young lady nursed her dying father here, hence Jane's experience of the hand across the brow.' The spirit in this room, Graham felt, was benevolent.

However, it is a different story in the attic store room of Wiggingtons. Jane refuses to go up there and dogs have behaved very strangely at the bottom of the stairs, growling and whining at an invisible intruder. Graham Wyley took up the case. 'There is something nasty and evil in this room', he concluded. 'I can't wait to get out. I got a choking feeling in my throat as soon as I entered. I feel it was about

1750 and a young man, on the run for murder and feeling the net closing in around him, came up here to hang himself from one of the beams, thus cheating the gallows. It is the evilness [sic] of this man's actions for taking another's life that remains in this room.'

Next door is **The Good Food Shop** where it appears the same Victorian lady floats in from Wiggingtons, with a companion, a Victorian gentleman in high collar. Before the First World War the shop would have been considerably larger as it was reduced when Mill Bridge was opened. The shop's proprietor also used to work at **Mill House** and was aware of an unfriendly presence in a back room which was once the kitchen.

Wallace House, a doctor's surgery in St. Andrew's Street, is the former home of Arthur Russell Wallace who is documented to have developed the theory of evolution before Darwin. Both men, unknown to each other, had been working along parallel lines of thought and reached the revolutionary theory in different ways. Darwin received a letter from Wallace describing theories he himself had already conceived but it was Darwin who actually went ahead and published. Wallace, it seems, was content that the credit go to Darwin for the theory that rocked the Victorian world.

Wallace said of the town in which he grew up, 'The old town of Hertford, where I first obtained a rudimentary acquaintance with my fellow creatures, is perhaps one of the most pleasantly situated county towns in England.'

Three ghosts have been seen here, all of them male. One walks the first floor corridor, one has been seen standing in a corner and another looks out of the window. There have been numerous sightings of these wraiths amongst the staff, but so far no reason has been put forward for their haunting.

Prior to the seventeenth century, the **Three Tuns**, now 'Thirsty Brandons', in St. Andrew's Street was an alehouse called the Black Lion. A lintel over the fireplace in the bar is believed to be an original timber from Hertford Castle. Around 1720 it was turned into a workhouse. A reminder of this harsh past drifts into the 21st century from time to time. Staff at the pub have reported seeing a bedraggled

spectre of a young girl who passes through a wall in the bar, then climbs a non-existent staircase to a room she would have shared in her workhouse days. It is believed she died of malnutrition but remains earthbound because as cruel as it was, the workhouse was the only home she knew whilst alive.

The staff don't seem to be bothered by the haunting; in fact a sign on the toilet reads: 'Beware of the ghost'!

Fred Roche's Shoe Shop stands further along St. Andrew's Street and prior to 1950 was an old cottage. As soon as Fred Roche entered the building he felt it was an unhappy place. Then one day his sister was frightened by the ghost of an old woman coming down the stairs and disappearing into a wall where once a door would have been. The ghost became a regular sight in the cottage after that. Linen is stacked and removed by invisible hands as if a bed is being made up.

Fred's brother, Andrew, was staying in one of the back bedrooms and one night he awoke suddenly and standing over him was the ghost of an old woman. He says: 'I lived here on my own for a time and at midnight I used to hear someone running up the stairs on a regular basis. The footsteps stopped outside my door and then I'd hear them running back down again, but when I looked, there would be nobody there.'

The old lady is believed to be one who lived in the cottage and went off to South Africa where she was swindled out of her savings so that when she came back to Britain, she was very unhappy and she transferred that feeling indelibly to the building.

One would assume that a historic place such as **Hertford Castle** would be overflowing with past inhabitants, but very little has been documented. There is a legend that a monk walks the grounds holding an apple, but quite why is unknown. Although this could be confused with the story of the phantom gardener dating from the 18th century, who would thump loudly on the door when the castle was a private residence and be seen by occupants, gliding through the grounds with an apple in his hand.

Now council buildings, a former mayor reported that lights would go on and off mysteriously and a dog could be heard barking in the building, although no dog was ever discovered. But during a Hertford

28. Hertford, Hertford Castle.

Council committee meeting in 1920 at the Castle, unexplained tappings were reportedly heard in the room.

One afternoon, a lady was walking along **Port Hill** with her daughter. As a young man walked towards her, she moved to one side to let him pass, but when she looked around he had disappeared. Thinking this a little odd, she voiced this to her daughter, who claimed not to have seen anyone pass them at all.

The man appeared thin, cold and hungry and wore an old fashioned costume with a wide brimmed hat, similar to that of a Quaker. He has been witnessed on other occasions near to the old Quaker burial ground.

The gruesomely named **Gallows Hill** has the reputation of being haunted by the sound of clanking chains and raised voices. A figure in grey loiters there. Perhaps this is a ghostly re-enactment of a condemned man's last journey, pursued by the angry mob.

Sources have also reported that the procession travels through a house at Pinehurst. And at an undisclosed address, a modern house in Hertford exuded an air of cold in a particular spot in the drawing room. The occupier called in a ghost investigator who said she could see a woman in grey with two children in the corner of the room, walking slightly above floor level as if they were going uphill. Another householder in the same area has experienced electrical problems and a shadow regularly appearing in the house. On investigation of local records, it was discovered that the cold spot was over the route taken by condemned people from the old Hertford jail to the gallows at the top of Gallows Hill.

The proprietors of **Gays Newsagent** said they had often heard the sound of a violin being played but had never seen the musician.

A young mother occupying one of the new flats in the Cowbridge area was disturbed when her four year old son began complaining of seeing a horse in his modern bedroom but so adamant and frightened was he about what he was seeing that she went to the local archives to find out what building had stood on the site prior to the flats. Research revealed that a knacker's yard had been in the near vicinity some years before. An old man was also seen in the flat.

HERTFORD HEATH

Manifestation: Gruesome Re-enactment

History:

In the late 1970s a man was walking his dog in the area of Haileybury College. Suddenly the air was filled with the sound of yelping hounds and out of the undergrowth towards him strode a large number of troops who then stopped and murdered one of their own soldiers. Shaken by what he had witnessed, the onlooker later undertook some local history research and discovered that Cromwell's troops had indeed marched along the road where he had encountered the soldiers. The records also reputedly confirmed that a killing had taken place in the spot.

HERTINGFORDBURY

Manifestation: Vision at the Rectory

History:

In 1643 a spectral vision was recorded as being seen near the old Rectory. It was described as a shining, silver sword hanging in the sky. Modern day thinking has likened this to a UFO sighting but frustratingly little detail remains of this story.

HIGH CROSS

Manifestation: Reflections of the Past

History:

In 1995 in a private house in East Herts, something very strange happened. Objects went missing, dogs began behaving strangely and barking at someone that wasn't there and then there was the mirror... A photograph taken in the kitchen mirror seemed to reveal the creepy image of a skull and the figure of a caped man. A strange reflection of the past or camera trickery?

29. Hertingfordbury, The Old Rectory.

HINXWORTH

Manifestation: **Screams in the Night**

History:

Hinxworth Place, the most northerly Hertfordshire manor house, began life around 1470 and has been much altered and added to over the years. Here the Hertfordshire historian Robert Clutterbuck, famous for writing the mammoth work 'The History and Antiquities of the County of Hertford in the early 1800s, was Lord of the Manor and claims to have seen the spectre of a monk long been thought to haunt the bleak manor house. The apparition was seen in the porchway leading to the cobbled courtyard.

At one time, a local newspaper reported that a plaque dated 1770 was once to be seen inside Hinxworth Place stating:

'This is the place where a monk was buried alive in this wall.
His cries can sometimes be heard at midnight'

During the Victorian period, the plaque was said to be covered by décor of the period and disappeared when repairs were carried out around the 1940s.

In the 1960s, the owner of the house complained of often hearing heavy footfalls passing along an empty upper corridor and through a modern partition dividing the house into two. The steps appeared to move outside the house and then fall away. Ancient plans revealed a former wing with a staircase in the exact place where the ghostly footsteps were heard to descend. Then appropriately enough, at Halloween 1968, the screams of a baby were heard from the area of the old staircase. No-one was in the house at the time.

Legend leaps to explain the mysterious cries. One Sunday evening in the 1800s the house owners had walked across the fields to the nearby church, leaving their child in the care of a young nursemaid. While the parents were out, a servant boy in the house played a practical joke with tragic circumstances. Climbing up the stairs with a sheet covering his head and making ghostly noises, the boy entered the

30. Hinxworth, Hinxworth Place.

room where the maid was attending the child. Terrified, she struck out at the 'ghostly' figure with a poker, sending the boy crashing to his death at the foot of the stairs in a puddle of blood. Attempts to revive the lad with cold water from the kitchen pump were futile.

On cold autumn evenings when the damp mists rise from the fields and curl around the silent house, terrified screams and the furious squeak of the water pump are said to echo around brooding Hinxworth Place.

HITCHIN

Manifestation: Phantoms of the Priory

History:

Now used as a conference venue, Hitchin Priory was previously an education centre. One day in 1980, the caretaker experienced something very strange. He said, 'It was in the afternoon and I was up in the boys' wing on the top floor when I got this cold feeling. I felt there was somebody there with me.' When he turned round, he saw the top half of a woman's figure floating up above the stairs at the end of the corridor. The ghost was dressed in a short sleeved blouse and had a pearl around her neck and spooked the caretaker so much, he refused to go back there alone.

In 1913, an advertisement appeared in the *Hertfordshire Mercury*, appealing for information regarding the grey lady apparition at Hitchin Priory. Local legend is rife with tales of secret passages running from the Priory to various parts of the town, one in particular is believed to have led to the gatehouse which stood on the site of number 17 Bridge Street and thought to have been used during dangerous times.

In Priory Park on the last day in January 1816, a local butcher called Richard Atkins was taking a stroll whilst waiting for Mr Cox, bailiff, in order that they could inspect some sheep together. He paused by the Carriage Road, which at that time led across the park to the Priory. As he stood waiting, he noticed a woman dressed in a

31. Hitchin, Hitchin Priory.

99

handsome red cloak and black hat coming towards him along the path. Atkins glanced away quickly to see if Cox was anywhere in sight and when he looked back seconds later, she had disappeared. Concerned, Atkins began walking towards where he had last seen the mysterious woman, but there was no trace of her yet no cover in which she could have hidden.

Manifestation: Hitchin's Haunted Houses

History:

Hitchin with its charming old houses huddled around St Mary's churchyard and its eerie gaslit alleyways, is a perfect haven for hauntings.

Flats now stand in Tudor Court, on the site of a house called **'Rosenberg'**, between Pirton and Offley roads. Rosenberg was a Victorian house which had a strange phenomenon with the interior walls. Once a year, on a certain date, the walls of one of the bedrooms looked to be running with water, but on being touched, were found to be quite dry. Tradition states that this is a reminder of the unhappy widow, Mrs Bowyer, who drowned herself in a nearby pond. Reputedly her 'dripping' ghost passes through a door leading from the Priory grounds into Charlton Road.

A gentleman in the 19th century, who was responsible for giving Hitchin its first sewers, lived in a house in **London Road**. After his death, heavy footfalls could be heard during the late evenings and appropriately enough, the sound of a toilet being flushed!

Number **30 Bancroft** was at one time the town workhouse. A child living at the house when it passed back into private hands, reported seeing a little old lady in an Elizabethan ruff and gown. She advanced towards his bed and then disappeared. This apparition was seen by both the child and his nurse, who was in the room at the same time.

The owner of number **37 Bridge Street** was already fed up with eerie bumps and crashes in his property, but then one day a lady walked into the shop saying she had been a wartime evacuee in

number 37 and had experienced a mysterious recurring dream during her stay there. The dream was that of a shadowy figure walking through the wall and across the floor of the small back room where she had slept. Taken aback, the owner told her that during rebuilding work at the rear of the house, the remains of a small staircase were discovered leading into this back room at the exact spot where the figure had been seen.

In 1969 it was reported that a soldier from the Civil War period materialised dramatically by the fireplace to a lady who lived in an old cottage at the junction of Sun Street and Bridge Street. He was thought to have been the spectre of a soldier who disappeared whilst billeted there.

The old **Union Workhouse** hit the local news headlines in 1907 when it was reported that its corridors were haunted at night by a spirit heard but not seen. 'A noisy ghost is undesirable and certainly less convenient than a woman in white' commented the newspaper. The ghost was believed to be male and so terrified both staff and patients that one nurse resigned and others refused to carry out night duty. Truth or newspaper sensationalism?

But the most terrifying house of all was the upper storeys of **10 and 11 Sun Street**, now **Philpotts** the house furnishers, a Queen Anne building, which for some time had been used as a flat. The events here were so fearful, they could have come straight from the pages of Edgar Allan Poe. Anyone who stayed here, soon left, frightened out of their wits.

The most haunted room seemed to be an oak panelled dining room with a large fireplace and a cupboard on each side. One cupboard had a false ceiling, which opened as a trap door into a small, dark room.

Footsteps would be heard at all times of the day and night, yet the place might be empty. One resident was woken by footsteps approaching her bedroom in the middle of the night. The brass handle of the door turned slowly and to her horror, the door began to creak open, but no-one stood in the shadow of light that was thrown across the room. Instead, she heard someone whispering her name. This was

too much, she leapt out of bed and fled past whatever it was, into the safety of her parent's room where, everyone woken, heard the ghostly footsteps retreating down the stairs.

A soldier on leave and staying in the house had woken the entire household with his screams one night. He claimed a large and powerful dark figure had pinned him to his bed by the throat and it had taken all his strength to free himself and cry for help. Afterwards, the family decided to all sleep in one room. But this did not deter the phantom. In the early hours of the morning, the entire family saw a dark hooded figure kneeling beside one of the beds. When it was challenged, the figure slipped feet first through the solid floor boards.

The air would turn suddenly cold in the flat and the door of the secret cupboard in the oak room, would fling open by itself, knocking noises would be heard all over the room and food and drink would be thrown over the occupants. Objects disappeared in front of people's eyes, never to be seen again and the activity became so bad, the family were forced to abandon using the room further.

In **Sun Street** near the waters of the River Hiz, it is said the clacking sound of a phantom bowls match can still be heard, re-enacted by two members of spectral clergy.

The **Sun Hotel** itself has an upstairs room believed to be haunted by the ghost of Lord Havisham who committed suicide here in the 1800s. Intriguingly, the hotel management refuse to say which of the rooms is haunted because the Lord's wraith is so frightening. A 'terrifying woman' is also a menace here. A former barmaid observed the cloaked figure of a monk walk from one corner of the bar to the other twice while she was pulling pints. On one occasion he actually ventured behind the bar and she thought he was going to help himself to a pint.

Yorkshireman Mike Marsden was staying in room 10 of the Sun Hotel when he was jarred awake, choking, with the 'body of a woman lying across his face'. Convinced she was trying to suffocate him and this was no dream, Mike was so afraid, he ran out of the building and walked around the town until daybreak. The hotel manager confirms

that Mike is not the only person to have encountered this frightening experience and some guests will refuse to sleep there after having only entered the room.

In the ancient attic of **Howell's Newsagents**, in Churchyard in 1979, a normal everyday event became an extraordinary spectacle. Shop assistant Ruby Males had gone up into the attic to make a cup of tea when suddenly she sensed the atmosphere change. The hairs began bristling on the back of her neck as she felt someone standing behind her in the cramped, beamed room. Turning her head she came face to face with a young man in Edwardian dress, calmly staring at her. Ruby could do nothing else but stare back in amazement and as suddenly as he appeared, the frock coated gentleman vanished in front of her. When the shock had worn off, Ruby still couldn't believe that she had actually seen a ghost.

It is thought that the gentleman spook Ruby saw is that of the Hitchin etcher Frederick Griggs who worked in the early part of the 1900s above the shop, which backs onto Howell's premises. During renovations at the newsagents in the 1980s, leather boots, clothes and clay pipes with Griggs' name on were discovered.

When children are in the shop, Griggs' spirit becomes agitated and he stomps about on the stairs. The shop owner's 5 year old daughter was 'pushed' down the stairs by an unseen force and dogs will never venture onto the top floor of the shop.

Nearby, at numbers **12 and 13 Churchyard**, in the 1930s, builders were carrying out alteration work. One morning, a workman arrived for work as usual but found everything strangely quiet. Puzzled, he entered the building and to his horror came across a body on the ground. Stretched out around him were the motionless bodies of his entire workforce. Although not dead, the men could not be revived for some time and slowly a very weird story began to emerge. Early that morning, the men had broken down a wall behind which was a secret chamber containing a vat of wine, a chalice and a human skeleton. The men had decided to sample the wine and it was then they were discovered by their employer, comatose drunk. The skeleton was never identified.

The George pub in Bucklersbury echoes with the sound of footsteps thumping around the building after nightfall and has a 'terrifying' feeling in the cellar, where dogs, cats and even the landlord refuse to go down after 11 at night.

Nearby the George was once the **Red Hart Inn**, which dated back over 500 years and believed to have stood upon the site of the town's last public hanging. In the late 1960s Mrs Shepherd, a trainee manager from London, awoke in her bedroom at the inn one night to see the shadowy figure of an elderly man sitting in an armchair not far from her bed.

Another monk is said to grace the **Coopers Arms** in Tilehouse Street, claimed to have been seen by a number of the pub's regulars.

Many people have reported seeing the unhappy wraith of hanged murderer Eugene Aram stalking the alley between Churchyard Walk and the High Street after dark. Aram was a man haunted by his conscience. On the run from the murder of a tramp in Yorkshire, it appeared Aram always had one eye over his shoulder and the lock on his bedroom door was kept heavily bolted. A scholarly man, in 1750 he became usher at a local boys' school and was a frequent visitor to Lord Lytton of Knebworth House. Lord Lytton's literary grandson, Edward Bulwer Lytton, was fascinated by Aram and wrote a novel about him, doing much of his research in Hitchin. Justice finally crept up on Aram in August 1758 in Kings Lynn, Norfolk, but the narrow passage known as Aram's Alley is still talked of by local people to be haunted by his ghost.

On the Hitchin to Stevenage road at Ashbrook, there is a haunting which is documented going back to 1910. Mr Harrison was out walking a little way up the hill towards Hitchin when at the top of the hill he distinctly saw the figure of a man dressed in white. The man seemed to be walking about in the middle of the road, looking for something.

At a mill house nearby, on September nights, it is rumoured that figures of a struggling man and a girl are seen at an upper window and footsteps and screams are heard. The story goes that the mill owner at the time threatened to throw out the girl and her mother and when the girl went to plead their case, there was a fight and she was killed. Once again a story lost and confused in the passage of time.

32. Hitchin, Eugene Aram.

Manifestation: Phantom Army

History:

In 1935 the director of a well known publishing house was driving along a stretch of the Roman road just outside **Holwell** village, when he came to a wooded area and there, sitting around blazing fires, were soldiers in short tunics, their armour piled on the ground around them. At first, the publisher thought he was witnessing the making of a film, except that the soldiers were transparent. When he reached the neighbouring farmhouse in which he was to stay, the comment made by his hosts on relating his tale, was 'So you've seen it too!'

At Holwell itself, the **moat house** is reputedly haunted by the ghost of a girl and has been troubled by mysteriously locking doors, toys and objects broken and moved about and dolls broken in pieces. No dates or other information exists.

Manifestation: Strange Goings-On at the Chapel

History:

Almost forgotten, swallowed up by trees and hidden in undergrowth, is the crumbling ruin of Minsden Chapel. Its walls long neglected are strangled by creeper and very little remains of this building which was once said to have belonged to the Knights of St. John of Jerusalem. The Knights Templars were located at Temple Dinsley a short distance away. The building fell into decline in the 1600s but the romantic tumble-down setting seemed to attract couples in the 18th century as marriages were recorded at Minsden up to July 1738, when a large piece of masonry crashed down during a ceremony and the Bishop of Lincoln refused to sanction any further marriages there. It was here, eminent Hertfordshire historian Reginald Hine would spend many hours in quiet contemplation and where, at Halloween 1943, he completed the final chapter of his book 'Confessions of an Uncommon Attorney'. The chapel ruins held such an allure to Hine that he had his ashes scattered there when he died in 1949 and beneath the twisted

33. *Hitchin, The Minsden Ghost.*

ivy and brambles, a weathered memorial stone can still be seen. But the presence of the Hitchin writer will not lie quiet and it is said his ghost walks at Minsden as a reminder of his promise to 'protect and haunt its weathered walls.'

In October 1929 a more sensational story hit the local headlines. A photographer visiting the ruins had 'by chance' captured a suspicious looking cowled figure on his negative. The photograph was investigated on behalf of the Society for Psychical Research and astoundingly the conclusion was reached that the figure was not due to 'fake' or abnormalities with the film.

The newspaper reports of the ghost of a Dame Margerie, who was a resident in the neighbourhood in the 14th century and benefactress of the chapel and who would undoubtedly turn in her grave if she could see how this tranquil ruin has been so neglected. But in the mid 1980s it came to light that the ghost of a small boy playing the flute has also been seen there.

In the 19th Century, ghost hunter Elliott O'Donnell visited the ruins accompanied by a professional medium, but she met with no success. Undeterred, O'Donnell visited again this time alone and reports he felt 'extraordinarily uncanny' at times. He was conscious of something scrutinising him although saw and heard nothing.

Whatever the truth is of Minsden Chapel, it guards its secrets well and today the only thing that appears to haunt these mysterious ruins is the desolate cry of the birds.

HODDESDON

Manifestation: Green Lady of Yew Arbor

History:

Hoddesdon's local historian, E.W. Paddick lived in Yew House for 22 years. The house was demolished when the Cedar Green estate was developed but a notable earlier resident was Edward Christian, brother of Fletcher Christian who led the mutiny on the Bounty. The Paddicks, however, were living in the house right up to the point of demolition.

'We used to hear the sound of running water and it splashing down the plug hole,' said Mr Paddick, 'but when we looked around, the bath was completely waterless, the taps wouldn't turn on and the water had been cut off!'

Yew Arbor was a 17th century house which was knocked down to make way for the Priory Close flats. Locally it was known as Coffin House for no sinister reason other than its overhanging top storey resembled a coffin shape. Several people saw a lady in green float down the staircase and disappear. In the 1930s, a well-known retired colonel of Hoddesdon had been staying at Yew Arbor and one evening complained to his hostess that he must have been given the wrong room as a lady wearing green was in there. He was informed that this was a ghost and that she could often be spotted in the mirror in that room.

Manifestation: White Christmas Ghost

History:

The **Bull** inn was famous for its sign-beam which was centuries old and spanned the road to the old Market House. At the beginning of the 19th century, the town watchman had spied a white ghost walk across the sign-beam to the Market House and back again. The tale grew and became legendary throughout the county and as far out as Cambridge and London. On Christmas Day 1800, the ghost was seen again, this time by the Landlord of the Bull who watched a white figure come through the window and get into bed in a little room where the woman servants of the inn slept.

34. Hoddesdon, The Bull Inn.

Manifestation: Hunt is on at The George

History:

In 1982 a team of paranormal experts, including Guy Playfair who became famously connected with the case of the Enfield Poltergeist, camped out at **The George III** pub in Hoddesdon.

The pub had experienced shelves collapsing, ornaments breaking, doors opening and closing by themselves and machines switching themselves on and off. The landlord's dog refused to go into the cellar, a common dog phenomenon.

KIMPTON

Manifestation: Spectral Light

History:

In the early 1900s, a letter appeared in the *Herts Advertiser* telling of a mysterious white light which had been seen floating between Chiltern Green and the Station, near the spot where a suicide's body was found. One person, thinking it to be an approaching bicycle, waited for it to pass, only to be startled seeing it disappear through the hedge.

KINGS LANGLEY

Manifestation: Cold Spot

History:

On the road from Kings Langley to Chipperfield there is a particular spot where psychic 'sensitives' feel uneasy and unusually cold. This phenomenon has persisted from as long ago as the Second World War. A writer on the way back from visiting a friend at the Chipperfield art colony had to walk home as there was no bus available at the time. Arriving at one particular spot on the journey he experienced an unmistakably eerie feeling; a prickling of the scalp and a violent shivering as if in intense cold. As he walked on, the feeling passed.

Manifestation: Ghost Car

History:

On the Watford by-pass at Kings Langley, modern day motorists driving along at dusk have been startled when their headlights pick out the terrible wreckage of a badly damaged car. Many people have stopped to go to the aid of the victims of the crash, but when they get out of their cars, the road is clear and the mangled remains of the family saloon have vanished. Luckily this apparition has so far only served as a warning to oncoming drivers rather than been the cause of any accidents itself.

Manifestation: Friars in the Priory

History:

On a particular summer's night, two friars in white robes can be found in the Priory orchard, digging the ground. Why they are there or what they hope to find from their spectral nocturnal dig remains a mystery.

KNEBWORTH

Manifestation: Jenny's Yarn

History:

Eerie shadows flit around the dark corners of this stately home. One look at Knebworth House and its creepy gothic frontage and you would be very disappointed if there were not a ghost or two here. Knebworth was the ancestral home of the Lyttons, a family to which writer Edward Bulwer Lytton belonged. There was a fortress on this site as far back as the 1300s but the present romantic curiosity of a building is a result of extensive restoration in 1843 by Bulwer Lytton. Here this celebrated eccentric author, and student of the occult, would receive his guests, an impressive selection including clairvoyants, artists and statesmen, clad in a velvet suit in the great hall of his self created palace. The two

35. Kings Langley, The Priory.

wings that contained 'the haunted chambers' disappeared during this time. Edward Bulwer Lytton wrote: 'The haunted rooms were pulled down in 1812 but were (in 1883) still remembered with awe and pride by elderly inhabitants of Knebworth village.' However one room remained haunted by a harbinger of impending death in the form of a radiant image known as The Yellow Boy.

Bulwer-Lytton had a macabre sense of humour. He would subject his guests to an evening of hair-raising tales about the Knebworth ghosts, as they gathered round the fireside before retiring to bed in the haunted room, leaving them to tread the stairs by candlelight, in a terrified state, jumping at their own reflections.

The Yellow Boy still comes to residents and visitors of the house to foretell their early death. He appeared to Lord Castlereagh, (1769-1822) statesman in Pitt's government, as he slept in a bedroom at Knebworth as guest of the Lyttons. The next morning at breakfast, Castlereagh complained to his host that something had awoken him in the night.

'I looked in the direction of the fire and saw, sitting with his back towards me, what appeared to be the figure of a boy with long, yellowish hair. As I stared, the figure arose, turned towards me and drawing back the curtain at the bottom of the bed with one hand, with the other he drew his fingers two or three times across his throat.'

On 12 August 1822 the fate of Castlereagh was that in a deeply troubled state of mind, wracked with gout and the pressures of his position in government, he took his own life. He cut his throat with a penknife in his dressing room and died almost immediately.

A girl with long blonde hair has been seen in Queen Elizabeth's room and unsurprisingly, the strong presence of the dark Bulwer-Lytton himself has been sensed in his study and the drawing room. Recently, two of the cleaning staff refused to go near any of Bulwer Lytton's rooms, feeling sure they would come face to face with his spirit.

But perhaps the best known ghost story associated with Knebworth House is that of Jenny Spinner. It was Christmas 1800 and the after dinner conversation soon turned to the festive favourite of ghosts. It was there the tale of Jenny emerged. This was later written in a pamphlet by a Miss James in the mid 1800s.

36. Knebworth, Knebworth House.

37. Knebworth, Edward Bulwar Lytton.

I stopped very often to listen whether any body walked in the picture gallery. Vide page 91.

THE HISTORY

OF

JENNY SPINNER,

THE

HERTFORDSHIRE GHOST.

WRITTEN

BY HERSELF.

"Conscience doth make Cowards of us all."

LONDON:

Printed for the Author; and sold by J. WHEBLE, No. 18, Warwick-square; and by all the Agents of the County Chronicle, in the neighbouring Counties of Herts, Essex, Kent, Surrey, &c.; likewise by the Booksellers in Town and Country throughout the Kingdom.

1800.

W. and C. Spilsbury, Printers, Snow-hill.

38. Knebworth, *The Jenny Spinner Book.*

At the end of the long gallery with its heavy tapestries and gloomy portraits, is a small, curiously carved door which opens into a room where Jenny worked alone at her spinning wheel, humming to herself. Jenny took her own life in this room and if you venture in after dusk and stand with the door ajar, the distinct whirr and buzz of her old spinning wheel can be heard. Some have even seen the troubled wraith itself, with pale 'countenance' and a red ring about its throat. But the legend of Jenny Spinner is nothing more than a story which was dreamed up around the fire during that cold Christmas in 1800 but which has become blurred into history. However, a gardener at the House swears he has seen Jenny in the kitchen garden.

Manifestation: Smells of the Past

History:

Ninningswood Cottage at Rabley Heath, now a private property, was formerly the old Pest House until 1830 and the smell of frying eggs and bacon drifts about even when the kitchen is empty and when the house has been unoccupied for several months.

The cottage was in operation as a pest house from 1774 and was where the sick villagers of Welwyn were dispatched, mainly with smallpox. Welwyn vestry records show that in 1769 the old pest house had fallen down and in 1774 a property in Ninningswood was taken over as a new pest house. Ninningswood Cottage was the only building listed in the area on the earliest tithe map for Welwyn so it is generally assumed that this building housed the pest house.

The new Pest House faced a test in its early days when sporadic outbreaks of Plague in the area meant its walls provided a sanctuary for the victims. A Plague burial ground exists nearby.

The cottage is estimated to have been built around 1650 but wattle and daub was discovered under some of the plastering in the 1960s, which places the building at a much earlier date as these materials were not used after the 15th century. The cottage is thought to have been built originally as one house but around 1851 it was recorded as

three separate dwellings. In the early 1900s an eccentric character lived in one of the cottages, and became locally known as 'the witch', perhaps it is she who still cooks her phantom breakfast for all to smell.

Manifestation: Tanks for the Memory

History:

An unlikely ghost is that of a phantom Second World War tank which drives slowly from Knebworth House lodge gate towards Codicote with its hatch open and a soldier in a steel helmet motioning all on the road to take cover, presumably from a spectral air raid.

LAYSTON

Manifestation: Legend of Lady Lemon

History:

The murky waters of the pond beside the old approach road to Alswick Hall conceal a story about Lady Lemon. One night, when Lady Lemon was being driven home to the Hall in her carriage, the horses bolted, startled by an apparition, which loomed suddenly ahead of them in the road. The coach and its occupants apparently overturned into the pond and no trace was ever found of her Ladyship and the coachman. It is said on the anniversary of this accident the eerie sound of horses' hooves and carriage wheels can be heard. But as to the identity of the original apparition, no-one knows.

Manifestation: Bells Ring out at Ruined Church

History:

At the bottom of a leafy lane at Layston stands St. Bartholomew's church, now a spooky ruin. In the 19th Century, bells were often heard ringing in the dead of night when it was known there was nobody up there. A group of ringers decided to go up and surprise the pranksters

119

39. Layston, Layston Church.

but as they neared the church, they saw it was brightly lit and the bells
continued to ring. As soon as the group entered the church, the bells
fell silent and the building was plunged into darkness. Nothing was
found to explain how this could happen.

LEMSFORD

Manifestation: Shades of the Past at Brocket Hall

History:

Magnificent Brocket Hall stands regally reflected in a beautiful lake, just
outside Lemsford. Now a high-class golf complex and residence of Lord
and Lady Brocket, this was once the home of Lady Caroline Lamb,
famously the lover of poet Lord Byron and less famously the wife of
Prime Minister Melbourne. Byron's ghostly funeral procession passes
slowly in front of the ornate iron gates which face the road. The poet
has also been seen wandering in the grounds, looking for inspiration.

In 2001, pop group Steps chose Brocket Hall as a location for one
of their videos and were spooked by objects moving about by
themselves and temperatures suddenly dropping in particular spots.

The Hall has been used as a location for film and television many
times over the years but in the late 1950s it provided the backdrop for
the spinechilling 'Night of the Demon', a film based on the unsettling
story by M.R. James, 'Casting the Runes'.

Manifestation: Gleaming Presence

History:

A 'gleaming presence' is said to hover on a stretch of wall opposite
Brockswood Lane and sometimes a little old man in monk's habit looks
down from the same spot.

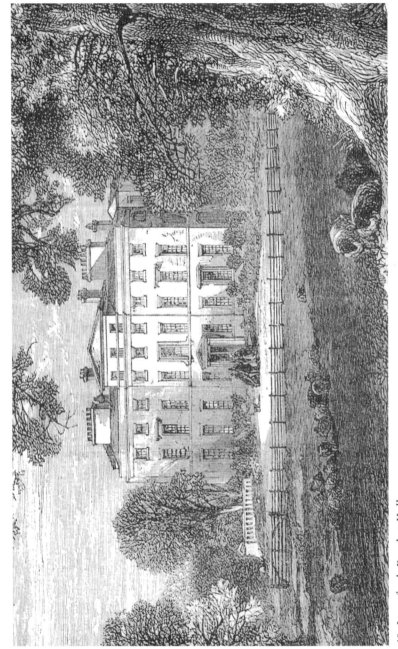

40. Lemsford, Brocket Hall.

LETCHWORTH

Manifestation: Ghost Lady

History:

Motorists have had to brake hard to avoid hitting the ghostly lady on the Willian road towards Letchworth Gate. The lady, dressed in a grey coat and with black hair, looks perfectly normal until drivers become aware that she is walking straight at oncoming vehicles without faltering. Then just as the cars swerve to miss her, she vanishes.

Manifestation: Unidentified Phantom

History:

A house in Letchworth named Scudamore was reported in 1946 to be troubled by footsteps and thumps every night. A dog living in the house at the time began to behave strangely and refused to enter a particular bedroom. If dragged in by the collar, he would struggle and growl to be free and once he had managed, would race out of the room and down the stairs to the sanctuary of the garden. Whatever was the cause of these odd events has never been identified.

Manifestation: Raunchy Reverend Returns to Old Haunt

History:

It was nearly 3 am and only the crackling of a dying fire could be heard in Letchworth Hall Hotel. The assistant manager and some volunteers had gathered themselves for a night vigil hoping to glimpse the ghost of a clergyman flitting across the landing.

In the mid 1980s, two of the female members of staff had been frightened by the Reverend's ghost, dressed in a shadowy cassock, drifting across the ballroom. This had prompted the irreverent men's nocturnal ghost watch. Clutching a bottle of something warming, the men chatted casually until the clock struck three and from above them on the landing, the handle of a door began to turn slowly. The men fell

into silence, eyes straining and hearts pounding. Inch by inch the door painfully opened. Was it the warming drink in the bottle or merely the expectation of what might be seen? Whatever, the assistant manager swore he saw the Reverend's ghost materialise on the empty landing that night.

The ghost is thought to be that of Reverend William Alington, previous owner of Letchworth Hall who had died in the 1860s. The clergyman was reputedly suspended from his office for drinking and bawdy behaviour with his parishioners.

LILLEY

Manifestation: Fortune of Fanny Ebbs

History:

Lilley is a tiny north Herts village, possibly best known for its associations with mysterious alchemist John Kellerman, who lived here in the 1820s. Kellerman was regarded with suspicion by the villagers, as he spoke in a thick, foreign accent and was never to be seen outside his large house, which he had taken to barricading with hurdles and man-traps to protect his solitary pursuits. Then as mysteriously as he arrived, Kellerman vanished without trace.

Another mystery in the village is remembered by older residents and involves a little sweet shop which existed next to the Silver Lion public house in about 1895. The shop was run by Fanny Ebbs, who didn't seem unduly perturbed by the strange tales circulating the village about her shop. One night, Fanny was lying in bed when, in the moonlight, she glimpsed the figure of a man who seemed to appear through the wall. The figure turned and walked down the stairs. Brave Fanny followed the ghost through the shop and into the kitchen and watched in amazement as it went over to the brick fireplace, knelt down and began to take up the hearth bricks. Then from a hiding hole it dragged out a large black kettle and took off the lid to reveal it was full of gold sovereigns. The ghost counted them all out and then back

in again. He then replaced the pot and took out another, filled in the same way. When the ghost finally vanished back through the wall, Fanny went over to the hearth to check she hadn't imagined the whole experience and on finding two solid pots of gold, removed the coins and put all else back. The story goes that the next night, the ghost appeared as before, but on finding the coins missing, vanished, never to return. Fanny continued running her sweet shop, even if villagers did begin to notice her becoming more eccentric, and after she died she left the remains of her fortune to the people in the parish. The moral of this ghost tale? You can't take your fortune with you.

Manifestation: Collection of Pub Spirits

History:

Landlady of the Lilley Arms pub, Sylvia Brown, had been troubled by unexplained events for over 20 years. A strange cold draught was constant in the saloon bar and her upstairs living room and when they tried putting up Christmas decorations in the dining room, after about an hour the decorations would twist and fall down as if pulled by an invisible hand. Hearing about the ghosts, a professional team of investigators visited the pub in 2001 expecting a half day investigation, but what they discovered kept them there for three nights.

The team were photographing the dining room and just before the decorations were torn down, an orb of white light was photographed by two separate cameras at the same spot from where they fell. The room went icy cold at the same moment, and one of the team members commented that their breath could be seen. Paranormal team leader Ross Hemsworth said he could find no explanation for the orb of light and the two camera lenses were clean and that theories of dust or pollen are fine except that he has never heard of dust or pollen demolishing Christmas decorations.

One of the Lilley Arms' spectral collection is thought to be Frances Mitchell, who ran her own millinery business at Stotfold and who came to see landlord Tom Connisbee around 1780. Sylvia believes it is mischievous Tom who pokes people in the back and when contacted

by one of the team's mediums who told him he was in the wrong century, a deep voice echoed back from Sylvia, who was in a semi-trance state, 'No! You are in the wrong century.'

A six year old boy visiting one summer recently said he saw a shepherd, who apparently wasn't welcome in the inn and stands in the yard. He also saw what he described as a 'see-through dog'.

When the medium walked into the Crooked Barn at the rear of the building, she asked if anyone had committed suicide here. At that moment, the camera man, who had been filming for the team's report, felt his entire face being stretched back. He said he felt he was being stretched all over and was so frightened he was unable to carry on filming. The whole building went very cold and the mediums could see a tall gaunt figure lying on the floor.

Whilst cleaning up the attic one day, Sylvia accidentally knocked over a bowl of walnuts which she picked up immediately, put back on the shelf and returned to her cleaning. While her back was turned, she heard a series of clips and taps behind her and when she looked round, the walnuts had been perfectly placed in a straight line on the attic floor. Sylvia says this all happened within the space of about five seconds.

LITTLE GADDESDEN

Manifestation: **Jarman's Ghost**

History:

When the Ashridge Manor House clock strikes midnight, the ghost of a local man rides furiously past on a headless horse – or so legend has it. Some tales go as far as to say the horse is not only headless but blue.

In the 18th century, a man named Jarman lived in the Manor House. He was said to have been in love with the heiress of Ashridge but was betrayed and committed suicide by hanging himself from a nearby oak tree. His spectral ride scatters the deer along the route to Bluepit Pond, opposite the Manor House. Some say he waters two white horses at the pond and, after a fresh fall of snow, the wheel tracks of his carriage can

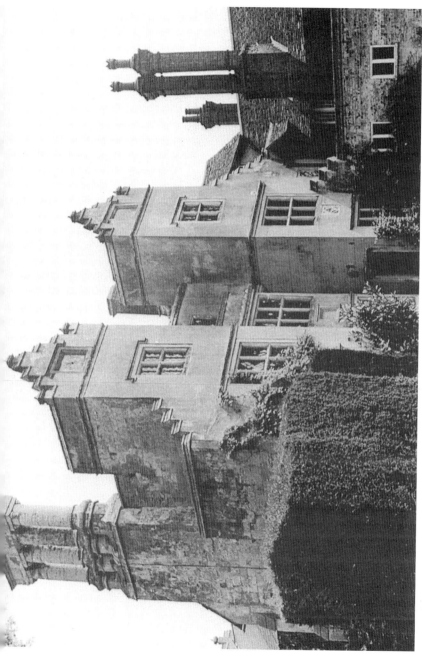

41. Little Gaddesden, The Manor House.

be seen leading from the old stables to the front door of the Mansion.

In the 19th century Jarman's ghost was well known for interfering with lamps in the Manor House and he is still believed to do so. His ghost was so troublesome, an exorcism took place. Seven parsons assembled and, as soon as the exorcism began, Jarman succeeded in extinguishing six of their seven candles, but the last candle stayed defiantly alight and his ghost was subdued for a while. But then, in the late 1960s, he was back to his old tricks when the resident, Miss Erhart, was thrown into sudden darkness as her standard lamp switched itself off. Not explained by a fuse or power cut as the lamp switch itself had been pushed. 'Jarman's Coffin' is the name given to one of the Manor's chimneys because of its curious shape.

John Aubrey in his 'Miscellanies', 1696 recorded that at Ashridge there was a monastery where an old manuscript entitled 'Johannes de Rupesscissa' was discovered. It appeared to be a book of occult spells and rituals to rid a haunted house of its evil spirits by smoking them out with special fumes.

LITTLE WYMONDLEY

Manifestation: Restless Prior

History:

A stone in the cellar of Wymondley Priory is said to be covered by a dark stain that no amount of washing will remove and is therefore assumed to be blood. Meanwhile, above ground, the apparition of the disinherited Prior wanders restlessly over the scene of his former labours.

LONDON COLNEY

Manifestation: Stable Sounds

History:

The Colney Fox pub was, up until recently, the Watersplash Hotel; an old coaching inn whose yard would echo with the sound of ghostly horses' hooves.

A local lady lived at the stables next door to the Watersplash inn-yard and on two occasions was woken at 5 am by the sound of hooves trotting. Thinking her own horses had got out, she leapt up and rushed outside to find nothing, only the silent moonlight. 'It wasn't just myself who heard the horses. One night I had five people staying with me and we all heard it and rushed outside but again, there was nothing. The next time we heard the trotting hooves, we stopped and listened carefully and could hear the jingling of harnesses and the sound of big wheels turning. It was as clear as day and loud enough to wake us all up.'

London Colney was only a small hamlet in coaching days, on the London-Holyhead road, but it was here that coaches would change horses before the ascent up Ridge Hill. The Watersplash, in its former days, was one of the first coaching inns where horses would be changed on their journey from London.

The nearby **Green Dragon** pub is said to still house the presence of a former landlord who died in debt and cannot rest.

Manifestation: Infamous Barmaid of the Bull

History:

Paranormal activity at the Bull Inn is well known in London Colney. Formerly called The Black Bull, this establishment can be traced back to 1726, but the building is believed to be at least 150 years older. Current licensees, Ben and Loral Bennett, were fully informed of the pub's spirits when they took over some years ago. Loral said, 'One of the previous owners woke in the night and saw someone standing at

the foot of her bed. The lady who took over from her always felt uneasy in that room and one day she was standing by the mirror doing her hair when she became aware that she felt very frightened. Her dogs were in the room with her and they began scratching at the door to get out. There was a very real presence in the corner of the room, which is a bit worrying as that is our bedroom!'

The ghostly activity became too much for the previous landlady and she called in an exorcist but this doesn't seem to have quietened the mischievous spirit for glasses are still flying off shelves and off the bar, smashing by themselves when no-one is nearby, and bottles flying off optics. Loral said the odd happenings seem to be focussed mainly on newly arrived female staff and after a while the activity stops again. One afternoon, the pub was shut while the previous owners uncovered a fireplace in the bar. This was thirsty work and afterwards they went to have a drink when, for some reason, none of the beer pumps were working. The cellar mechanism was checked and nothing appeared obviously wrong, so the cellar technician was called the next morning. As he arrived, the pumps began working as mysteriously as they had stopped.

'It's like this with everything', says Loral. 'Something will just stop working for ages, yet as soon as you call someone out to fix it, it suddenly works fine. Now if anything goes wrong, we just leave it and it seems to sort itself out.'

One night a pool match was taking place in the back bar. A crowd had gathered to watch when Loral saw the chalk board rubber thrown across the floor. Putting it down to some boys standing nearby she thought no more of it. After the match, the father of the boys came up to Loral in a state of concern. 'He said, I think you have a ghost in here. That rubber went flying across the room by itself. He was really freaked.'

The story behind the ghost seems to be very muddled. It is believed to be that of a young girl called Abigail or Annie who worked here sometime before the Second World War and who got pregnant by the landlord and hanged herself in an upstairs room. Although the story is

well known in the village, no record of her death is known to exist. A dark and gloomy room at the end of the corridor in the oldest part of the pub is where she is said to have ended her life. This room has a strange feel and has stood un-used by the two previous owners. Loral herself shuns the room.

Another one of the upstairs rooms has a sealed up doorway which used to open on to secret stairs leading down to the cellar where Masonic meetings were once held. The cellar itself has not escaped its share of weird goings-on. Landlord Ben has found himself on many occasions both locked in and locked out of the cellar even though there is no key and no obvious explanation for this occurrence. Like the story of the unfortunate barmaid, the odd events of the Bull inn remain a mystery.

Manifestation: Secrets of the Hall

History:

Lying on the edge of the honeycombed lanes of old highwayman country, is moated manor house Salisbury Hall. The present building was once a charming 17th century house associated with various famous residents, but it is now a collection of offices and the peaceful countryside location is bristling with the constant rumble of the surrounding motorways.

This fascinating house has had a chequered history. Built on a site that was inhabited since Roman times, in 1648 it was used as a headquarters and armoury by King Charles I during the Civil War, then purchased by his son, Charles II for his lover Nell Gwynne, lived in by Winston Churchill's mother and where Sir Winston wooed his future wife and used as a secret base for building the famous de Havilland Mosquito aircraft during the second World War. At 900 years old, the moat is the oldest surviving part of the building, dating from when Geoffrey de Mandeville (the Barnet ghost) was granted the land by William the Conqueror. Pottery fragments of 12th century origin have been discovered in the moat. The name is derived from the Earls of

Salisbury (those of Hatfield House) who bought the original property in the 14th century. Most of the Tudor buildings had been replaced by 1819 but an original Tudor brick floor was discovered under the black and white tiles of the main entrance hall.

After its part in the War effort, Salisbury Hall was abandoned and neglected until the late 1950s when it was discovered by the Goldsmith family, who lovingly restored it and opened it to the public. Mr Goldsmith heard happy girlish laughter echoing down an empty passageway and this sound has also been heard by many different people in a certain tranquil spot in the garden. Mrs Goldsmith heard footsteps in the passageway one early morning but on checking, the corridor was completely empty. Other previous occupants have also reported the sound of ghostly footsteps pacing up and down the part of the house near the Tudor wing which was destroyed in a fire around 1830. These footsteps are believed to be those of a Cavalier who committed suicide in one of the bedrooms after fleeing from the Roundheads. Sometimes he appears as a grisly vision with a sword sticking through him, although some who have seen him say it is obvious he shot himself. The Cavalier's pale ghost entered a bedroom one night in the 1930s, terrifying the resident.

In a room on the top floor, Mr Goldsmith had felt a presence and found out later that it was in this room an inexplicable bloodstain used to appear and disappear on the wall.

Nell Gwynne's oak beamed cottage stands on the left of the bridge as you enter the car park. Nell is famous for dangling one of her children out of the window over the moat, threatening to drown the King's 'bastard' until Charles begged her to 'pray, spare the Duke of St.Albans.' Many have seen the ghost of Nell herself at Salisbury Hall on the staircase and in the panelled hall, including Sir Winston Churchill's step-father George Cornwallis-West. In his memoirs he writes of seeing the figure of a beautiful girl in a blue three cornered shawl coming down the staircase. She looked intently at him and then turned and vanished into the adjoining passage. It was only when some time later he was looking at prints of Nell Gwynne did he realise who

the mysterious woman was. Tom Corbett, clairvoyant, was called in to investigate the ghosts in the 1960s and felt Nell occupied what was the green bedroom and Mr Goldsmith confirmed he too had sensed her presence here. Tom also picked up the spirit of a woman on the bridge over the moat.

Children staying at the Hall have been disturbed in Winston Churchill's former bedroom over the entrance way, now occupied by someone's computer desk in an office. They complained of feeling something standing by their beds and a governess spending a night in the same room saw 'something terrifying' come out of the wall near the fireplace and stand by the bed. She refused to spend another night in the house.

Outside on the little bridge, a former resident of the Tudor cottage was startled to see a young man dressed in a Cavalier's outfit standing gazing at her. As she watched, he seemed to go hazy and fade away. Luckily he had appeared minus sword and seemed relatively in one piece. The current residents of the cottage have often felt a presence on the bridge but believe it to be that of a messenger racing to the Hall during the Wars of the Roses and whose horse died beneath him. When the Hall was open to the public, American visitors particularly reported often hearing the sound of furious horses' hooves. At one time Tudor Cottage itself was an antique shop and poltergeist activity was reported here.

Despite that fact that the Hall is no longer a private residence or open to the public and some of its haunted corners are now occupied by photocopiers and fax machines, it still maintains an air of charm; a fascinating place of secret corridors, sliding panels and hidden rooms.

MARKYATE

Manifestation: Wicked Lady Rides Again

History:

Perhaps Markyate is best known for its notorious inhabitant, Lady Katherine Ferrers. This wayward, spirited female, famously known as 'The Wicked Lady', inhabited the mansion of Markyate Cell by day but after dark she would secretly don the cloak and mask of a highway robber and thus disguised as a man, mounted on a coal black horse, would rob travellers on the treacherous roads of Hertfordshire. Katherine, Lady Fanshawe, nee Ferrers, maintained this double life for some time, undiscovered until a fateful encounter near Nomansland at Wheathampstead, where she was shot and fatally wounded. Her horse managed to take her back to the secret doorway leading to her chamber, where she was found lying dead on the stairway. The doorway was subsequently bricked up and remained so until after a fire in 1840 when a hired gang of labourers from London broke it down. It was these workmen who claimed to have seen the ghost of Lady Ferrers swinging herself on a branch of a large sycamore standing near the house.

A substantial amount of treasure is fabled to be buried under the said sycamore tree, immortalised in a local rhyme:

Near the Cell there is a Well
Near the Well there is a Tree
And 'neath the Tree
The Treasure be.

Lady Ferrers was also seen near the kitchen chimney of the Cell and in recent times, a cloaked figure on horseback has been glimpsed pelting across the barren Nomansland Common, near Wheathampstead, and surrounding countryside on moonlit nights. (*see Wheathampstead entry*)

It appears builders are a very psychic bunch. In the late 1850s, more builders were working at Markyate Cell, this time repairing a wall, when they saw the figure of a nun walking in the direction of a

42. *Markyate, Markyate Cell.*

gate in the wall. She then disappeared. Knowing that this gate had not been in use for years, the men made an inspection and found that the gate had indeed not been opened for a long time. However, the nun was seen frequently after this at the Cell and walking in the avenue in the grounds near St. John's Church.

The Cell stands on the site which was once the Priory of Benedictine nuns, founded in 1145 and dissolved in 1537. Much alteration has taken place to this manor house over the years, but the original building dates from around 1539. Perhaps the nun that was seen by the builders has been walking the grounds for nearly a thousand years.

A report in a scrapbook of local newspaper cuttings claims that a baronet staying at the Cell fell asleep one evening, only to be rudely awoken feeling that someone had placed their hands on his shoulders and was trying to force him from his chair. Angrily resenting the intrusion, he swung his arm round to push the hands away but to his amazement encountered nothing. The grip on him released and he stood up and looked around. There was nobody in the room. The report ends with the statement, 'What better evidence of ghosts can be needed?' What indeed.

Manifestation: Figures in the Darkness

History:

In the 1930s, a water mains company were engaged on extension work in the **Hicks Road** area of Markyate. When the workers arrived early on the Saturday morning they were met by an uneasy night watchman who told them that at some time during the night he had seen an apparition walking along the Hicks Road by the side of the workmen's string of red lamps. He described the apparition as male who walked, looking neither right nor left, past the watchman's hut. The workers were ruthless in their scorn of the watchman until the following Monday morning when they unearthed two skeletons lying head to toe. Whether these hidden remains had any connection with the apparition seen by the watchman we will never know. Speculation as to the

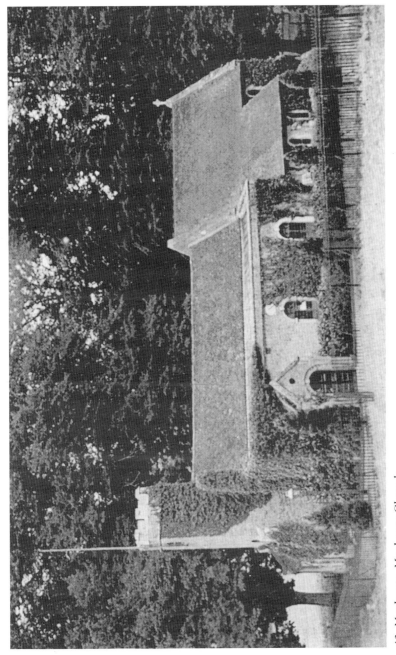

43. Markyate, Markyate Church.

origins of the skeletons ranged from victims of the Civil War to those of Dick Turpin who was rumoured to use the neighbourhood of Hicks Road frequently on his robbery run.

A taxi driver in the 1970s had the fright of his life when he thought he had hit a pedestrian outside the **Packhorse** inn on the A5 near Markyate. 'He was six feet tall, dressed all in white like a cricketer and suddenly stepped out in front of the car. I braked hard, but I was going too fast and went right through him.'

But when he parked the car and went back to find the body, there was not a sign of anyone and the car was free of any dent or scratch that would have occurred with such a collision.

The ghostly cricketer was thought to be that of a man killed whilst returning from a match at Woburn Abbey in 1958. Near the Packhorse, two team members were overtaking on the bend and crashed into an oncoming vehicle, two were killed and three injured. Other drivers since the fatality have reported seeing a man in cricket whites standing on the roadside near the pub, but just assumed it was someone hitching a lift after a post-match drink.

In the early 1990s, two local people were travelling along the **B4540** from the A5 past Markyate Cell leading up the unlit hill towards Luton. Both saw a white hooded figure walking along by the fence and vanish in front of their eyes.

Manifestation: Shattering Vision

History:

One rainy autumn night, Marion, a St. Albans lady, and her passenger were stuck in a traffic jam on the A5 passing Markyate Cell. As the line of vehicles crawled along ahead of her, they were suddenly startled when a horse and rider galloped across in front of the car. The rider was accompanied by a person on foot, who stumbled and put a hand out onto Marion's car bonnet. What happened next was unbelievable.

'The whole image of horse, rider and person on foot just shattered in front of my eyes', said Marion. 'It was like a huge crystal shattering into thousands of pieces and then they were gone.'

Stunned, Marion got out of her car to investigate, but there was nothing on the road to give evidence of what she and her companion had just witnessed. As she returned to her car completely bewildered, the driver from the car behind came racing over to her.

'What the hell was that?' he yelled. So Marion and her passenger were not the only ones to experience such a strange vision.

MUCH HADHAM

Manifestation: Vengeful Ghost

History:

This village set in lovely Hertfordshire countryside, is one long street of charming cottages, Georgian houses and quaint little shops. Its title is believed to date from Saxon origin and the village had the privilege of accommodating the Bishops' Palace until 1746, where the clerical elite would spend their summer months in rural retreat. Amongst others, Bishop Nicholas Ridley lived at Much Hadham whilst trying to convert Princess Mary to Protestantism when she lived at Hunsdon. Obviously his efforts were wasted as in 1553, when she became Queen, the displeased Mary had him burnt at the stake.

But like every delightful historic village, Much Hadham has its dark side and this can be found every February 13th when a wraith known as the Moat Lady appears and attempts to lure unsuspecting victims to their death. This vengeful spirit is supposedly that of a young woman who was murdered and her body dumped unceremoniously in the ancient moat at Moat Farm. When the moat was drained, her bones were uncovered and given a Christian burial but this doesn't seem to have satisfied her spirit as she still prowls the area on the eve of Valentine's day looking for victims.

In 1938 a one act play entitled 'Moat Lady' by Percy Ilott was published, allegedly based on this local ghost story.

Manifestation: Some Troublesome Spirits

History:

Before it was converted into the manager's residence, the back bedroom of the **Bull** inn was so troubled by a spirit that nobody could sleep there. If anyone tried settling down for the night, the ghost would tug off the bedclothes. Customers in the bar have also complained about being poked and prodded when nobody was nearby. One of the bar staff saw the shadowy figure of a man in a large hat and cloak walk across the bar.

In dwellings which were once part of the **Red Lion** inn, the ghost of a gentleman in brocade coat, knee breeches and buckled shoes has been seen many times in recent years. The Red Lion was built as a posting house in 1450 and subsequently became known as The Angel prior to becoming the Red Lion in 1720. The building has a colourful history; the ubiquitous Dick Turpin supposedly escaped from the inn through a secret passage and in the 1920s, during redecoration work, a pitiful heap of bones was discovered by workmen, believed to be those of a young girl. The inn has been closed since the 1980s and the premises split up into separate dwellings.

A **cottage** in the village was also on the receiving end of poltergeist activity and in November 2001 it became so disturbing that the family were forced to call in the local rector to bless the house.

NUTHAMPSTEAD

Manifestation: Phantom Regular

History:

The Woodman public house has a regular who never orders a drink, yet can be seen pulling up a chair and settling down for the evening. In 1980, the landlord was sitting at a table in the bar and watched open mouthed as the chair in front of him drew into the table as if pulled up by an invisible hand. He was so astonished that the only thing he could

44. Much Hadham, The Bull Inn.

think of doing was to look under the table to check for trickery, but there was none.

This is not the only odd occurrence in this 16th century inn, pictures continually drop from the walls for no reason, footsteps are often heard upstairs when everybody is downstairs in the bar and customers have complained of the feeling of someone standing alongside them at the bar when they are in fact alone.

A tiny old lady with beautiful silver hair has been seen walking through the bar but is this the mysterious presence or is there another ghost in the inn that is connected with the Second World War? When the pictures repeatedly fall down it is always the one of a B17 American bomber which made a miraculous return to its Nuthampsted base after a large hole had been blown into the nose of the machine, killing the bombardier.

PIRTON

Manifestation: Headless Horseman of High Down

History:

Tudor High Down House stands alone on a wooded knoll on the outskirts of Hitchin, its old leaded windows gazing over the rural Hertfordshire countryside. It was built by the Dowcras family from Lilley around 1510 and is the perfect fantasy house, an enigmatic network of secret passages and nooks and crannies.

On the night of June 15th every year a headless Cavalier rides a white horse from High Down House to Hitchin Priory from the tree where he was murdered, to the site of the old cell. His wretched wraith is also rumoured to descend from the tree and run down the avenue clutching his head in his hands.

This poor unfortunate soul was once a soldier by the name of Goring, who had been visiting a lady friend at High Down in the summer of 1648 when the Parliamentary troops came seeking out Royalist soldiers. He made his escape from the lady's chamber using a

45. Pirton, High Down House.

secret underground passage (which is said to still exist) and hid in the hollow of the wych-elm outside the gateway to the priory. Unfortunately he was spotted by the troops and dragged to the foot of the tree and hacked to death in cold blood within sight of his lady friend's bedroom window. The girl collapsed and died of shock shortly afterwards and subsequently, her unhappy wraith has been seen in the courtyard bedroom.

In the 1980s, a young man who did not know the story, was sleeping in this bedroom when he was awoken by a beautiful girl who seemed to sit on the edge of his bed all night.

Manifestation: Knocking Knoll

History:

A small earthwork at Pirton has acquired the title 'Knocking Knoll' because at certain periods, three loud and distinct knocks are heard emanating from beneath. Tradition tells of a warrior attired in armour who was buried in the knoll, his treasure chest interred beside him.

Manifestation: Ghost in a Hurry

History:

At Ivy Cottage in the 1950s, an elderly lady resided with her daughter. Visitors to the cottage reported a 'spooky feeling' and footsteps could be heard running around the house. So afraid was the daughter that she would wedge a piece of furniture under her bedroom door handle at night.

One summer afternoon the daughter had begun wallpapering one of the rooms when she heard a noise near the window. As she approached, two rolls of heavy wallpaper that she was carrying were lifted from her grasp and flung some feet away. Something rushed past her in a terrible hurry, yet no-one was in the house on this still, summer's day.

RADLETT

Manifestation: Recurrence at Wagon and Horses

History:

On the Elstree to Radlett road stands an old hostelry called the Wagon and Horses. One winter in the mid 1980s, on at least three occasions, a motorist reported observing a strange scene taking place opposite the inn. A man dressed in knee breeches, jacket and a tri-corn hat would help a lady in a grey dress down from a waiting coach, complete with horses, and they would cross the road and disappear into the inn.

REDBOURN

Manifestation: Black Bend

History:

On the St. Albans to Redbourn road beside the Pré Hotel is a treacherous bend where many motorists have come to grief over the years. Some report a strange feeling whilst driving past this spot and others have developed mysterious car faults at this point in the road which clear up as soon as they are back on the straight.

In the days before cars, it seems this location was already causing problems. The horses in a brewer's dray refused to pass the trees and the vehicle had to be turned around back homewards. In the early years of the 1900s, many people remember the story of a ghost here, although no specific details are given.

The Pré bend claimed another victim in 1978 which has an uncanny link to the following story of the next haunting in this journey through Hertfordshire's ghosts.

Manifestation: Bizarre Twists at the Bull

History:

The story of the **Bull** inn at Redbourn has more twists and turns than any good fiction novel which includes the former landlord battling with paranormal events and then becoming one of the suspected ghosts himself.

Howard Upton was the landlord of the Bull in the 1970s. During his time there, the building was in danger of collapsing. Four hundred year old timbers in the roof and walls were found to be rotting and on the verge of falling down. But weak beams were not the only problem Mr Upton had to face in this historic building. One of the bedrooms, known as the Blue Room, was always cold and whenever anyone tried to sleep there, covers would be yanked from the bed. This happened on more than one occasion to Mr Upton's niece until she refused to sleep there. A baby monitor also picked up strange noises, voices and a woman's crying coming from the room. When the pub was a hotel, a little girl staying in the room saw a ghostly lady, and two builders refused to pay their bill after a bout of ghostly activity left them feeling someone had been playing tricks on them.

Legend tells of a woman who lay in bed with pneumonia in the room and because her fever was so high, the covers were pulled off her bed to cool her down which resulted in her death. The Blue Room today is not blue at all, but its ceiling is much lower than any of the other rooms in the building, creating a claustrophobic feeling.

Tragedy struck on the 20th April 1978. Mr Upton was driving along the A5 towards the Pré bend, when his car suddenly went out of control and he veered across into the opposite lane and straight into the path of an oncoming car. He died instantly. There were no eyewitnesses to this tragedy and no explanation was found for why the car lost control.

Subsequent successors to the Bull after Mr Upton's death have reported further strange activity in the building, mainly when the clearing up is being done at the end of the night. In the public bar, a female member of staff was tapped on the shoulder and when she

146

46. Redbourn, The Bull Inn.

looked round, there was nobody there. This happened several times and she abandoned the bar in a state of shock.

One morning in 1999, Barry, the landlord at the time, changed the kegs and cleaning rig in the cellar. He went back up to the bar but found nothing was working. When he returned to the cellar to investigate he discovered the gas reading was at zero yet the gas bottle had been turned on. He knew he had turned the gas bottles off himself a few moments beforehand and as no-one else was in the pub there seemed no explanation for it. 'I had this feeling it was Howard Upton making his presence felt', said Barry, 'it's the kind of action only someone familiar with pub equipment would carry out.'

That same morning, a plumber turned up to do some work in the pub and by chance asked Barry if he still had the ghost that turned the gas bottles on as he had worked as an apprentice in the Bull just after Mr Upton's death and subsequently he knew of three managers to have experienced strange goings-on with the gas bottles.

To add further to Barry's beliefs that it was this former pub landlord who was behind the inexplicable events, an ornamental shield belonging to Upton would move around in the bar. 'You'd put it down in one place and come back five minutes later and it would have moved somewhere else with no-one touching it.' One day the shield flew off the shelf by itself and hit Barry in the back.

After closing one night, Barry had some friends over and they were sitting in the snug bar having a drink. One of the friends saw a figure moving nearby and they conducted a complete search of the pub, but there was nobody there but themselves. A loud banging noise can be regularly heard from upstairs when no-one is up there and Barry's dogs refuse to go down to the cellar. 'One day the dogs were going mad at the top of the cellar steps as if there was someone down there, but when I tried to get them to go down and search the cellar, they refused and one of them was so frightened he actually bit me!' said Barry.

Apparently there is one particular day of the year when the most activity happens. Coming down in the morning, Barry has discovered chairs and tables neatly stacked in the middle of the public bar when he had been the last one to leave the bar the previous night, problems

with electrical equipment and objects flying around off the shelves. Unfortunately Barry could not remember which day this was.

RICKMANSWORTH

Manifestation: Manifestation in the Moonlight

History:

During the Second World War, Lilian Carpenter was returning home to Rickmansworth late one evening having met with her fiancée in London. Lilian describes the scene, 'The walk from Rickmansworth station to where I was living at Long Lane, was a considerable one. On this particular night there was strangely no sound of gunfire. I was about 200 yards from where I was living when I heard a nearby church chime midnight. A bright full moon was shining, lighting up the lane when suddenly a headless, draped figure appeared about 50 yards in front of me and moved steadily towards me. Before reaching me, the apparition veered off into a very thick hedge and disappeared.'

Lilian ran the rest of the way home and in the security of daylight, told her story to her employer who informed her that the adjacent property called 'Lady Walk' had been the scene of a lady's murder in the 1800s and that at certain times her headless apparition would appear. Lilian must have been in just the right place at the right time.

Manifestation: Rattles in the Wind

History:

Leavesden Aerodrome has now long gone, making way for film studios, producing epics such as James Bond movies and more recently Harry Potter. But when the aerodrome's hangars used to back onto the main road, number 2 hangar had a haunted reputation. In around 1941, gale force winds were battering the county. An RAF corporal was opening hangar 2's door with the chains, which were attached to a ratchet, when a violent gust of wind seized the door and blew it down on top of

him. On windy nights, the Corporal's ghost walks abroad and the chains can be heard rattling, even though there are no chains there now.

Manifestation: Playful Presence

History:

A mischievous spectre haunts the 500 year old Feathers pub. One afternoon in 1985, the landlord, Percy Cross, was dozing in a chair when he was startled from sleep by a balloon being burst in his face. He leapt up but there was nobody around. A search of the pub revealed no sign of the culprit.

The barmaid felt a friendly presence enter her room in the early hours of the morning but another member of staff has had objects thrown at her.

Manifestation: Run-in with a Ghost

History:

In the 1930s, a man in the Watford Army cadets was cycling along Moor Lane to meet some friends when suddenly a ghost appeared in the road in front of him. Unable to stop in time, the cyclist swerved violently but still rode right through the apparition. When he finally got to his friends, he was white faced and breathless. The group speculated that perhaps the ghost was somehow connected to the old 'Manor of the More' which was situated off Moor Lane way back in the 8th century.

Manifestation: Time Frozen

History:

Ghostly footsteps were often heard in the old Swan Hotel and an old man would be seen roaming around the upstairs area, frightening staff and guests alike. Years later the hotel is gone and a frozen food supermarket stands on the site. Staff at the store have complained of being touched by invisible hands in the staff room and of feeling a presence around the

47. Rickmansworth, The Feathers Inn.

toilets. Both these areas are on the upper level of the building which is where the old man used to be seen. Another example of ghosts surviving longer than the buildings they originally haunted.

Manifestation: Grumpy Ghost

History:

In May 1970, a house in Croxley Green, near Rickmansworth, was troubled by poltergeist activity. Workmen fitting a new bathroom arrived for work one morning to find all their tools lying in the garden as though they had been flung there, but the doors had been firmly locked. Glasses, crockery and cutlery were thrown from the cupboards and smashed against the wall and footsteps were often heard overhead when there was nobody present in the house. A lady living at the house was convinced she saw a figure follow her down the stairs.

Manifestation: Admiral's Walk Amongst the Winds

History:

Rickmansworth's best known house is that of Moor Park mansion. It was here in the mid 18th century Lord Anson, famous as circumnavigator and naval commander in the rout of the French fleet off Cape Finisterre in 1747, retired. Here he built a stone temple and called it his 'Stone Temple of the Winds' of which his friend Dr Samuel Johnson wrote:

A grateful wind I praise;
All to the winds he owed,
And so upon the winds
A temple he bestowed

Ironically, the Temple was blown down in a gale in the early part of the 20th century but the old Admiral's ghost still enjoys a stroll amidst the ruins.

48. Ridge, Tyttenhanger House.

49. Ridge, Sir Henry Blount.

RIDGE

Manifestation: Ghost of Old Sir Henry

History:

Tyttenhanger House is a curious mansion house, lying between London Colney and Ridge. Originally a house was built here between 1396 and 1411 and was once the property of the monks of St. Albans. Many famous feet passed over its threshold including King Henry VIII and Catherine of Aragon. The house was then beautifully restored complete with Jacobean wood panelling and has long been haunted by the ghost of its previous owner Sir Henry Blount (1602-1681) who undertook the renovations in 1654. The rustling of his satin dressing gown pervades the centuries as he passes along the passageway on the second floor and into what was once his private study. Today Tyttenhanger House has been refurbished and is a business establishment.

ROYSTON

Manifestation: Frightening Events at the North Star

History:

'I am scared of the strange things that go on here', landlady Avril Roberts of the North Star inn confided to the local newspaper in 1992. And not surprisingly, as a string of unexplained incidents had dogged her and her husband from the moment they took over running the pub in 1991.

Things would disappear and reappear in unlikely places, pub electrical equipment would suddenly switch off during busy times, keys would vanish and then appear days later and objects move about seemingly by themselves. The pet dog would howl chillingly at a particular patch of wall and not allow Avril to stand between him and the wall. On other occasions, he would rush from a room with hackles raised. The bedroom is troubled by an unexplained tapping and one night a foul odour enveloped the bed with swirls of cold air.

As with most incidents in pubs, it is the cellar that appears most troublesome. A key to this part of the building vanished from the door lock and was found behind a small sink. Every one of the eight gas taps keeping beer flowing to the bar was suddenly switched off, rat poison, which had been cleared from the cellar, was found prominently displayed on a beer barrel but strangest of all was when an ice machine that had been full and working perfectly, was discovered minutes later by bar staff to be empty and switched off.

It wouldn't be unusual for the cellar to be found unlocked and with all the lights ablaze in the morning when staff came to open up, yet the same staff had turned lights off and locked the cellar only a few hours before. One wonders what exactly is haunting the North Star and what its activity is trying to convey to the residents of the pub.

Manifestation: Nocturnal Occupants of High Street

History:

At night just as most people are dropping off to sleep, the ghosts of the High Street are waking up. Figures run wildly up and down the street and phantom footsteps can be heard echoing on the empty pavements.

The ghost of a man who hanged himself in the doorway of a shop is said to return at night and scare the current residents. **Rolph's Garden Supplies** occupied the premises at one time and staff experienced the sound of footsteps when no human has been present, also objects being moved and tipped off shelves. The owner, Richard Rolph, was alone in the shop one night. 'I was up late painting and suddenly all the hairs pricked up on the back of my neck and I just had the urge to get out of there as quickly as possible'.

At 17 High Street, **Curwen, Carter and Evans** solicitors have a grey lady who roams the offices, again at night. One of the upstairs rooms, once called the Tudor Room, is always cold and has a feeling about it which makes staff disinclined to linger. This room has reported most sightings of the ghost and was where a hoard of bones was once discovered under the floorboards.

50. Royston, High Street.

In nearby **King Street**, a lady believes her home is haunted by an old woman and the business next-door is built on part of her garden and cleaners there have been frightened by the same figure.

At the old **post office** building, the sound of chopping wood has been heard late at night and the **Manor House** across the road has inexplicable noises of glass breaking and doors banging when no-one is responsible.

Manifestation: Henry Ghosts in at Hotel

History:

Banyers Hotel on Melbourn Street is an ivy covered building dating back to the 18th century, listed as a hotel in 1933. Parts of the building were once a vicarage and it takes its name from the Reverend Banyer, vicar of Royston from 1739 until his death in 1751, although according to the brochure, there has been a country residence on this spot since the reign of James I. The Banyers ghost is Henry, (seemingly a popular name for ghosts) reputed to be a Cavalier who removes his cape and bows gracefully when coming face to face with humans. Henry particularly haunts room 4 and is so much a part of the hotel, that a decision was taken not to modernise this room when refurbishment was taking place elsewhere in the building.

SARRATT

Manifestation: Midnight Visitor

History:

In 1897, on a gloomy Sunday in November, a professional gentleman mounted his horse and set off on a journey from London to the Hertfordshire village of Sarratt. On the way, a storm broke and the traveller arrived at his friends' residence of Rose Hall some hours later, tired, wet and cold.

That evening he fell gratefully into bed and was soon asleep. He was awoken not long after by the violent barking of his host's dogs. Managing to drop off to sleep again, the man was woken a second time around 2 am by the feeling of extraordinary pressure on his feet. In the half light, the traveller saw the figure of a well dressed man in the act of stooping and supporting himself on the bedclothes. The man wore a blue coat with bright gilt buttons but seemingly had no head. Startled, he sat up in bed as if to enquire the business of his night visitor, but as he did so, the figure disappeared and it was then he realised that the bedroom door was still locked as he had left it before retiring.

The next morning at breakfast the traveller mentioned his midnight intruder and was shocked to discover from his hosts that the room in which he had sleeplessly spent the night, was where a gentleman had been murdered some years before, his head being severed from his body. It later transpired that many people had seen this apparition.

There has been a manor on this site since the 12th century, according to the *Victoria County History*. One of the first tenants of 'Rooshall' was Geoffrey de Siret who was one of the knights of St. Albans in 1166. It later became a farm. Long term resident Ron Higgs is convinced the building is haunted and says there is an uncomfortable feeling inside the house and dogs would never venture upstairs. Ron says he had heard that the ghost is in fact a headless monk. Perhaps this may have some connection with a supposed monastic building in the grounds that burnt down.

SAWBRIDGEWORTH

Manifestation: Unidentified Phantoms

History:

A motley collection of unidentified ghosts appearing in a flat above a shop, have left the owner puzzled and confused about the reason for their visits.

Elderly resident Freda Byers lived in Bell Street in a flat above a shop that was originally three old cottages dating from around the time of the 17th century. In the mid 1990s, Freda began to be visited by strange apparitions. They would appear in the same room and always in the afternoon. Two women dressed in Romany outfits, one in a bright green cape, some sort of wild animal and a little boy with a wound over one eye would come and go regularly over a period of about two months, leaving Freda Byers baffled as to what message they were trying to convey to her from beyond the grave.

Manifestation: For the Love of a Horse

History:

An even more bizarre spectre in the village is that of Sir John Jocelyn, Lord of the Manor at Hyde Hall, riding at full speed down the avenue near the church on a charger which breathes fire. Tradition states that in the 18th century, Sir John quarrelled with the Vicar because the latter refused his request to be buried alongside his beloved horse in consecrated ground. Sir John therefore, left instructions that he should be buried without coffin or shroud in his park and the horse should be slaughtered and buried with him.

Sir John died without issue in November 1741 and was duly buried in his chosen site of a circle of yews in the grand avenue to Hyde Hall, with no stone or memorial. However, it is not stated what happened to his cherished charger.

Manifestation: Mystery Airman

History:

A man driving to work in the mid 1990s saw the apparition of a man resembling an American airman, in flying gear, on the roadside near the front gate to Warren Farm. The apparition was seen on more than one occasion by both this man and his wife as they travelled to and fro on the road passing west of the airfield.

Contemporary research revealed that the only fatality concerning an American in that area occurred on 3 April 1943 and involved a Lieutenant Smolenski, pilot of a P47c Thunderbolt. The aircraft suffered engine failure and crashed into a field near to Green Tye. Smolenski died in the crash fire.

SHENLEY

Manifestation: Nocturnal Nuisance

History:

A cottage in the grounds of the former Napsbury Hospital was haunted by the ghost of an old lady who caused the mortal occupier endless sleepless nights. Friends would come to the house, see a doorknob turning by itself and flee, refusing to set foot in the house again. Pet cats and dogs would dash up the stairs, stop dead half way up and turn and run down again as if something panicked them. In the middle of the night, footsteps could be heard climbing the stairs, slowly and painfully then pause, as if someone was catching their breath, and continue upwards until reaching the bedroom door, then the handle would slowly turn and a grey figure shuffled into the room. The duvet would then be torn off the bed and the occupant woken for the rest of the night. In the end, things became so troublesome that the female resident resorted to surreal negotiation with the apparition in the middle of the night, begging it to let her have some sleep. She said she

had nowhere else to go and they had to share the house somehow. This was all done very politely and she saw the old lady materialise at the foot of the bed and then slowly dissolve. Although the ghost still remained in the house and was often heard or seen coming out of the wall to stand with her back to the fire, nights became relatively peaceful afterwards.

SOUTH MIMMS

Manifestation: Visions at the Vicarage

History:

One night in the late 17th century, the Vicarage rang out with a woman's screams. It appears that the vicar finally lost his temper with his cantankerous wife and battered her to death with a poker.

Three hundred years on and the vicar complained of being awoken in the early hours, conscious of a presence in the 14th century Vicarage. He repeatedly had the sense that he was not alone and later discovered he had chosen to sleep in the very room where the murder took place.

His aunt came to stay and claimed to see a tall woman in a grey dress walk down the stairs. This apparition has been sighted by other people in South Mimms over the years. Nurses working at a nearby sanatorium in the early part of the 1900s were frightened by a lady in grey.

In the church itself, a parishioner reported seeing a priest kneeling at the altar rails and watched in amazement as the figure rose and vanished through the vestry door. Several people, when passing the churchyard late at night, had heard strange noises coming from one of the tombs, over which gruesome blue lights were moving to and fro. The crossroads in the centre of the village is the chosen haunt of a bent old man with a long grey beard and who raises his stick as a salute to the villagers as they pass by.

51. South Mimms, South Mimms Church.

Manifestation: Weird Wraiths at the Wash

History:

On the old Roman Road lies a spot known locally as the Wash. It was described by Elliott O'Donnell in his book 'Ghosts of London' as 'a strip of low-lying, swampy ground with a certain eeriness about it after dusk.' In the mid 1900s, a man crossing the Wash saw a strange figure, something like a cross between man and beast, rise from the ground, leap over the bridge and disappear into the mist beneath. The man took to his heels and ran.

The ubiquitous Dick Turpin also haunts this area, according to tradition, and in a nearby field one autumn around 1930, the body of a tramp was discovered. It appeared he had died from heart failure, but there were some locals who swore he had been murdered and subsequently the rumour began that the spot was haunted by ghostly lights and a headless man.

But the tramp was not the only person to be found dead in the field under mysterious circumstances. In March 1861, the body of a woman was discovered in a ditch and identified as a haymaker who had been missing for some months. Cause of death was never ascertained and local gossip persisted that foul play had occurred. Once again villagers shunned the spot where she was found, believing it to be haunted.

ST. ALBANS

This ancient Roman city is steeped in history and bursting at the seams with ghosts. Most houses, old and new, seem to have a presence lingering from a time long past. One modern council house in the Cottonmill area has a departed spirit who leaves deep, long scratchmarks in the wood of the occupant's wardrobe and bed-head.

Let's take a tour around the city, a gourmet guide for ghost hunters.

Manifestation: The Apparition of Mother Haggy

History:

One of the city's oldest tales was that of Mother Haggy in 1712, a dangerous time for anyone vaguely displaying any attributes of witchcraft. Mother Haggy was apparently renowned for her mighty pranks whilst alive and her apparition after death reportedly made such a noise and was so troublesome that, 'People to this day cannot bear mention of her name without the most dismal apprehensions.' So what did this old Albanian woman do that was so dreadful?

Mother Haggy married a yeoman and lived in good repute for some years. At the birth of her daughter, Haggite, a merry-making ensued during which the old woman's high crowned hat seemed to take on a life of it's own and leapt into her daughter's cradle, metamorphosed into a coronet before breaking into a thousand pieces. 'Such', Mother Haggy said philosophically, 'will be the fortune of my daughter and such her fall.' This occurrence is vouched for, so it is written, by a clergyman. Mother Haggy went on to display a gift for telling fortunes and discovering things lost or stolen and after her death was often seen riding at full gallop on her broomstick at noonday and swimming the river Ver on a kettle-drum. This amazing woman also reputedly had the ability to transform herself into any animal she chose.

Manifestation: Monks Business

History

The great Abbey of St. Albans has a commanding presence and it is here that the historical seed of the city was sown around the 3rd or 4th century when Alban, proto-matryr of Britain and the city's namesake, was beheaded by the Romans and in AD 793 a magnificent monastery was constructed on the site of his execution. The Shrine of Alban, housed in the Abbey, was a great centre of pilgrimage and was adorned in gold, silver and jewels together with the discarded crutches of those who had miraculously been 'healed'.

52. St. Albans, St. Albans Abbey.

53. St. Albans, St. Albans Abbey.

There are numerous stories of spectral music emanating from the great walls of the building. One summer evening, a lady passing the Abbey heard beautiful music and choral accompaniment so decided to slip in a back door and enjoy the music from inside but on finding the door locked, as soon as she touched the handle, the music immediately stopped and the Abbey stood in eerie silence. She pondered awhile just to make sure the place was really empty and far from being afraid, felt privileged for it's not every day you encounter an entire phantom orchestra.

Again, in the 1930s, Canon George Glossop had heard music on one occasion when he was completing a sermon in his home, Romeland House, alongside the cathedral. The music grew louder and louder before fading away. Three months later, during a performance in the Abbey of the music of Dr Robert Fayrfax, doctor of music of Oxford and Cambridge, who lived at Bayford, and was organist at the Abbey in the late 1400s, Canon Glossop recognised it as the music he had heard that night before. Fayrfax had died in 1529 and was buried in the Abbey.

Canon Glossop must have had an ear for music beyond the grave as one spring morning after the First World War, he was walking towards the Abbey when he heard organ music. Puzzled as to who could be inside the building so early, he slipped in the side door and as he approached the organ loft, the music abruptly stopped and he found the seat was empty.

It was Christmas Eve 1944. A Firewatcher on duty throughout the night at the Abbey witnessed something that could have been lifted straight from the pages of a Victorian ghost story. Bells began ringing when no hands tugged at the bell ropes, a candle lit by itself and the shadowy figure of a cowled monk wisped just out of vision. But the most frightening thing was when the great organ began to play; the keys being depressed by unseen hands and sheet music turned when the seat remained empty. If that wasn't enough, a spectral ghostly choir piped up to accompany the music.

It appears that this historic building has been the focal point for a large amount of energy over the centuries and its ancient stones are acting like a giant generator, playing back the past when conditions are

right. Other strange phenomena experienced here when the building is empty after dark, include lit candles and figures of monks moving about in the Watching Gallery, the unmistakable smell of incense and dark figures flitting in the shadows.

Countless sightings of monks are also predominant here. Processions of monks walk the aisle of this great building and then melt back into the past. Several pairs of eyes silently look down from the darkness of the Watching Tower, built so that the monks could observe the Shrine and ensure nobody robbed it of its precious booty. Also outside, passing from the Great Gateway to the west front of the Abbey, four, tall grey monks have been seen swaying slowly from side to side and appeared to be carrying a coffin. Inside the modern Chapter House a gloomy figure dressed in a grey habit, with head cowled and hidden has manifested many times in the Hudson Library. He was seen meandering in the same spot before the Chapter House was built in the early 1980s.

In 1872 a young girl called Lilian was a ward in **Sopwell Nunnery** and had come to be married in the Abbey against the wishes of her family. The bridegroom was a Sir Ralph and the tale goes that he was murdered by her brothers on his way to the Abbey. His ghost appeared to the wedding party and the shock was too much for the bride who dropped down dead on the spot. Her bridal wreath was preserved in the Abbey until the mid 20th Century.

Adjacent to the Abbey stands a row of ancient cottages on Romeland Hill. One of these, **Romeland Cottage**, was occupied by Francis Skeat and his family. Francis later went on to design some of the stained glass windows of the Abbey itself. Romeland Cottage is believed to have been built on the site of the Abbey's Charnel House where in Monastic times, the bodies of monks were laid awaiting burial. Mr Skeat's parents moved to the cottage in 1903 with their 3 children and Swedish maid Hilma.

One night, Hilma was making her way up the narrow stairs to bed, carrying her candle in her hand. Half way up, she became aware of a presence close to her and she found herself pinned against the wall. The candle was blown out and she was left in darkness. A cowled figure

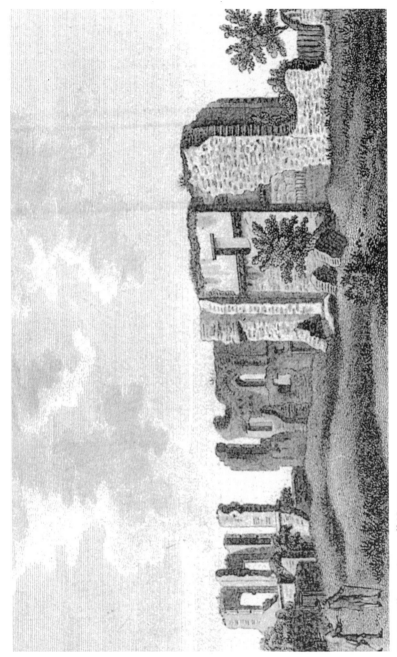

54. St. Albans, Sopwell Nunnery.

170

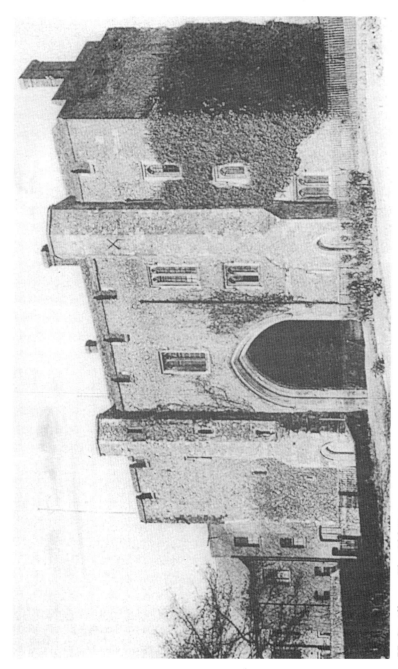

171

began to grow visible in the darkness and spoke to her in a language, later recognised as Latin. Eventually the figure vanished only to return the next night. This time Hilma was asleep and woke suddenly to see the figure in the moonlight, a metal medal glinting around his neck.

Mr Skeat's father called in Canon Glossop of the Abbey who came and spoke to the frightened maid. From her description, he recognised that the medal was similar to those given to pilgrims to the Abbey centuries before.

Staying in the Romeland area is **St. Albans School** in the shadow of the magnificent Abbey Gateway. A long dead caretaker's hobnailed boots have been heard clomping through the empty school corridors in the last few years. He seems particularly objectionable to building work taking place, as when the old biology department was being rebuilt he became noticeably active.

The **Gateway** itself reputedly has a ghost or two, unsurprisingly as for 500 years it was a prison. Screams and windows opening and shutting by themselves have been heard here.

Manifestation: In Every Nook and Cranny

History

Holywell Hill (once known as Halliwelle Streete) was originally the main route into the city from London. Coaches would climb the steep incline and travellers would get their first glimpse of the Cathedral and know they would be able to stop for rest and refreshment at one of the many taverns which lined the Hill in virtually an unbroken line. One of the first inns on the corner of Sopwell Lane, where coaches first entered the city, was the Crown and Anchor, a spectacular galleried inn. This beautiful Tudor building is now **Strutt and Parker** estate agents and the original 14th century gallery was later discovered lodged into a newer wall, its timbers still intact. The design revealed a series of small lodgings, each with a separate door.

Coming into the office early one morning, Leo Hickish, partner at Strutt and Parker, was grabbed by a colleague who anxiously pointed

out fresh, wet footprints on the flagstone flooring at the bottom of the stairs. They were alone in the building and neither had arrived for work barefoot and there seemed no explanation for this odd occurrence. Standing in the shadow of the old cathedral, as an inn, the building was once a hostelry for those on pilgrimage and one might speculate that perhaps these spectral footprints were perhaps belonging to an ancient visitor from the past. A further monastic connection can be made in the house next-door. Now a separate, private dwelling, this house once formed part of the Crown and Anchor. In the 1980s, the former owners learned to share their home with a ghostly monk, often seen standing beside the fireplace in the lounge, who became part of their family and was even a source of peace and tranquillity in times of stress.

Around the end of the 1990s, one of the estate agents was working in the upstairs office. He was about to pack up and go home for the day when he was startled by the gaunt face of a young woman suddenly appearing between the filing cabinets. The man rushed downstairs, ashen faced to report to colleagues what he had just seen. By all accounts this was a burly rugby playing man who was not the sort easily scared. The face had appeared at a window where the original open gallery had been closed in. During recent filming in this part of the building, a camera power pack physically switched itself off and an unseen hand turned lights back on after they had been most definitely switched off. Many of the weekend staff at the office have felt uncomfortable going into the upstairs area and have felt eyes watching them as they move around.

One of the main ghosts is said to be that of a Cavalier who sits beside the large downstairs fireplace and smokes a clay pipe. Leo Hickish and others of his staff have often reported sensing a thick column of pipe tobacco that moves its way around the office.

Early one summer evening, a team of paranormal investigators arrived at Strutt and Parker. The building was filled with streams of late sunshine filtering through the leaded windows and onto the ancient beams. Dowsing rods seemed to suggest that the building was

constructed on an area of ley lines, or energy channels which could be harbouring the ghosts. The team's clairvoyant, Marion Goodfellow, immediately sensed a stocky fellow in the cellars whom she 'saw' wearing a big wrap-around apron like a butcher's or a dray-man. Marion knew nothing of the history of the building, or that it was originally an inn until the 1950s. In the upstairs office she received the impression of a lady, which Leo later confirmed was at the same spot his former colleague had been frightened by the face in the wall. Marion detected a gentleman gasping for breath and felt he passed away in the main room from a heart condition. It was behind the wooden galleried partition that she saw his spirit dart off, as if made afraid by the intrusion. A digital photograph was immediately taken at the spot she indicated and a large orb, or ball of light energy, was revealed in the picture. This could not be seen by the naked eye. Then suddenly three members of the team stopped in their tracks and sniffed. Marion asked, 'Can anyone else smell pipe tobacco?'

Holywell Hill itself is said to be the scene of a coach drawn by headless horses which rattles up the road in the middle of the night, passing the **White Hart Hotel**, which is another seriously haunted location. This rambling 15th Century coaching inn has been a hot spot for ghosts for centuries. Many guests here have seen shadowy figures flitting about in darkened corners.

'You often feel a cold breeze as if someone has just passed by, but when you look round there is no-one there', says former member of staff Sue Pearce. Sue remembers one morning in the late 1990s she was setting the breakfast tables in the restaurant and she felt someone standing beside her. Thinking it was one of the staff, Sue turned around but the room was empty. She found it a very unnerving experience.

Another former member of bar staff, Jon Woollard told of heavy barrels being mysteriously moved around in the cellar overnight. 'You would come down in the morning and find full barrels scattered all over the place when they had been left piled up the night before and these are difficult for a strong man to move.' Lights go on and off of their own accord and the common problem of the cellar door locking itself without a key also occurs.

Former landlady Evie Scully, relates a strange occurrence in room eight. In recent years a guest staying in this room reported seeing a gentleman sitting on the edge of his bed. Then a strange message suddenly appeared on the bedroom mirror reading, 'Meet me in room' *seven at 7.30*'. The startled guest went hotfoot down to reception and reported this to Evie, and waited downstairs while she went up to see for herself. 'The writing was big and bold and sort of childish and written in a sort of chalky substance. I rubbed it off and went back downstairs. Within minutes the guest was back at reception, shaken and saying the writing had reappeared. Indeed it had, yet I knew I had rubbed that off myself.' Guests staying in room eight have often complained of finding towels strewn about the floor when they wake in the morning.

Other odd happenings include several sightings of a ghostly little girl by the fireplace in the bar and the fireplace in room seven was seen to be engulfed in flames even though it had been bricked up many years before.

In August 2001, the paranormal investigation team camped out at the hotel, fitting all the haunted areas with 24 hour surveillance cameras and brought along two clairvoyants who had never been to the building before. Within hours of arriving, one of the monitors in the control room suddenly went blank. On investigation it was discovered that the wires had been yanked out of the back of one of the cameras set up in the cellar below the restaurant. This would have been a violent action yet the camera had not toppled off its tripod and the cellar had been empty at the time.

During one midnight séance, the clairvoyant, Marion Goodfellow, went into trance and drew a picture of a young lady in Georgian style dress with ringlets falling about her shoulders. Marion felt this lady had strong links with the White Hart in around the year 1820. Often the wraith of a lady of this period has been sighted by staff and guests alike and long standing legend has it that the ghost is that of the unfortunate Elizabeth Wilson who failed to duck when the Northampton stage coach swung out under the hotel archway and allegedly lost her head in the impact. The year was 1820.

Marion also picked up the spirit of a little girl, the daughter of a John and Elizabeth, who had said there had been much sickness in the building in the past and that she had perished in a fire in 1803. An orb had been captured on the back staircase and the clairvoyant felt it was a little girl spirit. The researchers duly went off to dig around in the archives at Hertfordshire Archives and Local Studies and discovered that there was indeed a fire in the White Hart in 1803 and that the landlord at the time was a John Rudnan-Heyward whose wife was Elizabeth.

Mrs Perkins was born in **White Hart cottage** on Holywell Hill and one of her earliest memories is of a ghost in her bedroom wearing a white ruff round his neck and a black skull cap on his head. His face was blank with no features.

A Georgian House on **Holywell Hill** has experienced poltergeist activity in the cellar, believed to be a old as 12th century. There was also a problem with lights switching on and off and a definite presence in the house which the family got used to. Another house has the spirit of 'Granny Sheldrake' who wanders around freely and another has a noisy nun, heard going up and down stairs and moving about in the cellar.

A house opposite Sopwell Lane has the ghost of another old lady and before it was pulled down, **St. Stephen's Hill House** housed an apparition that liked to open and close doors and on particular anniversaries of events in the house, would become especially noisy.

Manifestation: Town Tour

History:

One of the earliest St. Albans ghosts appeared in 1258 at **St. Peter's Church**. A hermit sitting peacefully in the churchyard was disturbed by a vision of a bearded man, who rushed past her and climbed the tower of the church where he proceeded to proclaim: 'Woe! Woe! To all inhabitants of the Earth'. Coincidental or not, but the warning was followed by a great famine in which 15,000 people in London alone were said to have perished.

A small house near **St. Peter's Street** has a soldier who comes down an invisible staircase. In one of the **Pemberton Almshouses**, founded by Roger Pemberton, High Sheriff of the county in 1620, the bed would be made up before the occupier left the house, yet on returning a distinct shape was imprinted on the bedcovers and a strong smell of tobacco would pervade the house. The occupier lived alone and was a non-smoker.

One Sunday evening in 1872 two hundred people gathered in front of **Donnington House** in St. Peter's Street, pushing and shoving, with necks craned, eagerly looking up at the top floor window. This was the home of the surgeon Dr. William Russell and a passer-by had seen a figure wearing a uniform and a white hat, tapping at one of the upper windows. Believing this to be a ghost, he attracted the attention of another walking past and before long quite a crowd had gathered to catch a glimpse of the apparition.

They were in for a long wait however, as the ghost did not put in an appearance again until 1977 when it was identified as the good Doctor's butler who had been caught stealing his master's brandy and was sacked. Unable to bear the shame, the unfortunate butler had committed suicide in the upper room. When he was first seen at the window, it was not a white hat he was wearing but a wig and a butler's 'uniform'. The building is now called Mallinson House and is the headquarters of the National Pharmaceutical Association. Staff there have reported objects going missing and being moved about and a builder working in the house late one evening was met by the vision of a man who walked right past him and continued up the old staircase. The apparition was leg-less but the builder swears he was sober.

The former **Art School** building in Victoria Street had the reputation for being haunted in wartime. Firewatchers were scared late at night by unexplained bumps and bangs which came from a classroom where it was said that a teacher took his own life after his wife left him. The school was constructed in the 1880s.

Chequer Street was the scene of a furious battle during the Wars of the Roses in the 15th Century. Battlefield House, built on the scene of the fighting, was later demolished to make way for shops, but whilst

standing was well known for being haunted by the sound of horses' hooves and the clashing of steel, particularly on the 22nd May. A child staying in the house regularly saw a gentleman in a caped greatcoat and beaver hat, but he had no face. The chanting of monks was also heard there.

The shops adjoining Battlefield House too had their fair share of spooky goings on. Shadowy figures, the potent smell of flowers and phantom footsteps on the stairs.

W.H. Smith occupies an ancient building called **Moot Hall**, dating from the 15th century and once the old courthouse until 1829. However, a court building has stood on this site since 1283. In the 1600s the ground floor housed the borough gaol. Many criminals awaited the fulfilment of their death sentences here and perhaps the emotional scars are lingering still. Possibly the most notable trial was that of the participants in the 1381 Peasants' Revolt. Whether it is one of these rebels who returns to interfere with the lighting, nobody can say, but staff at the shop have grown accustomed to the friendly ghost whom they call 'Henry' even though he makes a nuisance of himself in the early morning by switching lights on and off.

An impressive building at the entrance to French Row, once called **The Gables**, now a collection of shops headed by Laura Ashley's, is haunted by an 'evil looking man' standing by a fireplace in the store-room on the top floor. In another room an old lady bends over some embroidery and witnesses have said when she is seen, an overpowering urge to jump out of the window is experienced. Stock is often moved and jumbled around and the building had the reputation of being haunted even in the Second World War when occupied by the Free French.

George Street is the oldest commercial street in St. Albans, growing up around the Abbey precincts to serve the needs of the many travellers and pilgrims who passed along this dusty thoroughfare in the 14th and 15th centuries. Originally called Cooks Row and then Church Streete in medieval times, it declined in fortune after the Dissolution, some of the inns being demolished or forced to close. Today, some very old buildings deceivingly lurk behind modern exteriors. One of the shops, now called Long Tall Sally, has a back room where the sound of

56. St. Albans, George Street.

179

footsteps have been heard and in its former existence as a pram shop, cradles would begin to rock by themselves in this room. The former owner had seen the spirit of a little girl on the stairs.

A corn chandler business called **Dixons** housed in the former George Inn, disappeared in the mid 1980s but refurbishment work to create individual shops seemed to wake the dead. Unseen hands began interfering with the stock and becoming a nuisance. Clay pipes and other artefacts from the inn period were discovered on the upper floors.

Across the street is a rambling building which now houses St. Albans Antique Centre. Above the shop are flats which have a charming outlook over the Abbey. In the late 1970s, Paul Rolfe was living in one of these flats and was often woken in the night by the sound of gushing water. The kitchen taps would turn themselves on in the middle of the night. Not only that but Paul saw an apparition in the flat as well. 'It was about 1 am and I'd just got back from going to see some friends', Paul explains. 'I saw this woman wandering down the corridor away from me, wearing a lace dress. The weird thing was she seemed to be floating a couple of feet off the ground and was almost a lime coloured, translucent figure. Then she simply disappeared into the end wall. It was a very peculiar experience.'

Fishpool Street can be traced as existing before the arrival of William the Conqueror. It was once the main coaching route into the town and had about 72 coaches a day thundering up and down. After Verulam Road was built at the end of the 19th century, this busy thoroughfare degenerated and became an insalubrious slum area which policemen would only patrol in pairs.

Today it might seem a quiet old fashioned street, but it is in fact quite a busy place, peopled with spectres who go about their business after dark. And a motley crew of spectres they are too; a grey man (as opposed to a grey lady!), a top hatted gentleman, a Cavalier, a nurse in a grey uniform and two white ponies and a chaise, driven by a gentleman in a Panama hat.

One house has a friendly lady ghost but next door is not quite so fortunate. It was reported that a woman was strangled in one of the bedrooms and more than one owner has woken in the night, panic

57. St. Albans, Fishpool Street.

stricken with the feeling of invisible hands around their throat, while St. Michael's Manor hotel has whispers of a ghost that walks down the main staircase. The original Manor House on this site was first built by the Gape family around 1512 on medieval foundations.

A woman in a long blue dress drifts between a house and the street outside in the early hours of the morning, desperately wringing her hands and wiping her face with a handkerchief. She is thought to be the ghost of a woman who had lived near the Red Lion and had accidentally smothered her baby daughter there in the 18th century. It appears she is destined to wander miserably for an eternity.

One of the most striking buildings in the street is that which looks most clearly like a coaching inn. This was a tavern called The Crow and formed part of a large hostelry with number 15 and had linking cellars. The old inn sign can be found stored away in St. Albans Museum. On Good Friday 1873, the bakery next door burnt down, damaging the inn's frontage. Before the First World War, the landlord was Thomas Baker who also worked as a blacksmith to King Edward VII, his forge being in Sloane Square, London. He would travel to London about 4 am and then return to serve customers in the evening. It was a hard life. Perhaps it is old Tom's shade which falls across the building, now a private residence, lifting latches and opening doors at the rear. Dogs and cats follow something with their eyes which is invisible to humans. A tapping noise, heard on the partition wall, is believed to be that of an invalid woman who lived there and would continuously tap on the floor to get the attention of her daughter.

A soldier from the Boer War has appeared at a bedside at sometime during the long, chequered history of this building and furniture was moved about on a regular basis in the dining room.

Because Fishpool Street was a main coaching route at one time, quite a number of buildings are former inns. Some of those which have vanished in the course of time are The Queen, The Royal Oak, The Cock and Flowerpot, The Blockers Arms, The Welclose Arms and the Rule and Compasses. The Angel stood at number 135 and was a large hostelry with vestry meetings being held in the cellar. Today a Cavalier floats around the cellar area; perhaps a former visitor to the inn?

A town like St. Albans must have innumerable phantoms lurking in its houses, but many have simply been lost in the mists of time as owners and occupiers die or move on and the stories disappear. However, here are just a few scant hauntings that have survived to be recorded.

Hall Place Mansion, which is sadly no more, provided sanctuary for King Henry VI during the Wars of the Roses, fought in and around the town in the 1460s. The house must have made quite an impression on the King because it was said his wraith drifted in and out of the panelling before Hall Place was demolished in 1906.

A scream ringing out in the night in a regency villa in **Welclose Street** was the start of supernatural events for a BBC producer in the 1950s. A face then appeared at the kitchen window and a rapping sound was heard. A woman in a long Victorian skirt was seen gliding along the hallway and also in the bedroom where the family's two year old daughter slept. More screams in the night prompted the family to call in the Church to try and rid the house of its spirit. An exorcism was duly carried out and troubles ceased. Later, when researching into the history of the house, it was discovered that it was formerly a kindergarten from 1900, and a miniature was found of a former occupant resembling the face that had been seen at the window and in the bedroom in the middle of the night. The story read that the woman had lost a baby at only six hours old, hence the apparition's attraction to the young child.

A spectral singing miller can be heard at **Kingsbury Water Mill**, his voice drifting above the sound of the rushing water and in a garden in **Verulam Road**, a woman in a straw hat carrying a flower basket can be seen lovingly tending a garden. In **Hill Street** an old gentleman warms his hands before a bonfire.

Another strange Church experience was reported in 1970, this time concerning St. Stephen's on Easter Sunday. A member of the congregation was in the vestry, later the Lady Chapel, counting the collection before taking the offerings to the Treasurer's House. Hearing the sound of footsteps, he spun round but there was no-one behind him. The feet continued to walk up the centre aisle, through the chancel to the altar. He immediately locked all the doors and searched

the chancel, but found nothing. Puzzled, he resumed counting when the footsteps began again, this time from the altar and disappearing through the locked door. With beating heart, it was only after the footsteps had gone that the man realised the floor on which he had heard the shoes clearly as if on stone, was carpeted.

Before it was dramatically reduced, **St. Albans Hospital** in Normandy road was haunted by what was believed to be a Sister who worked on St. Mary's Ward in the early 1900s. She was seen mostly at late evening in winter time, walking around the area near the medical library. Only above her ankles could be seen as the floor had been raised since the 1900s.

Batchwood Hall is now a trendy nightclub but originally was a charming country house set amongst fine land overlooking St. Albans. In 1989, whilst undergoing refurbishment, an unseen presence in the house began switching lights on and off and unlocking padlocks and generally moving things around. The activities seemed to centre around the hall and cellar and began when a Victorian fireplace was removed. A local newspaper reports that the restless spirit of the Hall may be that of Lord Grimthorpe who built Batchwood in the 19th century. He died in 1905 a millionaire several times over.

In an area of the town called **Cottonmill**, a family home is haunted by the ghost of the grandfather. Children in the house seem to be able to see and hear the old man quite normally. At one time, a two year old was walking along the hallway with her arm up as if holding an invisible adult hand and chattering away to a person she called 'grand-dad'. Another toddler refuses to enter a particular bedroom in the house, but his complexion becomes ashen and he runs away. This is the same room where the adults have seen the old man's shade.

Just outside St. Albans in **Park Street**, a lady in the 1980s appealed for help because she believed the spirit in her house was possessing her. After suffering the torments of a poltergeist for two years, the woman called in an exorcist. But that seemed to exacerbate the situation. The spiteful spirit then began to burn her, she claimed, stating that she had blisters all over her back and other burn marks. She would get a sudden, searing hot pain and the marks appeared on

her body in front of her eyes.

A nearby village to Park Street is **Frogmore** where the aircraft factory Handley Page was situated. The ghost believed to haunt this former factory was said to be one of the crew of a Victor bomber which crashed in 1958, killing two workers, one repairing a roof and the other in the paint shop.

Manifestation: Alehouse Apparitions

History:

For more than 600 years, the **Tudor Tavern** on the corner of George Street has provided refreshment and shelter for weary travellers and weekend revellers. The story of its ghosts has filtered down over the years. One is a shadow that follows the staff around when they are cleaning up in the late evening and one person was even chased out of the building by this shadowy ghostly inhabitant. Some say the spirit is that of a previous tenant or guest, others that it is the wraith of a soldier, brought in to die during the first battle of the Wars of the Roses when armies entered the town in 1455, marching right past the front of the inn.

The other ghost of the Tudor Tavern is a poltergeist, affectionately named 'Harry' who moves plates and glasses but also performs the ghostie favourite of switching lights on and off. A few years ago, the manageress at the time saw 'Harry' in some detail. He was sitting at a table, leaning on one elbow with a glass or jug in the other hand. He had dark curly hair and a beard and was dressed in a black tunic with buttons on the cuffs and a ruffle round his neck.

An underground passage leading to the Abbey has been discovered in the cellars and when it was called The Swan in the 15th century, the building was owned by a rich merchant and the front terrace became shops and living accommodation. Through the ages, it has passed through a number of different uses including a hardware store and an antiques centre called Mayles Corner. It reverted back to an inn in 1963 under its current name.

In the market place stands the **Boot** inn which as recently as 2001 was experiencing problems with the electrics; the usual lights coming on and off, the juke box would creepily spring into life even though nobody had switched it on, plus the fruit machines were always playing up. The activity seemed to begin during some building work in the interior when a dried up bunch of flowers was discovered hidden in the wall. The building is thought to date back to the 17th century.

A very strange happening occurred at the **Hare and Hounds** at the bottom of Folly Lane. In the late 1990s, barmaid Marion Powell arrived at the pub early one summer morning to help out with the cleaning. The accessories she needed were kept in a cupboard in the cellar and as she was half way down the steps she suddenly became aware of an overwhelming presence and the air turned freezing cold. Marion stood paralysed with fear as an 'overwhelming blackness' rushed up the steps towards her, enveloping her in a feeling of pure evil.

'It felt like something was opening up and I was going to get swallowed up' said Marion. 'Then I heard this voice screaming at me to get out and I ran up the stairs and clasped onto one of the wooden posts in the bar. I was terrified out of my wits.'

It appears that wasn't the only problem with the cellars. Sometime after this frightening occurrence, the pub began to have a blockage in the sewage system. On investigation, the landlord discovered a vile substance oozing from one of the bricked up walls. At one time, the adjoining building was part of the city gallows and once dead, the bodies would be kicked over into a trough which is now part of the cellar. The bricked up wall is what separates the two buildings.

In the bar, the front door opens at the far end and then closes by itself. For the time it takes for someone to walk from one end of the bar to the other, a door at the opposite end does exactly the same thing. This happens up to three or four times a day.

In 1672 a cottage called the Falcon was built on this site, originally wasteland adjoining an orchard; it became known as the Hare and Hounds by 1804.

The **Three Hammers** at Chiswell Green, named after its former incarnation as a blacksmith's shop until the mid 1880s, had a problem

with clean glasses throwing themselves off shelves.

Strange noises and an unpleasant atmosphere pervade a back room at the **Goat** inn. Also a door opens and closes and appears to lock itself. The building dates back to around 1578 and has spent much of its life as a common lodging house. Standing on what was once the principal road into St. Albans from London, it was one of the many inns that serviced stage-coaches with horses, food and accommodation. The inn was in sight of the city gallows where prisoners from the Moot Hall were brought after sentencing.

Peter Ransome was manager of the Goat from 1979 to 1986. During his time here he experienced many strange happenings.

'One night I fell into bed after work and went into a deep sleep. Suddenly I was wide awake and staring at this ghastly face at the end of my bed. It was beyond description, but scowling and unpleasant.' Pete says his room, at the front of the inn, was always icy cold and had a particular presence. He came into his room on numerous occasions to discover his guitar had moved from where he had left it.

Further down Sopwell Lane from the Goat is the **White Lion** pub, believed to date from 1594. A young girl is reputed to stare out of the window waiting for the lover that never came, for the story goes that he was hanged on the gallows, presumably just out of her view. Present staff at the pub have reported seeing a shadowy face appear outside the small window in the bar on average about once a month and one customer got the fright of his life when sitting with his back to the window, enjoying a quiet pint, as a hand thrust through onto his shoulder when no-one was behind the glass and the window was shut.

Someone was seen sitting beside the fireplace in the bar even though the area had been closed off and a barman saw a ghostly hand on the stair rail going down to the cellar when no-one was nearby.

It was a normal Monday morning on a hot August day in 1987. The head chef of the **King William IV** pub went into the cellar to get some stock cards.

'I looked up and there was this bloke standing there dressed in army uniform', she says. 'It was green coloured with buttons down the front and he was about 6ft 2 inches tall and had a moustache.'

At first the soldier just looked at her, so she called for the manager, who rushed down in time to see the man as well. Then he just disappeared.

Apparently the pub was built just before the War in 1937 and it quickly gained the reputation of being haunted. A ghostly figure was seen in 1939 walking across the bar after closing and pots and glasses would fly about the room. During the War, the pub became a regular haunt for the Home Guard after drill.

The **Verulam Arms**, opened in 1853, has experienced a number of odd events including objects flying off shelves and walls and the universal electrical problems. While the **Six Bells** in St. Michael's has ghostly footsteps that follow the staff around and a figure has been glimpsed in the kitchen area. This ancient hostelry is late 16th century.

A much altered building in the market place was the **Wellington**, an inn until 1972. Now an opticians in the entrance to modern shopping centre Christopher Place, the building is barely recognisable as a former inn. The ghost here is that of a mischievous little boy called Charlie who is perpetually looking for his mum. In the 18th century, he had ran out as a coach turned into the yard and was killed. When the Wellington occupied the building, a former barmaid said she felt unseen hands stroke her hair and kiss her forehead. Footsteps stalked an empty room and the sound of heavy furniture could be heard being dragged across the floor. Lights turned on and off and something would bounce up and down at the end of occupants' beds in the middle of the night. Apparently when a sceptical customer loudly voiced his disbelief in ghosts, a soda syphon rose slowly in front of him.

A séance was held with a local psychic group in the pub and Charlie's spirit came through. He told them he had lived at the pub when it was called the Blue Boar in the 18th century and told the sitters about the stables being full of horses. A frenzied finale of raps and bangs followed the end of the séance.

In September 1972, the building ceased to be a pub and was considerably altered and was taken over by a butcher's shop called Mathews. The ghost remained steadfast, however, and would reportedly touch the faces of women assistants, interfere with the tills,

bang doors, push over rubbish and generally make a nuisance of himself. One of his favourite tricks seemed to be repeatedly puncturing the manager's car tyres. One of the butchers saw a small misty figure in the cellar behind the shop, another saw a man in the yard at 5.30 in the morning, standing with his arms folded and women shoppers have complained of feeling something like cobwebs brushing their faces. A mirror was found smashed to pieces one morning, even though the screws that had held it to the wall were still in place.

Three hundred years on in 2002, staff at the optician's currently occupying the building are still reporting strange phenomena. Two women, who didn't know about Charlie, described a recurrent feeling of having cobwebs brushed across their faces. Another lady talked of having her shirt tugged by invisible hands and customer files are often disappearing only to reappear minutes later. But there is a 21st century twist to this old story; the shop possesses surveillance cameras and often the lights are found blazing on in the morning. When the cameras are checked, the cleaners are clearly recorded switching all the lights off, but suddenly around 4 am every single light will flicker on by itself, even those in the toilets which are in a different part of the building and on a separate circuit. 'Even the heating will come on by itself', said one member of staff, 'and we've had all the wiring checked and the shop has been refurbished, yet still we find lights on inexplicably when we come to open up. It happens too often to be a coincidence.'

As with a lot of ghostly activity, premises on this site over the years have all experienced electrical problems; fridge metres constantly burnt out, radios and fires switching themselves on and off. One school of thought on paranormal activity is that entities draw on electrical energy in both appliances and mortals alike to enable them to manifest.

Standing at one end of the historic French Row with its cobbled pathway is the historic **Fleur de Lys** pub. This ancient thoroughfare got its name from the town's occupation by French soldiers in December 1217. King John of France quartered his troops around the neighbourhood of High Street. In medieval times this back-street market was called Flesh Shambles and sold anything from butter,

cheese and eggs to shoes. When the King was captured, he was housed for a couple of days in a private house, which later became the Fleur de Lys inn. Feet from the past still tread the floors here at the Fleur. Keys rattle where no keys can be found and the feeling of being watched has been experienced by the staff.

The **Fighting Cocks** inn, a curiously octagon shaped construction overlooking picturesque Verulamium lakes, purports to be the oldest inhabited licensed house in England. Its cellar is built on an 8th century gatehouse to the abbey and is constructed of tiles, snatched from the ruined Roman city of Verulamium. In 2001, a member of staff with psychic sensitivity, was hoovering in the bar about 9.30 one morning when out of the corner of his eye he saw figures emerging from the cellar and climbing the stairs from the cockpit. He turned and stared in amazement as monks in brown habits, seen from the knees upwards, casually wandered through the pub and sat down at the fireside table and stayed for some minutes before fading away. Another member of staff was found shivering with fear and would say nothing except he had seen a ghost in the building. Another odd event concerns a set of keys which were left on the bar one night after closing. The manager at the time had gone down into the cellar to change the barrels. When he returned some time later, the keys were no longer on the bar but he discovered them hanging on a key holder, swinging violently of their own accord, yet he was alone in the building.

Manifestation: Gamut of Grey Ladies

History:

Number **17 High Street** is one of the oldest surviving buildings in St. Albans. Squashed in uncomfortably between a monstrous 1970s shopping centre and historic Waxhouse Gate, the date on this three storey house reads proudly 1665. Now housing a funky retro shop, this was once part of Fiske's, a large department store spanning a quarter of the High Street; most of which was destroyed in the building of Heritage Close in the 1970s.

58. St. Albans, The Old Fighting Cocks.

It appears the premises have always been haunted by the ghost of the manager's daughter, a young corset maker who was kept locked in her room by her father because she had fallen in love with one of the storemen. Miserable, she eventually took her own life and shortly after her death, a table of wedding veils was often found upset as if she couldn't bear the thought of anyone else getting married. Even today she appears in the basement and stock will go missing or become jumbled. When Fiske's still occupied the site, shop assistants would glimpse this unhappy wraith in grey and particularly at Christmas time, footsteps could be heard in the upstairs quarters.

Some years later an adjacent shop was occupied by Fads, a DIY store and rolls of wallpaper and paint would be found thrown about in the mornings when staff opened up. Obviously the ghost was particular about its décor. Other shops adjoining number 17 have also experienced problems in the cellars with stock being thrown about and a monk has even been reported in one basement.

In St. Peter's Street stands a grand building dating from 1763. Now a building society, number 16 was once **The Grange** and used as council offices. Staff working there have been spooked by a ghostly presence, watching doors open and close by themselves. A sad looking lady in a long grey dress wanders wistfully around the building.

The ghost first put in an appearance in the 1940s, but then in the 1970s, a caretaker was alone in the cellar when suddenly the atmosphere became icy and he got the feeling there was an eerie presence there with him. One member of staff came to the building for an evening class and on arriving early, let herself in the back door. 'There was a most peculiar atmosphere' she reports, 'an intense cold even though the storage heaters were on.' The woman experienced a strange sensation of swishing as if something walked past and felt the presence to be malevolent and female.

A decade later, staff were clearing up after the Mayor's banquet at the nearby City Hall, now the Alban Arena. The manager heard someone passing his office door and thinking it was a guest who had lingered behind after hours, he went out to help, but was met by the vision of a lady in a long grey dress who melted away in front of his eyes.

The ghost is believed to be that of Dorothy Osborn, whose father-in-law, Mayor John Osborn, built the Grange. At one time the building would have been entered through a courtyard and surrounded by beautiful gardens. Dorothy killed herself in the 18th century when she discovered her husband had a mistress. The City Hall has been built on what would have been the gardens of the Grange and no doubt where Dorothy did a lot of walking and pondering in her time.

Doomed to dust forever is the young chambermaid of **Ivy House**. This rambling 17th century building, built by Sir Christopher Wren's master mason, is another of the 'grand old ladies' of St. Albans past. So terrified are they that office staff refuse to return to the building after dark or be the last one out on a winter's evening. The staircase and cellar are always clean and dust-free, but not by human hands, taps turn themselves on and doors open and close by themselves.

One manager, who did brave it into the building alone one Friday night, has the following tale to tell, 'I returned to the office to collect some important papers. It was dark and windy and as I went through the front door I saw a figure in white standing on the stairs. It appeared to be a young woman with blonde hair. She gave me a cursory glance then disappeared up the stairs.' The poor man ventured no further into the building but fled without ever collecting his papers.

Other people who have been on business at Ivy House when it has been empty have reported unexplained footsteps on the back stairs and cleaners have experienced strange noises and watched doors open and close by themselves as if someone has just walked through them.

And the odd thing is the hand rail on the cellar stairs is always highly polished and never needs touching by the cleaning staff; even when refurbishment work was being carried out, the staircase always mysteriously escaped the dust and debris.

The legend is of a young chambermaid called Miss Meades who found herself pregnant by a member of the household and as a terrible consequence was walled up in the chimney.

The other ghostly lady of the town can be found in the 15th century building that was formerly **Sally Lunn's** eating house in St. Michael's. More of a lady in white than grey, she has been seen by restaurant staff

sitting on a bench and described as being about 45 years of age and dressed all in white. A former owner said she would regularly meet the ghost on the stairs at 4 am when she was in doing some early baking. Staff have reported the feeling of being watched and sometimes she offers a pair of spectral hands to help out, but then they disappear into thin air. It has been surmised that this was Sally herself, the former owner of the business, who supervised the staff to make sure everything was running smoothly.

Manifestation: Romans in the Gloaming

History:

St. Albans' history is inextricably linked with the Romans so it is not surprising the spectre of a Legionary or two is still being glimpsed marching along old routes and roadways. The Roman City of **Verulamium** is little more than fragments of crumbling wall dotted about the undulating parkland through which the river Ver runs peacefully. But this tranquil scene belies a violent past. In AD 61 the skies above Verulamium were aflame with a red, smoking glow as Queen Bodicea of Iceni and her armies, on a revenge mission, rampaged through the city, slaughtering and destroying all in their path and burning the city to the ground. Archaeologists say that a layer of ash can still be found beneath the ruins today.

A 25 year old man, walking home through Verulamium one summer evening in 1985, was startled by the sudden appearance of a Roman Centurion on a charger. So frightened was he, that as he fled from the apparition he tripped and damaged both his shoulder and knee and ended up in the local hospital.

A misty night near Christmas in 1970 and two boys cycling through the park believe they came face to face with a soldier of a different kind. The ghost of a Cavalier floated towards them in a 'silver haze'. He was described as wearing a tunic with silver buttons and tassels. His baggy trousers were tucked into a pair of high boots turned down at the top while his hair was long and curly and he seemed to be carrying a

sword as he glided majestically towards the bridge. This particular ghost must have got lost in the wrong dimension as there appears to be no historical explanation for why he would be haunting Verulamium lake.

More recently, local character Ginger Mills lived in a caravan which was permanently parked alongside the lakes. He would often go strolling around the park in the early hours of the morning and on one occasion he heard the sound of marching feet getting closer and closer. A great group of men seemed to be approaching him from behind, so he stopped and stepped aside as the phantom army passed right by him. He swore he felt the icy breeze as they went past.

Roman soldiers have also been seen around the former mansion of Nicholas Bacon at **Gorhambury**. Queen Elizabeth I visited the house here in 1570 and was reported to have remarked: 'My Lord, what a little house you have gotten.'

An area of St. Albans clustered round a pub of the same name, is known as '**The Camp**'. This in fact originates from a time when a Roman encampment occupied the ground here. An old resident of the city has a flat in this area and one afternoon he heard the sound of marching feet on gravel outside the window. The sound passed right beside the window and resembled a large body of marchers. The strange thing was that the ground outside was all silent grass, with no gravel to be seen.

Roman soldiers have also popped up in a kitchen in a modern house in **Kingsbury Avenue** startling the residents and another in **Camlet Way**, thought to be the site of a Roman cemetery. You never know on whose bones is built your house…

Just outside St. Albans, on the road to **Wheathampstead**, the sound of a harness jingling has been heard by many travellers, followed by the appearance of a column of men marching along the roadside, dressed in leather kilts with metal breastplates and helmets and swords strapped to their sides. The soldiers are said to vanish into the mist leaving behind just the sound of tramping feet and jingling metal.

59. St. Albans, Gorhambury House.

Manifestation: Shining Vision and Shadow Child

History:

Pré House near St. Albans was described in Victorian times by a child who lived there, as: 'a long two storied house, late Georgian in design with a wide veranda which in summer was always filled with pot plants, geraniums, lobelias, fuschia and orange trees. The lawn sloped down to the tennis court and beyond the meadow was the river.' This idyllic picture was painted by Constance Toulmin, young author of *'Happy Memories a description of family life in Victorian England'* and whose book was finally published in 1960. The cellar of the house was ancient and believed to be all that remained of an old inn, built for sheltering pilgrims on travels to the Abbey.

She goes on to describe how each of her 13 brothers and sisters had their own little garden in which to make their mud pies, let their childish imaginations run wild or sit quietly and read. It sounds like a paradise but this tranquil garden also harboured an apparition from another world.

One night in the 19th century, Isobel, one of Constance's younger sisters, was out in the garden chasing away a noisome cat that was causing a disturbance. It was a clear summer night and as she glanced up at the stars, she noticed a shining figure, about twice the height of a man, standing behind the tall hedge. She said, 'It was quite motionless and perfectly lovely. It stood absolutely still for about three minutes and then as I turned to another sister who had entered the garden, it vanished.' The figure she described as wearing a shimmering robe of white with a golden radiance about his head and shoulders which gradually enveloped the whole of his body.

Apparently Isobel was not the only person to encounter this vision, which has been witnessed by many people in St. Albans throughout the centuries, including the Toulmin family butler and her elder brother Henry.

The Pré is now a hotel and restaurant and claims to be haunted by a 'shadow child' who appears in wedding photographs taken in the grounds, usually in the month of August. Meanwhile inside the house,

in one particular room residents have reported mysterious tappings on the door and quick footsteps up and down an empty passageway. Isobel, however, has her own unusual theory about the shadow child. She believes it is her ghost that is seen. So strong was her love for the place she feels she has left a permanent image scarred in history which is replayed whenever strangers stand in one particular place on the lawn.

'I never liked strangers on the lawn,' she said, 'and I would always chase them off.'

Manifestation: **Ghost for Sale**

History:

A modest two-line advertisement in a newspaper led Alban Warwick and his wife to the hideaway charm of Hill End Farm near Gorhambury in the mid 20th century. It read, simply: 'Farmhouse for sale near St. Albans.' This intriguing 15th century cottage in peaceful countryside has beams, some of which have been dated to have come from Francis Bacon's house, a priest hole and ceilings embellished with the Tudor Rose and Fleur de Lys, perfect ingredients for a spooky past, which indeed it has. Hurried footsteps are heard often on the gravelled path, but when the door is opened to the visitor, no-one is there. The family dog would also hear footsteps and bark furiously at the phantom caller.

ST. PAUL'S WALDEN

Manifestation: **Village Fireside Tales**

History:

On certain nights of the year in the winter, Hertfordshire families would traditionally huddle around the fireside and tell ghost stories. In the Parish of St. Paul's Walden, childhood home of the late Queen Mother, tales would be told of the headless coachman who speeds along in a phantom coach on the old road to Hitchin which once crossed **Dove House Close**, now a meadow. Then there is the restless spirit of

Bob Archer, the old squire of **Bendish**, riding his horse, the white apparition of **Walden Abbots**, screaming spooks at **Tan House** and the haunting voice of the old village choir.

The church is haunted by the spectre of a woman who drowned herself in nearby old Bury pond in the 18th century and ghostly footsteps are said to follow nocturnal walkers on the footpath down Mill Hill to the River Mimram

STANDON

Manifestation: Uninvited Guests at the Star

History:

It was just a normal Tuesday night at The **Star** inn in 1972. Landlord Frank Spelling had locked up and retired to bed. About 3 am he rose to go to the toilet when he heard a noise downstairs in the empty bar. He went down to investigate and could see something moving around. As he got closer, he couldn't believe his eyes, a dozen or so people were gathered around a long table. The men were all in tri-corn hats and a beautiful tall Latin woman stood amongst them, wearing a big coat and they were all laughing and swigging from tankards. Frank could hear what he describes as soft 'flutey' music in the background.

He strode into the bar ready to confront the uninvited guests, but as soon as he went through the door, the room became silent and empty with just the moonlight shining through the window onto the granite gravestones in the church opposite. Frank rubbed his eyes, doubting his own vision. Puzzled, he left the bar and turned to go back up to bed, but then decided to have one more look to make sure he had definitely been mistaken, he peered again through the bar door window.

'My heart almost leaped out of my body', said Frank, 'Not only were they all back again, but this time they were joined by a buxom looking wench.' Again he opened the door but for the second time, the room was completely empty and the figures had instantly vanished.

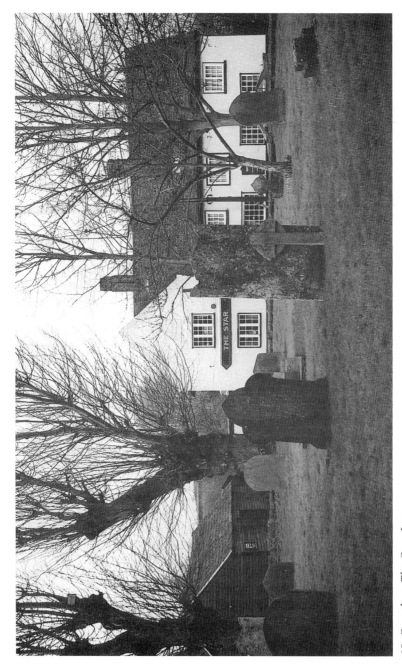

60. Standon, The Star Inn.

Frank went back to bed, convincing himself that it was his mind playing tricks on him, and said nothing to anyone about his strange experience, nothing until some months later when two women came into the pub one afternoon. The older lady was about 65 and said she had grown up in the Star and asked if anyone had seen the ghosts recently. She then recalled coming back from a party late one night and, creeping in the back door, had been startled by a group of people in the bar area. She then described the exact scene Frank had witnessed that night in 1972 right down to the hats and tankards.

In the 1700s the Star was called the Maypole and was a popular coaching inn.

STEVENAGE

Manifestation: Black Hound of Six Hills

History:

On the 7th May 1910, historian W.B. Gerish received a secret letter, begging him not to reveal its content to a living soul. Having ensured a confidence, the letter went on to reveal a frightening experience occurring to a lady in Stevenage late one night.

The lady was walking along Bury Mead with company when their attention was taken by a shadow which appeared to rise out of the ground and come towards the Avenue. The party were curious and carried on walking towards the shape. As they got closer, they saw it was a large black dog, as big as a donkey, its head bent towards the ground and its tail curled over its back. As it passed them, the group turned to watch its progress only to find it had disappeared.

The letter went on to confess that a gamekeeper had seen the same apparition near a field gate which opened onto a by road to the Avenue. The large black hound rushed by him and through the closed gate in the direction of Six Hills. As the gamekeeper continued on his path towards Whomerley Wood, the dog appeared again, nose to the ground and tail bent back and seemed to be following him into the lonely

The 6 Barrows near Stevenage 10. July 1724.

61. Stevenage, Six Hills Way.

woods. The gamekeeper became very afraid and turned round to head back in the direction of his friends' house, too nervous to complete the journey to his own home. The letter ends as it began, pleading with Gerish not to publish any of the information contained therein.

Black dogs traditionally in folklore have been seen all over the country and generally are thought to be the harbingers of death or disaster. In some places, the Devil himself is believed to take the form of a spectral black dog.

Manifestation: Ghosts of The Grange

History:

The caretaker of a school in Stevenage often worked alone at nights, but he had to pluck up a great deal of courage just to enter the building. It wasn't the children of the present that terrorised him, but shades of the past.

The Grange is a looming building in which the caretaker's dogs cannot be persuaded to enter. 'During my time at the school I have had five dogs from a corgi through to an elkhound but I couldn't get any of those animals to set foot in that house', he says.

So what is it about The Grange that is so fearsome? Not long after the caretaker had begun work at the school in 1965, he was crossing the playing field with an assistant one bright Sunday morning when they saw a man standing in the garden dressed in brown livery, watching them. Puzzled as to what someone was doing loitering in the school grounds, the caretaker challenged him and the figure simply disappeared. The staring stableman has been seen on numerous occasions and it has been suggested that perhaps he is connected with a time when The Grange was a coach house and burned down in the 1800s and a stableman died in the blaze.

One night, the caretaker, finishing his night duties, turned the lights off and left the building in total darkness. He had barely walked 150 yards when he turned and with horror he saw the building ablaze with light.

Other spirits that have been encountered in this strange old house are voices in empty hallways and women sitting on the stairs.

Manifestation: Grocer's Ghost

History:

Henry Trigg refused conventional burial in consecrated ground because he was afraid grave robbers would deny him his chance for eternal life. Perhaps he was right, because eternal life appears to be what he has attained as his spirit has been roaming free for over 300 years now.

In 1724, grocer Henry passed away but having once seen body snatchers steal a body from the churchyard, he had requested to be placed in a lead coffin which was laid in the roof of his house. His house then became The **Castle** inn, subsequently the Westminster Bank. During the Second World War, some American soldiers supposedly stole Henry's bones as souvenirs, putting dog bones in their place and Henry's spirit has been restless ever since.

In 1975, a local newspaper reported that nobody would work late in the building for fear of bumping into Henry, like the experience of the workman five years earlier when the bank was being renovated. He claims to have seen a man in a striped apron glide by and vanish through a wall.

Manifestation: The Return of the Saint

History:

The spectacular spectre of St. Nicholas is said to appear as a knight in armour, riding a white horse from the churchyard bearing his name, through the gate and off down the hill as far as the Alms House where he disappears.

Manifestation: Mysterious Visitor

History:

It was an ordinary summer night in 1998. A family were living in a new house on a modern estate in east Stevenage. The husband had been awake for a little while, staring at the ceiling, hot and restless. About 3

62. Stevenage, Henry Trigg's Coffin.

am he caught something move out of the corner of his eye and looked towards the stairs. To his horror, he clearly saw a man coming up the stairs in the landing light, which was always left on for the two children. He froze as he watched the figure turn and enter his son's room. His son had taken a real dislike to sleeping in there of late and had asked to sleep in his sister's room. Thinking it was one of the gypsies that had recently camped nearby, he leapt out of bed and charged into his son's room to confront the intruder, but the room was empty. He felt very uneasy; he had seen with his own eyes nobody leave the room yet where could the stranger have gone? He scoured the house, but there was no sign of anyone, nor of a break in and the family dog was sleeping soundly. Who this night visitor was, no-one knows.

TEWIN

Manifestation: Three Ladies of Tewin

History:

Lady Cathcart of Tewin was a notorious character whose strong personality, it seems, has survived the passing of time and her wraith haunts Tewin Water House near Welwyn. A great beauty, the lady married four times and lived to bury each of her husbands. When she married her fourth husband she had inscribed on her wedding ring: 'If I survive, I'll make it five.' Sadly she did not but attained the advanced age of 98 before being buried in a special vault in Tewin Church which she had made for her first husband, Squire Fleet, in 1789.

Her long life was nonetheless chequered. The last husband, an Irishman named Colonel Macquire, kidnapped her away to Ireland and held her prisoner for twenty years until his death finally released her and she came tearing back to her beloved Tewin Water with a strong spirit. Here she lived for another twenty three years more, unmarried. Her ghost glides ponderously amongst the trees at Tewin Water, reflecting on her adventurous life. A room in the house itself, known as Lady Cathcart's room, has long had the reputation of being haunted by her spirit.

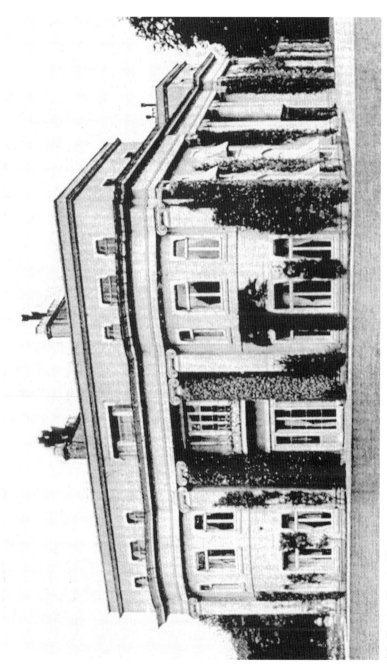

63. Tewin, Tewin Water.

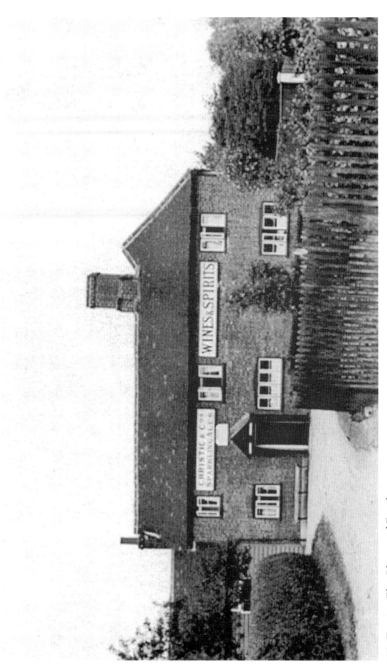

64. Tewin, The Plume of Feathers.

Dr Yarborough, Rector of Tewin, recorded a story at an unknown date, sometime between 1682 and 1710, from his well respected acquaintance, General Sabine, Governor of Gibraltar. Whilst laying dangerously ill of his wounds after a battle abroad, the General lay awake in bed one night when the curtains at the foot of the bed were suddenly drawn back and, by the light of the candle in his chamber, he saw with surprise, his wife standing looking at him. His wife, Lady Hester Sabine, was a lady he greatly loved and was at the time in England. She then faded away, leaving him astounded at this extraordinary vision. He later found out she had died at about the time her apparition appeared at his bedside. The General himself died in Gibraltar in 1739.

A marble tomb commemorating General Sabine now rests just inside the doorway of Tewin Church and the figure of Lady Sabine wearing a black cloak with a hood, lingers near the monument. In the early 1980s, two visitors to the church heard the sound of rustling crinoline skirts in the aisle and felt a strong female presence in the bell tower.

Another local woman, Lady Ann Grimston is said to have been the despair of her local parson with her unorthodox views on religion. On her deathbed in 1713, she questioned belief in life after death. Folklore has it that she stated, as she lay dying, that if she would rise again, may seven trees spring from her grave. Today her time-worn tomb can be seen, surrounded by rusted railings and split dramatically by a tree which has grown into seven parts. The ghost of Lady Ann herself has been seen often, floating about the churchyard, especially by the bell ringers who are around at the church at all times of the night.

Manifestation: Fine Array of Spectres at the Plume

History:

A murdered body discovered bricked up in the fireplace and a candle that lights itself are just two of the ghostly goings-on at the **Plume of Feathers** pub. There is an especially weird feeling down in the cellar. In 1999 a female member of staff was trapped alone there in the dark

after the swing door refused to open. She explained, 'There is no handle on the outside of the door so it wasn't being held from the bar as a joke. It also just swings back and forth, so is unlikely to have jammed fast.' Eventually it 'just opened' and she was able to escape. Startled, as she tore out of the cellar, her colleagues swore they had not been playing a joke on her. The ghost of a little girl has been seen by the bar staff at the top of the cellar steps and beer taps open and close by themselves.

The cellar has a tunnel running across to the main house and the pub was once Queen Elizabeth I's hunting lodge in the 16th century. Apparently the building can only ever be used as a pub, not a house, as this is written in the deeds. The cellar was originally the servants' quarters and is now bricked up but said to be haunted.

Mark Thomas, the manager at the time, was sitting by the fire one afternoon, enjoying a bit of peace and quiet during closing hours, when he heard a noise behind him. Spinning round, he saw the candle on table 8 had lit itself. There was nobody else in the pub and he had extinguished all the candles after the lunchtime shift.

Two phantom old men have been seen in the bar, one sitting at table 8 and the other, by bar staff, leaning on the bar and facing the wrong way. He is in fact propping up a long gone bar which used to face the opposite direction. One of the bar men feels his name may be 'Dave' and often sees shadows flitting out of the corner of his eye on quiet afternoons when hardly anyone is in.

In the 17th century, the body of a woman was discovered bricked up behind the fireplace near table 8. She is said to have been killed by her husband when he returned from two years at sea to find her pregnant. He then disposed of her body. The fireplace is now filled in.

A long table in the restaurant area behind table 8 has a lady with long grey hair wearing a see-through dress and who cackles at the staff and the ladies toilet has a very creepy feeling. Staff believe the ghosts pick on them, making them unnaturally clumsy behind the bar and in the kitchen, the oven switches itself on every day and when the Chef turns his back, the gas is turned up and time and again the soup is burned because of this mischievous behaviour.

THERFIELD

Manifestation: Secrets at the Fox and Duck

History:

In the 1970s, a ghost story surrounding the village pub was kept under wraps and the whole village closed rank, refusing to discuss a mystery that they could not explain. The ghost was thought to be that of the previous, late landlord and a temporary management couple that had taken over the **Fox and Duck** in July 1975, were said to be 'tired and strained' by all the strange events going on there.

Footsteps running across the upstairs landing, toilets flushing and bottles rattling have been heard by staff and visitors alike when there has been nobody accountable for the noises. Lights going on and off and lamps being turned around were commonplace. On one occasion the light above the dart board was completely turned the wrong way. The managers, no longer able to cope with sleeping upstairs, brought a mattress downstairs and slept in the lounge bar.

One night the police were called over an alleged break in. They heard footsteps upstairs and went to investigate, tracing the noises into the room belonging to the former landlord but despite searching the area, nobody could be found. With no forthcoming conclusion and villagers continuing to refuse to comment, the mystery was never solved.

THUNDRIDGE

Manifestation: Supernatural Army

History:

In November 1978, a lady from the Old Vicarage at Thundridge wrote to the local newspaper, telling of a very strange experience she had when she was young.

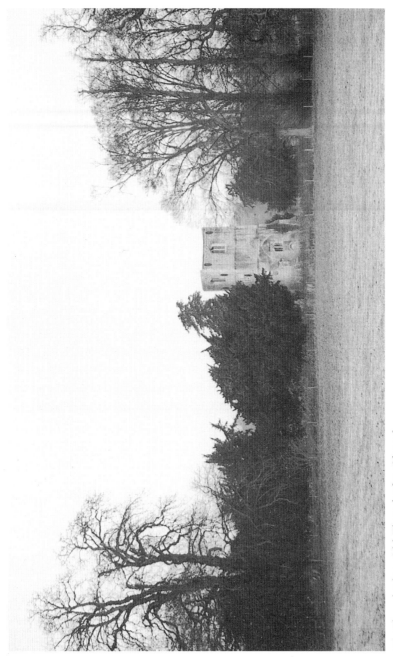

65. Thundridge, Old Thundridge Church.

She was walking along the River Rib towards the ruins of the old church when she was surprised to hear loud shouting and saw fires burning in the old church. Suddenly a troop of soldiers wearing helmets and metal breastplates rushed towards her. She was so terrified that she was frozen to the spot, unable to move. But when they reached her, the soldiers divided and passed by without speaking. It was only after they had melted away, the lady realised she had experienced something unearthly from centuries before.

TRING

Manifestation: Hounded from Hell

History:

In the little village of Gubblecote, near Tring one morning in April 1751, a poor old couple in their 70s were dragged out of the church by a crazy, drunken mob. They had been placed in the church for their own safety when it was heard that a riotous crowd were baying for their blood, suspecting them of witchcraft. Led by a chimney sweep by the name of Thomas Colley, Ruth and John Osborn were dragged to the horse-pond at Long Marston, stripped and with their thumbs and toes tied together, thrown into the water three times to sink or swim as part of an ancient practice of witch trial. If a witch sank she was innocent, guilty if she floated. Both John and Ruth died as a result of suffocation and exposure. As perpetrator of the murder of this innocent couple, Colley was hanged, although not before penning a remorseful letter just prior to his death. His body was gibbeted at the spot near where the deed was committed and ever after a strange black dog haunted the area.

A local school master was returning home late one night in a gig with another person. He writes:

'When we came near the spot where a portion of the gibbet had lately stood, we saw on the bank of the roadside a flame of fire as large

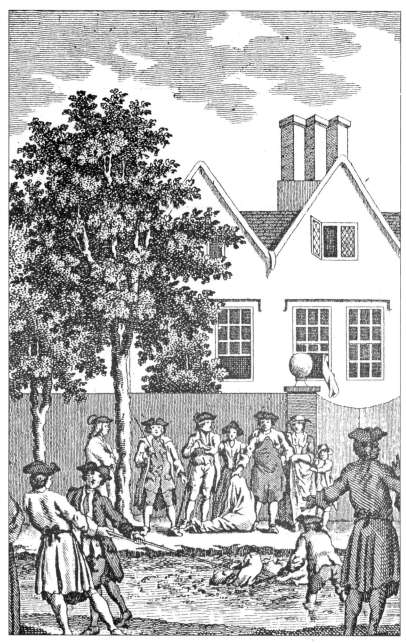

66. *Tring, The Murder of Ruth Osborn.*

as a man's hat. "What's that?" I exclaimed. "Hush!" said my companion and suddenly pulling in his horse, made a dead stop. I then saw an immense black dog just in front of our horse, the strangest looking creature I ever beheld. He was as big as a Newfoundland, but very gaunt, shaggy with long ears and tail, eyes like balls of fire and large, long teeth for he opened his mouth and seemed to grin at us. In a few minutes the dog disappeared seeming to vanish like a shadow or to sink into the earth and we drove on over the spot where he had lain.'

Manifestation: Ghosts in Brief

History:

Tring has a collection of hauntings, those recorded include a lady who is seen floating down beside the drive of Elm House, some way above the ground, and a grey lady who rustles around the recreation ground at Grove. On New Year's Eve, a coach and four headless horses is seen speeding down to Pendley Beeches, and crossing from the park gates to the churchyard in the early hours of the morning is an undefined ghostly figure. A phantom horseman gallops the road between Tring and Aldbury and Roman soldiers in full battle dress still march along Akeman Street, the old Roman road. Around 6 am, groups of Roman soldiers have been seen assembling ready for a re-enactment of some long past battle on Wiggington Common. During the Civil War, Wiggington Common served as camp for some of Cromwell's troops and there have been reports of Roundheads seen in this vicinity in the evening twilight.

WADESMILL

Manifestation: Fiddler of the Feathers

History:

The **Feathers** inn is an ivy clad 16th century stage coach inn on the A10, the major coaching route from Cambridge to London, and was

67. Wadesmill, The Feathers Inn.

216

known as The Prince's Arms in 1615. At its peak, the inn had stabling for over a hundred horses and coaches would rattle in and out of its inn-yard many times a day.

It was on one such busy day that a young girl was in the cobbled yard playing a violin when a coach, on its way to London, swung in to change horses. The girl was run over and killed and it is her ghost who now haunts the Feathers today. The haunting sound of a fiddle echoes sadly around the building.

WALKERN

Manifestation: Tale of Dr Birdsall

History:

This is one of those stories which have been handed down in ghost-lore and of which scant information remains. Suffice to say that in the village of Walkern at sometime in the past existed a cottage by the name of Fairview which was haunted by the ghost of a Dr Birdsall.

Walkern is perhaps best known for being the home of the Wise woman of Walkern, Jane Wenham (*see Hertford*).

WARE

Manifestation: The Great Bed

History:

In 1463, journeyman carpenter Jonas Fosbrooke from Ware presented the Royal family with a magnificent bed, the like of which had never been seen before. It stood a massive 12 feet square and was described as a 'rare specimen' so richly and beautifully was its bedstead carved.

It was given to Edward IV for the purpose of 'princes or nobles of gentle blood to sleep in.' The King was much pleased and, staggered

at the standard of workmanship, granted Jonas Fosbrooke a pension for life.

The Bed became the property of Thomas Fanshawe, Lord of Ware manor, in the 1500s and in 1575 it was sold and began a tour of the various inns of Ware, taking pride of place in the Crown, the Bull, the George and the Saracen's Head.

People would come from miles around to see this outstanding specimen of furniture and over the centuries, playwrights and poets including the likes of Dickens, Ben Johnson and Lord Byron, commemorated it. So celebrated became the Bed that it was mentioned by Shakespeare in 'Twelfth Night' and everyone in the theatre audience was acquainted with it. In a poetical itinerary of 1596 it was written:

'At Ware was a bed of dimensions so wide
Four couples might cosily lie side by side
And thus without touching each other abide'

But those who stayed a night in the Bed did not have a restful night. They would be pinched, nipped, scratched until eventually they were forced to seek comfort elsewhere. One gentleman, Harrison Saxby, a Master of the Horse to King Henry VIII, braved a night alone in the bed for the love of a local girl, but was found in the morning on the floor beside the Bed, covered in bruises and in a state of complete exhaustion. The spiteful spirit haunting the Bed was thought to be old Jonas himself, angered at the treatment of his supreme work and for the base commoners who were occupying the Bed when he had designed it for noble blood.

By 1761 the Bed's history was written all over it. Sadly defaced by its many occupants with various dates and initials carved in its once magnificent woodwork. The adventures of the Great Bed of Ware ended in the 1800s after a spell in Rye House, and it was finally rested in the Victoria and Albert Museum in London where it can still be seen today.

68. Ware, The Great Bed.

Manifestation: The Ghost of Old Hope House

History:

Now destroyed, Hope House stood proudly overlooking the River Lee and Ware Lock. In the mid 1980s, when the house was demolished by Glaxo to make way for a new manufacturing block, Roman coffins were discovered in the grounds. When the house was a home in the early part of the 20th century, it was haunted by a spirit that would walk restlessly along the second floor landing at night. One bedroom facing a giant chestnut tree, was icy cold. There was no gas lighting at the top of the house, so the whole of the upper floor was eerily lit by candles and none of the occupants could bring themselves to look in the bedroom mirror by candlelight in case the face of the ghost appeared over their shoulder.

Two cats living in the house were so terrified by the ghost, one leapt from an open window and fell to the ground breaking its neck, the other was running from something, its hair all on end and pelted headlong into a cellar door and was killed outright.

Occupants of Hope House believed the spirit to be that of a man who was hanged on a spot at the rear of the house.

A more recent haunted property is one in **New Road**. The occupants were subjected to doors opening by themselves, taps being turned on full blast and footsteps walking up and downstairs. Whilst watching television one night, the footsteps thumped down the stairs and 'something' came and sat down on the sofa so that the cushions dipped.

Amwellbury House is reputedly haunted by monks who walk in the grounds on land belonging to the Abbey of Westminster and their chanting is heard inside the house.

Manifestation: Laying of the Ware Ghost

History:

At the end of the 19th century, Hertfordshire historian W.B. Gerish appealed for information about the laying of a ghost in Ware churchyard. Apparently, some thirty years previous, several clergymen had been witnessed laying a ghost at midnight amidst the graves.

69. Ware, Ware Church.

WATERFORD

Manifestation: Long Gone Village Inhabitants

History:

This is a charming little hamlet just outside Hertford nestling in peaceful countryside. Mr Ivor Childs was driving past Waterford Church just after midnight with his wife and sister-in-law. He describes the night as being brightly moonlit almost like daylight. 'As we passed the Church a figure in a long white flowing garment suddenly appeared from the churchyard coming towards the road. I slowed down quickly, afraid I might hit this young woman who was bareheaded with beautiful hair and features. But my wife said, 'Don't stop, don't stop it's a ghost.' However, I did pull up to look round and see the figure literally glide across the road into the recreation field opposite and just disappear. We all three saw it!' Mr Childs drove along that stretch of road many times afterwards but has never seen anything of the like again.

Waterford Church has a fascinating history of its own that is worth mentioning here. Consecrated in July 1872 by Bishop Wilberforce, son of William Wilberforce who abolished the slave trade, its stained glass design was entrusted to artists William Morris and Edward Coley Burne-Jones; a partnership legendary in the history of art. Dante Gabriel Rossetti is also represented in the Church's glass, ensuring that this humble little village had the finest collection of pre-Raphelite glass in the world.

A young woman living in Hertford often uses the Waterford road when visiting her mother in Stevenage. She has always been what she calls 'psychic' and will regularly see the ghosts of people long gone lining the side of the road or working in the adjoining fields, all in their contemporary dress. At Waterford beside the green telephone connections box, she often sees a man in a floppy hat and 1940s khaki coloured clothes. Further along the route of her journey she has seen three women sitting on the grass verge of Hooks Cross, usually at sundown.

70. Waterford, Waterford Church.

In the 1970s, a young woman living at 46 High Road, Waterford, had two very strange experiences. One night she woke to find a lovely young lady standing over her. She was wearing a long white dress and had long blonde hair without a hat. She smiled in a warm and friendly way and stood for some minutes before slipping back into the wall and disappearing. Could this be the same woman in white that was almost run over by Mr Childs? Local legend is that a young woman drowned in the river Beane which ran through the back garden of the house.

In the same room some months later, the young woman also saw the ghost of an old lady dressed in possibly Victorian clothes. This time the apparition drifted back out of the door. The witness, now 50 years old, is adamant that neither vision was a lucid dream.

WATFORD

Manifestation: Wonderous Wraiths of Watford Town

History:

A shady bridle path running from Station Road to the railway bridge in St. Albans Road was once known as **Featherbed Lane**. It is here someone is supposed to have hanged themselves and subsequently locals say the quiet little lane has been haunted by all kinds of unearthly noises. In folklore, many believe this to be the place where troubled spirits gathered.

Around the end of the 18th century, a man known as Jockey Fenson who resided at a place, locally called the 'Pesthouse', committed suicide and was buried unceremoniously in a hole in a dell known as **Hagden Lane**. Not long afterwards, a rumour spread that a spectre clad in white walked the lane nightly and might sometimes be seen sitting on the gates or gliding noiselessly over the adjoining field. A great fear seized the children of the neighbourhood and even many adults refused to pass the dell or go anywhere near it. The perturbation of people became so great that the parochial authorities had the body removed and it was supposedly buried in a corner of the old churchyard.

Mr Henry Williams in his 'History of Watford' writes, 'A house now occupied by Mr Downer, stationer, was untenanted for a very long time before he took it. The cause was said to be that it was haunted by the spirit of a lady who had previously resided there.' However, apparently Mr Downer had an untroubled residence.

The **Palace Theatre**, built in 1908 as a music hall and a venue where Charlie Chaplin performed before he was famous, is a haven for ghosts. Theatres seem to possess a certain atmosphere, harbouring all the played out emotions of both performers and audience. Here, the footsteps of some long dead performer still grace the boards and at 3 o'clock one morning, workmen erecting a new set watched in amazement as they followed the direction of the phantom footsteps only to watch the stage curtains part as if someone had just passed through it. For some unknown reason, those who have heard the ghost have nicknamed it 'Aggie'.

Mill End Community Centre has been troubled by footsteps, doors opening and closing by themselves and lights going on and off. The building was the old Shepherd's Infant School built in 1909-1910 on a former field. One night, the caretaker had switched off the lights, locked up and was walking away from the building. He got as far as the gates when all the lights suddenly came back on. Then another night, one of the classroom doors refused to lock, when it had previously been no trouble at all. The caretaker had no choice but to leave the door unlocked and leave for the night. The next morning when the staff arrived to unlock, the door that had been a problem was firmly locked.

A lady called Margaret was combing her hair in the ladies' cloakroom late one evening when she saw someone standing behind her in the mirror. It was a young blonde woman in Edwardian dress with a large hat and when Margaret asked what right she had being there, the Edwardian woman answered, 'I have got as much right as you.' Shocked, Margaret then found she was alone in the cloakroom.

Tenants of **Green End Farm** near Watford were driven out by the ghost of a little old woman in a black gown with white lace. She would wake people in the night by yanking off their bedclothes. Then residents would hear a jingle of harness and the sound of feet clattering

over cobbles outside. Yet there are no longer cobbles in the yard as they were removed many years before. These events are believed to date back to the time of the Civil War when Cromwell quartered some of his soldiers in the attic of the farmhouse.

The farmer's wife in the late 1940s was a Mrs Keeble and she is said to be quoted in a Sunday tabloid of September 1950 as having grown used to the phantom sights and sounds of her accommodation. Talking of the little old lady in black, she said, 'During the day I meet her on the stairs or when I am cooking. Sometimes I feel she is the rightful owner and I am only the guest.'

A factory in **Otterspool Way** is haunted by the figure of a man wearing a foreman's white overall and smoking a pipe. His description is thought to fit with that of a former foreman who collapsed and died there in the 1950s. Night shift workers at the factory have been terrified of meeting the ghost and one who did, fled never to return. Sometimes the ghost appears to be faceless.

One night, a member of staff was working late when he saw the back of a man appear from a locked room. From behind, he looked stocky and had grey hair.

97 High Street was haunted by the spirit of an old lady who previously lived in the house and for many years after she died, the building remained empty. Still in the **High Street**, the upper floor above Jackson's the jewellers is haunted by an Elizabethan gentleman complete with doublet, hose and ruff. When it was occupied by a restaurant, staff saw him wandering about when the customers had left. One man, who came face to face with the apparition, described him as an old man just over 5ft tall and wearing stockings, doublet and puffy short trousers. 'It was grey, like a grey mist' he said. 'It had no colour and it was impossible to say whether the doublet was made of velvet or leather.'

Without telling other colleagues of what he had seen, reports began filtering in from others who had met the Elizabethan, often seeing him walking as if on a lower level. The building is 15th century and a second level was added after 1588. One lady arrived for work and was greeted by a gentleman but on turning round to respond, found nobody there.

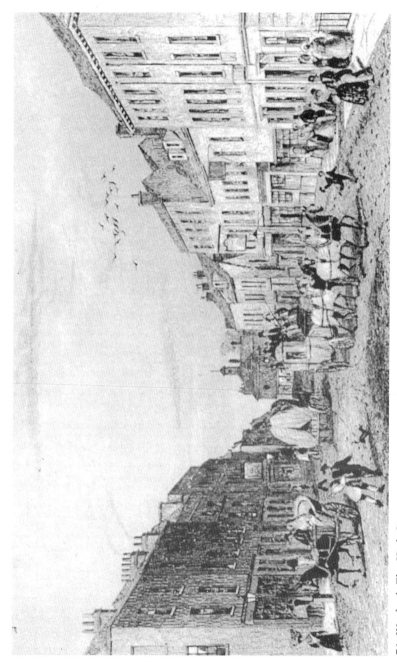

71. Watford, The High Street.

227

Two 400 year old cottages in **Bushey Mill Lane** have now been demolished but would have originally been one building. When occupied by a builder named Mr Browne and his family, there seemed to be always a presence lingering in the building which caused no-one in the house to like being alone and trips to the bathroom or adjoining bedrooms would be made in pairs. Strange noises emanated from somewhere beneath the stairs and on many occasions when he was alone in the house, Mr Browne would be woken from a deep sleep by heavy noises on the stairs. So convinced was he that there were intruders in the house, the police were called several times but no-one was ever found. Mr Browne began to hide weapons around the house for his own protection and had window frames screwed down. Not long afterwards, the house was subject to compulsory purchase and demolished at a later date. Mr Browne was not to discover the cause of these strange nocturnal noises until sometime later when he had left the building.

Apparently there was a bricked in chamber under the floor and when police came digging the garden one day on a separate investigation, the story came to light. Many years ago a married couple owned the property and when the wife disappeared, her family became concerned about her lack of contact and the police were involved in trying to trace her whereabouts. The woman was never found.

A little girl who appears on the stairs at the **Royal Masonic School**, was supposedly injured when thrown by her pony and died in one of the upstairs rooms. Despite being well heated by large radiators, that particular room remains unearthly cold. The school, like so many other buildings with ghostly occupants, has trouble with its lighting.

Making their presences felt at **Scotsbridge Mill** in the late 1980s, ghosts appeared to be objecting to turning a former paper mill into a restaurant. They seemed in concordance with local residents who were against the Mill as a location for a new Beefeater Steakhouse. With a repertoire more varied than a Beefeater menu, the ghosts moaned, groaned and made objects appear and disappear. But dish of the day was the headless horseman who took his ghoulish gallop through the grounds. Surveyors and brewery staff were suitably spine chilled and

in the end the meddling spirits won the day as the plans were dropped. However, the building was eventually turned into a restaurant some time afterwards.

On Halloween in 1989, some members of the Society for Psychical Research spent the night at the Mill but discovered nothing more than 'cold spots'. Although one local man can remember seeing the ghost as a child, playing with some friends around the deserted Mill at dusk one evening before refurbishment. He said, 'I swear even to this day that I saw it. It was like Dick Turpin riding towards me without a head, but wearing a frilly ruff. It galloped past and off into the distance without leaving any hoof-prints.'

At the offices of the **Watford Observer** newspaper, catering staff arriving early in the morning have experienced feelings of being pushed by invisible hands and prodded in the back. One lady was pushed so hard she fell to the ground.

One night, a member of staff working alone late in the canteen heard the sound of something being thrown at the window from outside. The noise continued, so he went to investigate, but no-one was around and yet the sound carried on. Then an eerie whistling started in the building and frightened the lone staff member so much he had to turn the radio on full blast to block out the spectral sound.

A young woman in a house in **Tudor Avenue** woke one night to see the petrifying figure of a cowled monk at the foot of her bed. She described the apparition as having 'evil, glittering eyes' and its arms reached out from the folds of the gown towards her throat.

Manifestation: Do Not Disturb!

History:

The building of a rail tunnel through part of a churchyard near Watford seemed to arouse a lot of objection, from the dead. During the construction work, coffins fell open and human remains tumbled out into the rail workers below.

Once the line was finished, the steam engine drivers seemed to experience problems passing one particular point in the tunnel where

a sudden, vicious blow-back caused several drivers severe burns. The point was traced as being where the line had cut into the churchyard.

Manifestation: Lord Capel of Cassiobury

History:

If you are brave enough to venture to Cassiobury Park on a moonlit night, particularly around the 9th March, you are likely to run into the headless wraith of one of Watford's most aristocratic ghosts. Lord Capel roams the pathways of Cassiobury Park after dark and some say without a head, when others describe him with long hair and a full moustache. Many people talked of his apparition and were wary of approaching the Park after nightfall.

Cassiobury House was once the family seat of the Earls of Essex and stood grandly overlooking the park of landscaped gardens and avenues of ancient trees until 1927 when the estate fell into ruins.

Lord Capel has been described as one of the most zealous and highly esteemed members of the Royalist army, fighting bravely for Charles I during the Civil War. He finally surrendered to General Fairfax and was beheaded in 1649, the same year as the King. According to legend, Lord Capel's heart was taken to the family home at Hadam Hall and was later moved to Cassiobury House where it seems to have been forgotten.

In 1830, a bargeman passing by the old watermill at Cassiobury Park, described his encounter with the ghost:

'It stood on the lock gate, its long white robes fluttering in the moonlight and the faint clink of iron chains could be heard.' Although this 'ghost' turned out to be nothing more than the family footman robed in white sheet and having an after midnight jape at Lord Capel's expense.

72. Watford, Cassiobury.

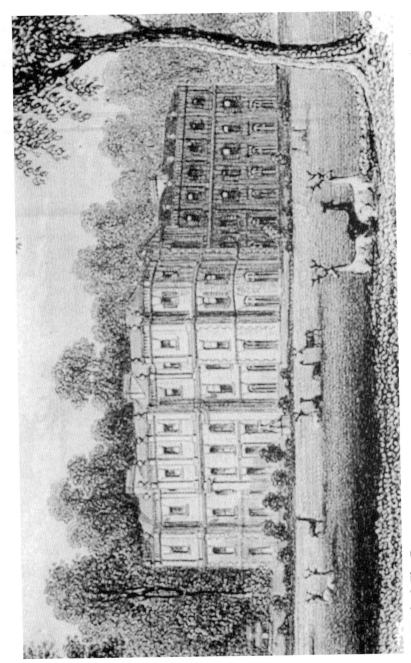

73. Watford, The Grove,

Manifestation: Haunter and Hunted

History:

On stormy nights at The Grove, a ghostly fox hunt is said to be re-enacted all around the grounds. The terrifying sight of Lord Doneraile, condemned to ride forever with hell hounds in pursuit of an equally phantom fox, haunts the park throughout the year.

The Grove is another one of the county's glorious stately homes built around 1756 which, in its heyday, was where the aristocracy were entertained in the beautiful Hertfordshire countryside. King Edward VII was among the guest list. Now a hotel, the mansion was home to the Earls of Clarendon until the 1920s.

This bizarre re-enactment is Lord Doneraile's eternal punishment for converting an ancient chapel in the basement of the mansion, into a kitchen when he built the Grove in the 18th century. But a building existed on the site long before the 1700s and experimentation in the cellars dates the foundations of the building to over 500 years old. A former warden at the house saw the ghost on many occasions. He told the *Watford Observer* in 1974, 'When we came here in 1957 they decided to do some alterations and when they took down some plaster in the present entrance lounge, they discovered a font in the wall. It was pale blue and built into a wall 3ft thick.'

WATTON-AT-STONE

Manifestation: Hall-full of Hauntings

History:

Frogmore Hall is an imposing looking, red brick building, tucked away in 14 acres of countryside near Watton-at-Stone. The original Hall stood closer to the riverbank but was demolished in 1860 because of the damp and the present country house was constructed further up the hill. Now the headquarters of Jarvis plc, the house was once the family home of the Hudson family.

In the 1980s, children were heard coming up and down the main staircase, chattering and laughing and then their voices faded away in a room off the main hall (now the chief executive's office). A cleaner working at the time, heard the voices coming closer, then disappearing and was very frightened.

Edwina, a former occupant of the Hall in the 1800s, walks down the staircase, leaving the strong scent of lavender lingering in the air. She is supposed to have hanged herself in the gothic looking tower at the top of the house.

The manager of a security company that patrols the house reported a coach and horses had been seen on various occasions driving past the main entrance towards the stable block. An old gentleman walking slowly around the gallery above the main hall in dark clothes and a cloak was seen by a former employee and a security guard in the 1990s. This has been identified as the Reverend Thomas D Hudson, former owner of the Hall and who died in 1889 aged eighty-five. Above the main hall used to be a chapel, now converted into offices.

In the former older building, the lady of the house was said to have stood at the highest window day after day, waiting for her husband to return from the French wars. He never did, so she killed herself and her ghost continued to wait at the window, watching for her man's return.

The area around the **church** is haunted by an unhappy grey lady who is thought to have thrown herself off the tower when she was spurned in love.

WELHAM GREEN

Manifestation: Domestic Dramas at the Greasy Spoon

History:

One night, a group of friends gathered at a house near Welham Green, watched stunned as a tall pottery teapot lid lifted itself in the air and smashed before hitting the ground.

'That's Lydia' said the former house owner, 'She's always doing things like that.' And just to prove her point, she displayed a collection of glasses all smashed in exactly the same distinctive way that she had found in the cupboard earlier. She held one of the glasses aloft, saying, 'This one smashed by itself in front of everyone while it stood on the worktop. No-one was near it, but we all saw it smash.'

The house was a former café on the Great North Road, and as a private home, it was said to be haunted by the ghost of the café owner whose remains lie buried in the garden. In its last days as a café, it was run by an elderly couple, Lydia and her husband. Lydia died of cancer and her ashes were buried beneath a tree in her beloved garden. Her husband, unable to cope with running the business alone, sold to a builder, who transformed the place into a lovely family home.

People using the bathroom have been touched by invisible hands or had their clothing tugged. Upstairs, bags, make-up and other objects have suddenly gone missing only to reappear in an obscure place later on. 'It's always happening' said a member of the family. 'I put something down, turn for a split second and then I go to pick it up and it's vanished. It happens too often to be coincidence.'

Lydia's favourite haunt however, is the kitchen. She pulls hair, plays havoc with the crockery and throws objects from the fridge. Lydia has also been known to undress the guests. One visitor, standing in the kitchen, felt her belt being undone and slipped off her.

'There is one particular spot in the kitchen where everything happens' said the former house owner. 'I would open the cupboard and glasses would just come flying out at me. I think this room was her domain when she ran the café and she sees me as intruding.' Her husband had felt himself being pushed downstairs at one time and in the toilet and dining room, a coldness lingered that never changed, no matter what the weather. Coincidentally these rooms face the tree under which Lydia's ashes are supposed to lie.

During their occupation in the house, the family saw things moving out of the corner of their eyes, but when they turned, there was nothing there. A misty form was witnessed once by a younger member of the family.

WELWYN

Manifestation: Wraiths of Old Welwyn

History:

Captain Neall, the grandson of George Edward Dering, owner of 'Lockleys', wrote a letter to a local magazine in the 1970s, telling the story of the building's hauntings first hand.

Lockleys is an old building, recently Sherrardswood school, that stands on land which has been inhabited since prehistoric times. Celtic burial places have been found there and the manor of Lockleys was in existence since 1303, the present house dating from 1715. The building has had many illustrious owners, among them John of Gaunt, Henry IV and Captain Edward Wingate who represented St. Albans in the Long Parliament just prior to the Civil War.

Captain Neall states that his great-great grandmother, the Dowager Lady Shee treads the fine tulip wood staircase on occasions and was seen by his wife, smiling in the open bedroom door one morning. Other stories tell of a spectral painter who is occasionally glimpsed working at his easel. Some people have reported seeing his grandfather George Dering sitting on a tree stump overlooking the bowling alley. Dering was, among other things, an esteemed inventor and was a friend of Jean Francis Gravelet, better known as 'Blondin' the tight-rope walker, and together they practiced this art at Lockleys. Blondin stayed at the house before his first crossing of the Niagra Falls in the mid 1800s.

One night sometime around 1940s-50s, one of the staff had been on late duty at the house and on her way to bed, she saw a strange looking man in the maids' quarters. She watched and he eventually went away but in the morning when she described him to another member of the household, she was told she had perfectly described Squire Dering who had been dead for quite some time.

Dering's foundry at Lockleys was fitted with one of the first lightning conductors in use and he is also responsible for reconstructing the Welwyn to Hertford road at the point where it passed his property, changing its course further to the south. Always

74. Welwyn, Lockleys.

75. Welwyn, George Dering.

regarded as an eccentric, reclusive bachelor, it came as a surprise after his death in 1911 to discover he had been married and divided his time between the marital home in Brighton and his recluse at Lockleys

In the little village of Welwyn itself, an old man named Thompson living in a caravan on waste ground in **Mill Lane**, had once been part of the travelling fairground folk. An educated man, he had been making a living reading and writing letters for those who were illiterate but could no longer survive on this solely, he died penniless and alone in the village rather than ask for help. His body was discovered on Christmas Eve when locals forced open the door of his caravan. Three days later, a letter arrived for him, saying he had inherited a fortune. Older residents of the village swear that Thompson comes a knocking at folks' doors on Christmas Eve.

In the 1980s, a taxi driver was delivering passengers near to **Guessen's House** opposite the church. All those in the car saw a young lady in white with a grey shawl and wearing a sun bonnet over golden curls, emerge from a wall and cross to the church. Villagers often see her crossing the road. She is thought to be Lady Betty Lee who came to live at Guessens House in 1731.

WELWYN GARDEN CITY

Manifestation: Ghosts of the Garden City

History:

An old lady stalks the grey hospital corridors of the **Queen Elizabeth II** in Welwyn Garden City. Nurses on the night shift have reported seeing her shadowy figure scuttling along and of feeling uneasy alone on the ward. One nurse told of seeing a misty vapour rising from at least two of her patients at the moment of death. She felt drawn to open a window to allow the spirit to leave the place.

At **Guessen's Court** near the town centre, a former hotel building was said to be haunted by a lady murdered in the time of the Crusades who now appears around 23rd-27th July each year. The story goes that

Richard Whyte, one of the knights on crusade with Richard I, took a mistress and installed her in an extension of Handside farmhouse (upon which Guessen's Court now stands). But when Whyte's wife heard of this, she had the building burned down. White was furious and in a rage, he killed his wife, severing her head. The King pardoned him because of his great service in the crusades and he was later made Lord Lieutenant of the county. But which of the murdered women is the lady who haunts Guessens (Danish for guest)?

When the Treetops Hotel occupied the building in 1969, the manageress told of one night soon after they moved into the building, the chef heard the noise of pots rattling in the kitchen when the room was empty, lights mysteriously turned themselves on and off and the telephone began ringing but was eerily dead when answered. Staff also reported feeling an 'invisible force' that barred entry into a room adjoining the Banqueting Hall.

A séance was held one night in the bar of the **Barn Theatre** in old Handside Lane. Mysterious flickering lights began to appear and the blackened old beams, which allegedly were originally ships' timbers, began to glow red. Doors with no locks jammed fast and the sitters became terrified. Only when the séance halted did things return to normal. One actor at the theatre, who experienced ghostly activity there, refuses to discuss his experience. So what does haunt the ancient old Barn? An electrician working there often sensed the presence of something 'nasty' and saw a strange luminescent glow on stage when none of the lights were on. He says, 'I am very sensitive to presences and can feel when a ghost is around. One night we had been telling ghost stories in the bar, which seemed to get an energy moving. A group of us progressed to the auditorium where I tuned into the unpleasant spirit, which I felt to be a male.' What happened next can only be described as a possession. The electrician began shaking uncontrollably and arguing and swearing with something unseen. 'I wasn't afraid,' he said, 'I believe a spirit cannot hurt you as it's already dead. It's your fear that hurts you.' A priest was called to the Barn some time later to perform an exorcism and the spirit quietened down.

The theatre has many ghosts flitting around. A little boy wanders

the boards, thought to have been killed by farm equipment at some time in the distant past, and the spirits play havoc with the electrics. Women do not like going into the kitchen at the rear of the building, formerly the old wardrobe area, because it is always unnaturally cold and they feel uneasy and a lady working in the back office one day had brought her pet Labrador in with her. Suddenly the dog stood up and began growling, its hair on end. Uncharacteristically it could not be calmed. The lady, believing there to be an intruder in the building, walked with the dog towards the stage but it became more agitated and eventually she had to take it out of the building before it calmed down.

Children's voices have often been heard echoing in the empty theatre, the restless footsteps of a past thespian still tread the corridors and one young couple who stayed behind late in the theatre one night were so terrified by 'something' that stalked the stage that they fled, refusing to be alone there again.

In the days when set builders would work into the early hours constructing scenery, one worker was up a ladder on the stage when he heard footsteps coming down the corridor. It was 3 am and he was alone in the building. The footsteps continued onto the stage and looking down he saw bits of wood moving around. He remembers nothing more until he found himself outside the theatre and very afraid. Another set builder working through the night was startled when suddenly the stage lights came up then slowly went down again. He looked over into the lighting box to see who was playing tricks on him at such an hour, but chillingly there was nobody there.

Haunted houses are dotted about all over the county and it is virtually impossible to trace every single haunting. However, a lady in **Panshanger**, near Welwyn Garden City, was on the verge of selling her home because she could no longer cope with sharing it with an 'unseen presence'. Calling in a psychic, she was told that an 18th century mother searched for her child in the house. The psychic contacted the spirit and from then on it quietened down. He said:

'Spirits are like children, they want attention and once you make contact and explain how things are, they are ok.'

In November 1974, a ghost reportedly terrified the occupants of a

nine-roomed house in **Applecroft Road** so much so that an exorcism was demanded. Originally it was occupied by 'artistes' from the Campus West theatre complex, but after residents fled from the alleged haunting, the council proposed to use the house as a hostel for homeless families.

WESTON

Manifestation: Phantom Coach and Horses

History:

On nights when the moon is full, a phantom coach and four, complete with passengers and lamps lit, comes full pelt down Lannock Hill and as it nears the bottom, turns over into a chalk pit and is seen no more. According to tradition, four horses drawing a coach containing a newly married couple, ran away down the hill, crashing at the bottom and the two occupants were thrown out and killed on the spot.

According to folk legend, the vicarage cellar is also haunted but like a ghost, the story has vapourised into the mists of time.

WHEATHAMPSTEAD

Manifestation: Secrets from Beyond the Grave

History:

Deep mystery surrounds the death of Ann Noblett. She was last seen getting off a bus in the Lower Luton Road in December 1957. Her body was discovered, frozen solid, on a mild January day in a wood at Whitwell. While police and villagers had been frantically combing nearby woods and fields for clues, seventeen year old Ann had been strangled and hidden in an industrial deep freezer for over a month. Detectives ascertained she had been stripped then gruesomely re-dressed in the same clothes she was wearing when she disappeared. When she was found, her hands were gently placed across her chest and she was still wearing her glasses. She had not been robbed, in fact

her purse was found alongside the body with no money missing. This apparently motiveless killing has baffled police for nearly half a century. Ann's murderer or murderers have never been found and today her case still remains unsolved.

Seventeen years after her death, Ann again hit the local headlines when her ghost returned to a premises near her former home, frightening the occupants so that they refused to linger after dark. The premises in Marshalls Heath Lane, formerly a pig farm, in the 1970s was occupied by several businesses and one in particular was a plant hire company. Staff reported odd experiences, locked doors would continually open and one man who took part in the original search for the dead girl, was feeding the cat one night when he felt something touch his head. When he looked round there was nobody around and nothing to explain the sensation. The cat itself would suddenly arch its back and hiss at something no-one could see.

Another man said he had seen a young girl playing at the end of one of the sheds. He shouted to her but when he went to speak to her, she had vanished, yet there was no exit for her to have taken and she would have had to walk past him, as he approached her, to have escaped.

Today Marshalls Heath Lane is a winding, unlit road which passes through woods on the way to remote farm buildings and this lonely location has an atmosphere of possessing a great many secrets. Ann's remains lie with those of her father, who died in 1985, in a peaceful corner of St. Helen's churchyard in Wheathampstead. Perhaps her spirit cannot rest until her killers are brought to justice, but possibly by this time they themselves now lie beneath the ground.

Manifestation: Wicked Lady Rides Again and Again

History:

The story of Wicked Lady Katherine Ferrers has already been told in connection with Markyate, but just between St. Albans and the village of Wheathampstead, lies a stretch of barren common known locally as 'nomansland'. It was on this scrubland late one bright moonlit night in

243

1970 that a gentleman was exercising his dog when he heard the sound of a horse galloping at high speed through the shrubs. It was heading towards him and came so close he could have touched it, but nothing could be seen, not even a movement of the bushes. The only sign that he hadn't imagined the experience was that his dog had become petrified and was barking wildly at something unseen.

A pub nearby the common is named The Wicked Lady and was believed to have been used for illicit meetings with her companions in crime. The pub's manager in the 1970s was Doug Payne and he said that customers had often heard the sound of a woman weeping. Lady Katherine would ride to the **Tin Pot** pub at Gustard Wood, just up the road, and change into her highwayman's clothes. Two people who stayed in the room she used said they experienced a 'strange presence' and were obviously disturbed by what they felt, as the next morning one of them wrote a poem about it and it was put up in the bar.

WHITWELL

Manifestation: Fishy Tale

History:

At the top of Bury Hill, ghostly old Betty Deacon cooks her sprats every Tuesday. Perhaps she is re-enacting a long forgotten time when she would walk to Hitchin market and return with her fish to fry.

The **Bull** inn in the village, nestling at the bottom of Betty Deacon's hill, had a troublesome haunting for some time until a skeleton was unearthed. The most recurrent ghost there was that of a recruiting sergeant at the time of the Napoleonic Wars but during building work in the 1930s, the skeleton and shreds of a uniform, like the one that had been seen on the ghost, were discovered and given a Christian burial to lay the ghost. The inn was first identified in 1675 but is thought to be medieval in origin.

WIDFORD

Manifestation: Babes in the Wood

History:

An old legend in Widford involves more disappearing children. The Plumer family, a family of distinction, occupied a house named Blakesware in which descendants would see two infants gliding up the great staircase at midnight. These were thought to be the 'babes in the wood' both of whom had mysteriously and suspiciously vanished.

WORMLEY

Manifestation: Tales from the Wood

History:

Another woods story is that of ancient Wormley Wood which was first mentioned in 6th century documents. 'Worm' is derived from the Saxon corruption of 'Vermes', which macabrely refers to a wasteground near the River Lea, where bodies of Danish soldiers lie after a battle in the area. Is it these soldiers' spirits that wander restlessly the woodland floor? William the Conqueror reputedly marched through the woods with his army after Hastings en route to the north of England.

Manifestation: Pastor who Missed the Last Show

History:

The Paradise Park animal centre is an unlikely place for a haunting, but it simply goes to show that it isn't just creepy old buildings or ruined castles that possess ghosts.

A former keeper in 2000 was closing up the Jungle Theatre one evening when she saw a shadowy figure in black slip into the theatre.

Wondering how he had managed to enter a locked building, the keeper followed him to tell him the theatre was now closed. As she caught up with him and called out, he turned briefly before disappearing through a solid wall. In shock, the keeper later was able to describe what she had seen. He was dressed in long, flowing black robes with a lace neckpiece and resembled an old fashioned Pastor.

An explanation put forward is that allegedly, the birds of prey enclosure was built over a former plague pit and the spectral long-departed Pastor was connected with this site.

APPOINTMENTS WITH APPARITIONS

For those who take ghost watching seriously, here are a few dates for the diary. The following apparitions are allegedly supposed to re-enact their ghostly pasts on the dates given.

DATE	HAUNT	VENUE
13th February	Moat Lady	Much Hadham
9th March	Lord Capel	Watford
11th March	Robert Snooks	Boxmoor
10th May	Friars	Braughing
15th June	Goring	Pirton
23rd-27th July	Lady of Guessens	Welwyn Garden City
August	Shadow Child	Pré Hotel, St Albans
October	Grey Lady	Balls Park, Hertford
1st November	Sir John Jocelyn	Sawbridgeworth
1st November	Mary Ann Treble	Abbots Langley
23rd December	Grey Lady	Bishops Stortford
Every 6th Christmastide (next appearing 2004)	Sir Geoffrey de Mandeville	Barnet
31st December	Coach and Four Horses	Hatfield House

HAUNTED HERTFORDSHIRE
BIBLIOGRAPHY

ABBOTS LANGLEY

'Haunted Britain' 1973 A Hippisley Coxe

ALDBURY

Hertfordshire Countryside Sep 1971

ALDENHAM

Hertfordshire Archives and Gerish Collection, Box 5
Local Studies

Hertfordshire Countryside Apr 1973

Sep 1978

Oral testimony 2001 Lynn Englebright

ANSTEY

Hertfordshire Archives and Gerish Collection, Box 6
Local Studies

Hertfordshire Mercury Mar 7 1903

Sep 28 1934

Herts and Cambs Reporter May 3 2001
and Royston Crow

ASHWELL

Hertfordshire Countryside Nov 1977

Nov 1981

'Ashwell Before 1939' n.d A Sheldrick

ASTON

Hertfordshire Mercury Nov 11 1983

AYOT ST LAWRENCE

Herts Advertiser	Oct 31 1980	
Welwyn Hatfield Times	1950	
'Our Haunted Kingdom'	1973	A Green

BALDOCK

Hertfordshire Countryside	Nov 1977	

BARKWAY

Herts and Cambs Reporter and *Royston Crow*	Jul 4 1986	
'Haunted Britain'	1973	A Hippisley-Coxe

BARNET

Hertfordshire Mercury	Jan 1 1927	
	Sep 1 1933	
Potters Bar & Cuffley Press	Apr 19 1995	
The Star	Dec 15 1925	
Sunday Dispatch	Jan 1 1933	
Hertfordshire Countryside	Jan 1969	
	Mar 1995	
'The Mummy of Birchen Bower & Other True Ghost Stories'	1985	H Ludlam
'Haunted Churches & Abbeys of Britain'	1978	M Alexander
'Railway Ghosts & Phantoms'	1992	WB Herbert

BERKHAMSTED

Berkhamsted Gazette	Dec 26 1969	
Hemel Hempstead Gazette	Apr 14 1978	
'Reminiscences of Berkhamsted'	1890	H Nash

BISHOPS STORTFORD

Hertfordshire Archives and
Local Studies

Gerish Collection, Box 18

Bishops Stortford Citizen	Jun 19	1996
	Dec	1996
	Jan	1997
Herts & Essex Observer	Nov	1974
	Mar 17	1983
	Jan 28	1988
	Dec 14	1995
	May 31	2001
Hertfordshire Mercury	Mar 31	1923
Hertfordshire Countryside	Jun	1974
	Jul	1975
	Nov	1988

BOVINGDON

Hertfordshire Archives and
Local Studies

Gerish Collection, Box 18

Hertfordshire Mercury	Jun 3	1911
Hertfordshire Countryside	Nov	1988

BOXMOOR

Hertfordshire Countryside	Nov	1990	
'Gothic Hertfordshire'		1989	J Westwood

BRAUGHING

Hertfordshire Mercury	Oct 7	1911
	Apr 6	1912
	Dec 22	1967

BRICKENDON

Herts Advertiser	Dec 28	1984
Hertfordshire Mercury	Jan 31	1920
	Feb 7	1920

Hitchin Museum	Nov 22 1902	
Newspaper Scrapbook, Vol. 5		
Oral testimony	2001	(name supplied)

BROXBOURNE

Hertfordshire Countryside	Oct	1994
Hitchin Museum Newspaper		
Scrapbook, Vol. 5	Nov 22 1902	

BUNTINGFORD

Hertfordshire Mercury	Jun 10 1949	
	Dec 22 1967	
	Mar 30 2001	
Buntingford Journal		
(Vol 4, no 4)	May	1979
(Vol. 4, No. 5)	Jun	1979
(Vol. 4, No. 6)	Jul/Aug	1979
(Vol. 4, No. 7)	Sep	1979
(Vol. 4, No. 8)	Oct	1979

BUSHEY

| 'Ghosts of London' | 1975 | J Hallam |
| Oral testimony | 2001 | BBC film crew |

BYGRAVE

Hertfordshire Archives and		
Local Studies		Gerish Collection, Box 18
EHAS Transactions	1911	
(Vol 4, part 3)		

CALDECOTE

| North Herts Gazette | Apr 24 1980 |

CHESHUNT

Hertfordshire Archives and
Local Studies

Gerish Collection, Box 18

Hertfordshire Mercury	Feb 6	1909
'Phantoms of the Night'	1956	E O'Donnell

CHIPPERFIELD

Watford Observer	Feb 14 1997

CODICOTE

Hertfordshire Mercury	Nov 2	1912
Stevenage Gazette	May 30	1968
EHAS Transactions (Vol. 5)		1912
'Haunted Mid Herts'	n.d	Mid Herts Teachers Ass.
'Hertfordshire Folklore'	1977	D Jones-Baker

DATCHWORTH

Letter to Ruth Stratton	1996	(name supplied)
Hatfield Herald	May 20 1988	
Hertfordshire Countryside	Mar 1981	
Hertfordshire Mercury	Jun 17 1975	
	Jun 27 1975	
	Apr 27 1984	
Stevenage Gazette	Jan 16 1975	
Welwyn Hatfield Times	Jun 13 1969	
	Jul 11 1969	
	Oct 9 1970	
	1984	
	Feb 19 1987	
The Countryman	1951	
'Five Hides Village'	1985	Beachcroft & Emms
'Our Haunted Kingdom'	1973	A Green

ESSENDON

Hertfordshire Countryside	Apr	1968	
Hertfordshire Mercury	Sep 7	1984	
'True Ghost Stories'		1990	V Rae-Ellis

FLAMSTEAD

'A New History of Flamstead'	1999	E Edwards

GILSTON

Herts & Essex Observer	Jun 25	1998

GRAVELEY

County Press	Jan 6	1831

GREAT HORMEAD

Hertfordshire Countryside	Nov	1988

HARPENDEN

Harpenden Advertiser	Dec 20	1984
	Jan 5	1985
Review This Weekend	Dec 7	1985
Welwyn Hatfield Review	Mar 28	1985
Hertfordshire Countryside	Mar	1985
Campaign for Real Ale magazine *'Pints of View'*	Apr/May	2001

HATFIELD

Hertfordshire Archives and Local Studies		Gerish Collection, Box 37
Cassell's Saturday Journal		1894
Hertfordshire Mercury	Oct 5	1907
	Dec 22	1917
	Apr 3	1915
North Herts Gazette	Feb 15	1985
Watford Observer	Jul 3	1915

Welwyn Hatfield Times		1950	
Hertfordshire Countryside	Summer	1957	
'Haunted Houses You May Visit'		1982	M Alexander
'Haunted Mid Herts'		n.d	Mid Herts Teachers Ass.

HEMEL HEMPSTEAD

Hertfordshire Countryside	Oct	2000	
'Our Haunted Kingdom'		1973	A Green
'Hertfordshire Inns &		1995	Joliffe & Jones
Public Houses'			
Phantomorfraud		2001	website

HERTFORD

Hertfordshire Mercury	Sep 6	1902	
	Oct 4	1902	
	Aug 8	1914	
	Mar 5	1976	
	Oct 27	1978	
	Dec 24	1991	
	Oct 27	1995	
Hertfordshire Countryside	Nov	1998	
'Ghosts of Hertford'		2000	R Stratton
'Leahoe House'			K Griffin
Oral testimony		2001	(various names supplied)

HIGH CROSS

| *Hertfordshire Mercury* | Mar 17 | 1995 |

HINXWORTH

| *Hertfordshire Countryside* | Sep | 1981 |
| | Dec | 1981 |

HITCHIN

Hertfordshire Mercury	Jan 2	1904
	Feb 1	1913
	Oct 31	1929

Letchworth & Baldock Express	Feb 10 1981	
North Herts Gazette	Aug 9 1985	
	Oct 11 1985	
	Jan 23 1987	
Stevenage Gazette	Jan 23 1975	
	Aug 23 1984	
	Nov 15 1984	
EHAS Transactions	1911	
(vol 4, part 3)		
Hertfordshire Countryside	Summer 1953	
	Spring 1957	
	Dec 1969	
	Dec 1977	
	Jan 1979	
	Dec 1980	
	Jun 1985	
	Dec 2001	
Hitchin Journal	1983	
'History of Hitchin' Vol. 1	1927	R Hine
'Phantom Footsteps'	1959	AA MacGregor
'History of Hertfordshire'		WB Gerish's grangerised copy of Cussan's
'Strange happenings in Hitchin & North Herts'	1978	Pigram

HODDESDON

Hertfordshire Archives and Local Studies		Gerish Collection, Box 49
Hertfordshire Mercury	Dec 28 1975	
Lea Valley Mercury	Dec 3 1982	
Hertfordshire Countryside	Jan 1968	

KIMPTON

Hertfordshire Archives and Local Studies		Gerish Collection, Box 52
Herts Advertiser	Jan 2 1904	

KINGS LANGLEY

Watford Observer	Jan 7	1911
Hertfordshire Countryside	Summer 1962	

KNEBWORTH

Hertfordshire Mercury	Jun 1	1901	
	Aug 6	1902	
	Dec 2	1911	
	Dec 26	1914	
Stevenage Comet	n.d		
Welwyn Hatfield Times	May 20	1977	
	Jan 31	1969	
Hertfordshire Illustrated	1894		
Review (Vol.1)			
Dictionary of National Biography			
'Haunted Mid Herts'	n.d	Mid Herts Teachers Ass.	
'Our Haunted Kingdom'	1973	A Green	
'Britain's Haunted Heritage'	1990	Brooks	

LEMSFORD

News of the World	Jan 28	2001	
'Haunted Mid Herts'	n.d	Mid Herts Teachers Ass.	

LETCHWORTH

Herts & Beds Citizen	Jan 23	1970
North Herts Express	Feb 6	1986

LILLEY

Hertfordshire Countryside	Mar	2001
'Tales of Old Hertfordshire'	1987	D Jones-Baker
Phantomorfraud	2001	website

LITTLE GADDESDEN

Hertfordshire Archives and Gerish Collection, Box 30
Local Studies

Berkhamsted Gazette	Mar 3 1967	
	May 19 1967	
Hertfordshire Countryside	Winter 1949/50	
'Little Gaddesden & Ashridge'	1983	H Senar

LITTLE WYMONDLEY

| Hertfordshire Mercury | Jan 14 1913 | |
| 'History of Hertfordshire' | | WB Gerish's grangerised copy of Cussan's |

LONDON COLNEY

Herts Advertiser	Oct 26 1973	
	Nov 9 1973	
	Mar 22 1974	
Hertfordshire Mercury	Jun 5 1909	
	May 1 1909	
Midweek Recorder	Mar 11 1975	
Welwyn Hatfield Review	Mar 19 1981	
'History of Salisbury Hall'	2001	Bournewood Partnership
'Stately Ghosts of England'	1977	D Norman
'The Ghost Book'	n.d	Thresher & Carrington
'Life of Lady Randolph Churchill' (Vol.2)	1971	R Martin
'History of Hertfordshire'		WB Gerish's grangerised copy of Cussan's
'Supernatural St.Albans'	2002	Rolfe & Stratton
Oral testimony	2001	Tudor Cottage residents
Oral testimony	2001	Lynn Englebright

MARKYATE

Hemel Hempstead Gazette	Aug 18 1950	
Hertfordshire Mercury	Oct 29 1910	
Herts Express	Dec 8 1905	
'Hertfordshire Houses –' Selective Inventory	1993	JT Smith

'Ghosts of London'		1975	J Hallam
'Some Hertfordshire Tragedies'		1913	WB Gerish
(unpublished manuscript)			
Oral testimony		2001	(name supplied)

MUCH HADHAM

Herts & Essex Observer	Jan 8	1987	
'Hertfordshire'	Jul	2001	
'The Moat Lady'		1938	P Illot
'Much Hadham – a		2000	J Page
Millennium Scrapbook'			

NUTHAMPSTEAD

Herts and Cambs Reporter	Feb 29	1980
and Royston Crow		

PIRTON

Hertfordshire Mercury	Apr 12	1913	
EHAS transactions (Vol. 4)		1911	
Hertfordshire Countryside	Dec	1980	
'History of Hertfordshire'			WB Gerish's grangerised copy of Cussan's

RADLETT

Hertfordshire Countryside	May	1984

REDBOURN

Herts Advertiser	Feb 12	1937	
	Oct 14	1977	
Oral testimony		1999	(name supplied)

RICKMANSWORTH

Watford Observer	Aug 2	1985
	Feb 14	1997
	Mar 21	1997

| *Hertfordshire Countryside* | Nov | 1992 | |
| 'Folklore of Hertfordshire' | | 1977 | D Jones-Baker |

RIDGE
| 'Millennium History of Ridge' | | 2000 | |

ROYSTON
Herts and Cambs Reporter	Sep 19	1986	
and Royston Crow			
	Jan 17	1992	

St. ALBANS
Hertfordshire Archives and
Local Studies Gerish Collection

Letter to Ruth Stratton		1995	(name supplied)
Herts Advertiser	Dec 22	1955	
	Dec 18	1970	
	Feb 1	1974	
	Feb 21	1975	
	Mar 27	1975	
	Dec 23	1976	
	Dec 24	1980	
	Dec 11	1981	
	Feb 12	1982	
	Apr 29	1983	
	Jun 7	1985	
	Dec 4	1991	
	Jan 3	1993	
	Jul 12	2001	
Midweek Recorder	Mar 11	1975	
St Albans, Welwyn and	Jun 13	1985	
Hatfield Review			
	Apr 16	1987	
	Aug 20	1987	
	Aug 27	1987	
	Nov 11	1998	

Sunday Times	Jan 21 2001	
Watford Observer	Dec 16 1911	
	Nov 8 1913	
Hertfordshire Countryside	Apr 1968	
	Sep 1970	
	Jul 1978	
	Aug 1990	
St. Albans Now !	Apr 1995	
'Good Ghost Guide'	1994	Brooks
'The Ghost Book'	n.d	Carrington & Thresher
'Story of St. Albans'	1962	E Toms
'Inns of Hertfordshire'	1962	W Branch-Johnson
'History of the	1991	R Stratton
Fighting Cocks Inn'		
Francis Skeat	1992	Letter to Ruth Stratton
'Supernatural St. Albans'	2002	Rolfe & Stratton
Oral testimony	1980s	(name supplied)
Oral testimony	1984	(name supplied)
Oral testimony	1992	(name supplied)
Oral testimony	1992	Ginger Mills
Oral testimony	2001	Leo Hickish
Oral testimony	2001	Paul Rolfe
Oral testimony	2001	(name supplied)
Oral testimony	2001	Bar staff – Fighting Cocks
Oral testimony	2001	Pete Ransome

ST PAUL'S WALDEN

'Old Hertfordshire Calendar'	1974	D Jones-Baker

SHENLEY

Oral testimony	2001	Lynn Englebright

SARRATT

Hertfordshire Archives and		Gerish Collection Box 66
Local Studies		

Hertfordshire Mercury	Aug 6	1904	
Watford Observer	Jul 7	1913	
	Feb 28	1997	
	Mar 28	1997	
'Victoria County History of Hertfordshire'			

| 'Phantoms of the Night' | | 1956 | E O'Donnell |

SAWBRIDGEWORTH

Watford Observer	Oct 27	1994	
EHAS Transactions (Vol 2)			
'Victoria County History of Hertfordshire'			

| 'Where the Lysanders Were' | | 1995 | P. Doyle |

SOUTH MIMMS

| *Evening Standard* | Sep 19 | 1928 | |
| 'Haunted Britain' | | 1948 | E O'Donnell |

STANDON

| *Mail on Sunday* | Dec 31 | 1989 | |

STEVENAGE

Hertfordshire Archives and Local Studies			Gerish Collection Box 72
Stevenage Gazette	Jan 2	1975	
Hertfordshire Countryside	Dec	1980	
'Haunted Mid Herts'		n.d	Mid Herts Teachers Ass

TEWIN

Hertfordshire Mercury	Sep 2	1905	
	Sep 2	1911	
Welwyn Hatfield Times	Jan 7	1966	

Hertfordshire Countryside	Dec	1998
'Haunted Mid Herts'	n.d	Mid Herts Teachers Ass
Oral testimony	1999	Bar Staff – Plume of Feathers

THERFIELD

Herts & Cambs Reporter and	Aug 29 1975	
Royston Crow	Sep 15 1975	

THUNDRIDGE

Hertfordshire Mercury	Nov 10 1978	

TRING

Watford Observer	Dec 2	1911	
	Apr 13	1912	
'Ghosts of Tring'		1976	S Richards

WADESMILL

Menu for the Feathers Inn	1982	

WARE

Hertfordshire Archives and Local Studies		Gerish Collection Box 79
Hertfordshire Mercury	Jan 20 1933	
	Sep 29 1986	
The Citizen	1911	
'Tales of Old Hertfordshire'	1987	D Jones-Baker
'Haunted Britain'	1973	A Hippisley-Coxe
Oral testimony	2001	(name supplied)

WATFORD

Hertfordshire Mercury	Aug 5	1911
Morning Leader	Oct 18	1898
West Herts Post	Sep 9	1928

Watford Observer	Nov 1	1913	
	Nov 14	1914	
	Nov 23	1918	
	Jun 29	1973	
	Mar 1	1974	
	Mar 28	1980	
	Jan 15	1988	
	Oct 30	1992	
	Feb 21	1997	
Hertfordshire Countryside	Jul	2000	
'History of Hertfordshire'			WB Gerish's grangerised copy of Cussan's
'Our Haunted Kingdom'		1973	A Green

WATTON-AT-STONE

Letter to Ruth Stratton		2001	(name supplied)

WELHAM GREEN

Oral testimony		1993	(name supplied)

WELWYN

Welwyn Hatfield Times	Dec 28	1962	
	Jan 7	1966	
Hertfordshire Countryside	Aug	1973	
'Haunted Mid Herts'		n.d	Mid Herts Teachers Ass.

WELWYN GARDEN CITY

Hertfordshire Countryside	Jan	1970	
Welwyn Hatfield Times	Jul 4	1975	
	Nov	1992	
	Jun 11	1997	
'Haunted Mid Herts'		n.d	Mid Herts Teachers Ass.
Oral testimony		2002	Barn Theatre actors
Oral testimony		2001	QEII Hospital Nurses

WESTMILL
Hertfordshire Mercury Jul 5 1913

WESTON
Hertfordshire Mercury May 3 1913
 Jun 27 1914

WHEATHAMPSTEAD
Herts Advertiser Dec 18 1970
 Jan 10 1975
'Our Haunted Kingdom' 1973 A Green

WHITWELL
Welwyn Hatfield Review Apr 1 1982

WIDFORD
Hertfordshire Mercury Jun 1912

WORMLEY
Hertfordshire Countryside Oct 1994
Oral testimony 2002 (name supplied)

MISCELLANEOUS
'Tour Through Hertfordshire' 1921 WB Gerish
'Folklore of Hertfordshire' 1970 WB Gerish
'Haunted England' 1940 C Hole
'Phantom Britain' 1975 M Alexander

UNEXPLAINED
OXFORD
AND
OXFORDSHIRE

Marilyn Yurdan

UNEXPLAINED OXFORD AND OXFORDSHIRE

by Marilyn Yurdan

Unexplained Oxford and Oxfordshire is the result of several years of collecting strange stories and folk tales from all over the county, including the vale of White Horse which was transferred from Berkshire in 1974. As befits a part of the country which has been at the cross-roads of human activity from prehistoric times onwards, there has been no shortage of material, and haunted sites in Oxfordshire range from the conventionally creepy to the modern council house, and sightings vary from vague, unidentified shapes to recognisable local characters.

The majority of the accounts covered by the book have been taken from the extensive 'Ghost File' of Oxford and County Newspapers, others have been told directly to the author and the rest are part of the rich and ancient folklore of Oxfordshire. Three of the extraordinary happenings recorded in the book took place when Marilyn was present, and she is always interested in hearing from other people about similar experiences.

The
Book
Castle

A Book Castle Publication

HARE & HOUNDS

The Aldenham Harriers

by Eric Edwards

Organised and legal hunting for hare within thirty miles of the centre of London is a remarkable thing, and yet it has been going on regularly, and indeed frequently, for 124 years. This book aims to tell the story of how it all came about; the people and places involved, the characters, the trials and the achievements of the followers of a pack of hounds kept for the purpose in the same kennels in Hertfordshire for over fifty years. It all started in Aldenham, in an area now largely covered by the urban sprawl of Boreham Wood and hemmed by the M1, A1 and M25. It is indeed astonishing that in an area between Bedford and London, heavily populated as it is today, and with major roads and railways radiating outwards from London every few miles, such an essentially rural activity thrives and, politics permitting, appears to have a bright future.

A Book Castle Publication

266

CRIME IN HERTFORDSHIRE

Volume One: Law and Disorder

by Simon Walker

This volume covers the history of law and order in Hertfordshire from the Anglo Saxon period to the middle of the twentieth century. Criminal law, the courts, the punishments and the means of enforcement have changed over the course of more than a thousand years, and the author traces those changes, illustrated with examples drawn from throughout Hertfordshire.

He has included the unusual and the commonplace; from murder to highway robbery and petty theft. What is the truth about trial by ordeal? What happened to John Doggett who swore, "By God, he shot your dogs" in the 1600's? Take a tour round the prisons and places of confinement in the country; what were conditions like in the dungeon at Bishop's Stortford castle? Meet the "resurrection men," or body snatchers, the murderers, thieves, poachers and vagabonds. How was law and order enforced in the past, and how did the police forces of today originate? This book will appeal to students of both the history of crime and punishment and those interested in the history of Hertfordshire as a whole.

A Book Castle Publication

267

JOURNEYS INTO HERTFORDSHIRE

ANTHONY MACKAY
FOREWORD BY
THE MARQUESS OF SALISBURY

JOURNEYS INTO HERTFORDSHIRE

by Anthony Mackay

This collection of nearly 200 ink drawings depicts the buildings and landscape of the still predominantly rural county of Hertfordshire. After four years of searching, the author presents his personal choice of memorable images, capturing the delights of a hitherto relatively unfeted part of England.

The area is rich in subtle contrasts – from the steep, wooded slopes of the Chilterns to the wide-open spaces of the north-east and the urban fringes of London in the south. Ancient market towns, an impressive cathedral city and countless small villages are surrounded by an intimate landscape of rolling farmland.

The drawings range widely over all manner of dwellings from stately home to simple cottage and over ecclesiastical buildings from cathedral to parish church. They portray bridges, mills and farmsteads, chalk downs and watery river valleys, busy street scenes and secluded village byways.

The accompanying notes are deliberately concise but serve to entice readers to make their own journeys around this charming county.

A Book Castle Publication